D1538919

moda fad

MODAFAD TWENTYFIVE EDITIONS

BARCELONA
BRANDNEW
FASHION
DESIGNERS

Editor
Chu Uroz / ModaFAD

Published by Actar
Barcelona / New York
www.actar.com
info@actar.com

Image editor and design
Pablo Rovalo / Research Studios Barcelona

Content editor and texts
Yolanda Muelas

Translation
Patricia Paradela

Distributor
Actar-D
Roca i Batlle, 2
08023 Barcelona
T. +34 934 174 993
F. +34 934 186 707

Actar-D USA
158 Lafayette St. 5th floor
New York, NY 10013
T. 212 966 2207
F. 212 966 2214
officeusa@actar-d.com

ISBN: 978-84-96959-65-6
DL: B-39744-08
© of the edition, Actar
© of the photographs, their authors
© of the text, their authors

ModaFAD
Plaça dels Àngels 5-6
08001 Barcelona
T. +34 93 443 75 20
F. +34 93 329 60 79
modafad@modafad.org
www.modafad.org

With the colaboration of
Curators:

Pilar Pasamontes
Marcel Montlleó
Juan Salvadó

Archive coordination:
Miquel Malaspina
Silvia Aldomá

Research and images:
Tatiana de la Fuente
Óscar Fernández

ModaFAD:
Chu Uroz President
Pilar Pasamontes Vicepresident
Alessandro Manetti Treasurer
Josep Abril
Miquel Malaspina
Executive directors:
Tatiana de la Fuente
Silvia Aldomá

Sponsors:
Cervezas Moritz S.L
Ajuntament de Barcelona
Generalitat de Catalunya

Schools:
IED BCN, IDEP, ESDI, ICM, Escola de la Dona

"ModaFAD 25 Editions" recull l'aventura de ModaFAD, una associació sense ànim de lucre formada per estudiants, proto-designers, autodidactes, estilistes, dissenyadors multidisciplinars, sponsors i institucions.
L'objectiu: llençar els joves dissenyadors cap a una projecció internacional, sempre des d'una perspectiva Barcelona. Ens importa sobretot l'aspecte creatiu del món de la moda i ens retroalimentem dels nostres descobriments que acaben convertint-se en els futurs col·laboradors. Aquesta és la nostra peculiar fórmula FAD que ens defineix com una gran família multidisciplinar més enllà del coolhunter...

We are a family.

"ModaFAD 25 Editions" recoge la aventura de ModaFAD, una asociación sin ánimo de lucro formada por estudiantes, estilistas, proto-designers, autodidactas, sponsors diseñadores multidisciplinares e instituciones.
Nuestro objetivo: lanzar a jóvenes diseñadores emergentes hacia una proyección internacional, siempre desde una perspectiva Barcelona.
Nos importa el aspecto creativo del mundo de la moda y nos retroalimentamos de nuestros descubrimientos, que acaban convirtiéndose en futuros colaboradores. Esa es nuestra peculiar fórmula FAD que nos define como una gran familia multidisciplinar más allá del coolhunter...

We are a family.

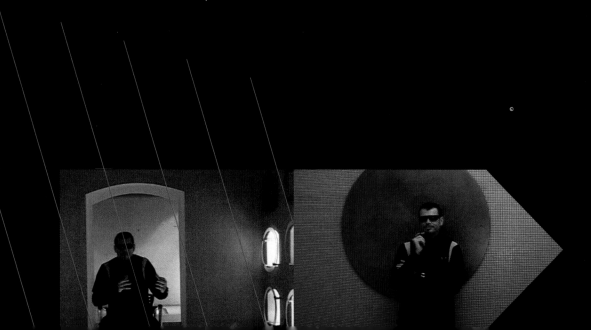

"ModaFAD 25 Editions" portrays the ModaFAD adventure, a non-profit association formed by students, stylists, proto-designers, self-taught practitioners, multidisciplinary designers, sponsors and institutions. Our goal: launch from a Barcelona perspective emerging young talent into the world.
Above all we care about the creative aspect of the fashion world and we get feedback from our discoveries, which become future collaborators. This is our peculiar FAD formula that defines us as a multidisciplinary big family beyond the coolhunter...

We are a family.

Chu Uroz / ModaFAD President

Fashion –as the teacher Gillo Dorfles wrote, with great future vision almost thirty years ago– is "one of the safest parameters to measure the psychological motivations of the psychoanalytic, socio-economic humanity. Not only has to do with how we dress, but it is a sociological and aesthetic factor that extends to decoration, objects, philosophical direction, political, scientific, literary, artistic, in a word, all areas that for one reason or another are therefore subjugated to it."

It is difficult to draw a linear history of an institution as dynamic and noisy as ModaFAD. 25 editions of passion, suffering and, above all, lots, lots of dedication to everything emerging, young and fresh from the different environments linked to fashion.

ModaFAD has been, is, and will be, before anything an entire concept translated into action: to support unconditionally the creative talent as a crop field for the creation of enterprises and the promotion and awareness of the culture of fashion. That is why ModaFAD has always tried to interpret the multidisciplinary and eclectic nature of fashion, in this way, one might say, it has never been only a simple gateway.

Its structure of a three-day program, developed especially in the last 5 years, is structured with an initial moment of cultural-nature –most of the times explosive– which has the clear purpose of promoting the most eclectic realities and open a window towards an international and global territory, searching for content among artists or on the most representative movements, more for tradition than innovation in the sector.

They belong to this first day, many exhibits as European Fashion Logos Mutant, conducted in collaboration with the Austrian institution Unit> F

ModaFOOD, an exhibition crossed between fashion and cuisine, through several interpreters as Ferran Adrià, Bigas Luna or Boris Hoppek, the creative workshop fashion-music-video of Chicks On Speed, as well the retrospective exhibition of Sybilla on the occasion of the design year or advertising campaigns of Oliviero Toscani for Fiorucci or a presentation on a kit form in collaboration with the trend magazine UOVO.

The second day of the program is the time to introduce young talent to the city, a collective gateway as a metaphor of a process of selection of concepts, creativity and technical control of the tools of the profession. Among the finalists they will choose a winner who has the opportunity to have a fashion show of its own collection in the following edition. They always invite international emerging designers as valid reference point.

The third day is probably the most social, public, democratic and democratizing of fashion in the city: the MerkaFAD. Twelve hours of continuous movement between different stands where the public can get close to the collections, touching fabrics and finally has the option to buy. It is an important first test that allows you to understand that a good concept should become a good product to succeed in a hyper-competitive market.

This formula ModaFAD, since the beginning has known –perhaps better than other demonstrations– how to represent the freshness and strength of a fashion image of Barcelona linked to trends in the street, to a lifestyle and multi-disciplinary thinking, casual and unconventional regarding the most orthodox of *prêt-à-porter* and the *haute couture*. An avant-garde formula from a long list of other events that exist today to promote young fashion design in Europe and emerging countries. It may

be that the largest merit of ModaFAD has been contributing to position before many other cities temples of the Fashion System, a new global concept of fashion no longer simply regarded as a professional sector and market but as a phenomenon, flexible and extremely variable on continuous adaptation to social situations and moments constantly changing, capable of recording mutations of the contemporary social fabric and to move them forward with an even faster pace of the already high-speed information of the XXI century.

25 editions ago, to develop this concept from an institutional perspective has been very valuable, by those who from a totally unrelated to the profit-making point of view, better represented by the spirit of the FAD and the true soul of Barcelona, have believed in the project and wanted to dedicate many hours of their time to organize and start a new platform, by the various local administrative and political institutions that have provided a vital support for their development.

The future of ModaFAD is today, as its history, more than ever linked to the future of fashion in this city. And is called professionalism.

That is why it is important that all the professionals, social and political institutions have made clear that a good plan is not enough to position definitively Barcelona as a reference city on the global map of fashion without a project and a strategy of building systems that's able to see involved in a plural and cooperating way the lifeblood of the sector: from designers to schools, from different political parties to commercial institutions; from the production to the retail and all other actors: the press, the buyers, and different companies, etc..

This book, throughout the peculiar story of the ModaFAD, tells the visual story of many of the protagonists of the fashion in Barcelona and its ability to adapt to the changes on weather. Tells the past and present but with its images, the sensitive and attentive reader can capture all our perspectives and suggestions of a perhaps not too distant future.

Alessandro Manetti
Design Manager

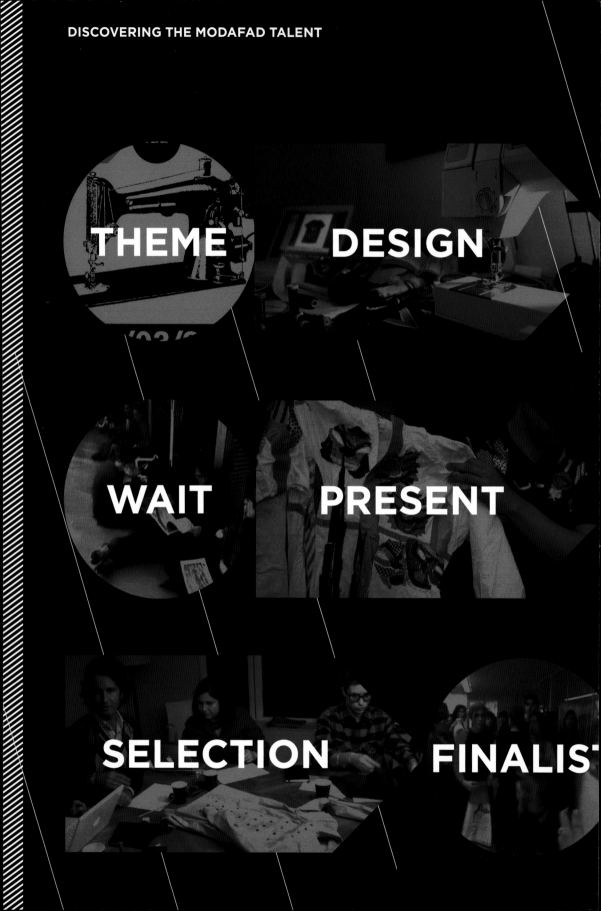

THEME

DESIGN

WAIT

PRESENT

SELECTION

FINALIST

The ModaFAD team proposes each season a theme around which the participants must design a fashion collection (female, male or accessories) this theme will be the conceptualization axis of the entire collection from the outset in conducting a progressive Sketchbook of their work until the physical execution of the garments. This guideline should be faced and argued by the participant in the oral presentation to the jury.

BOOK **JURY**

COLLECTION **PRIZE**

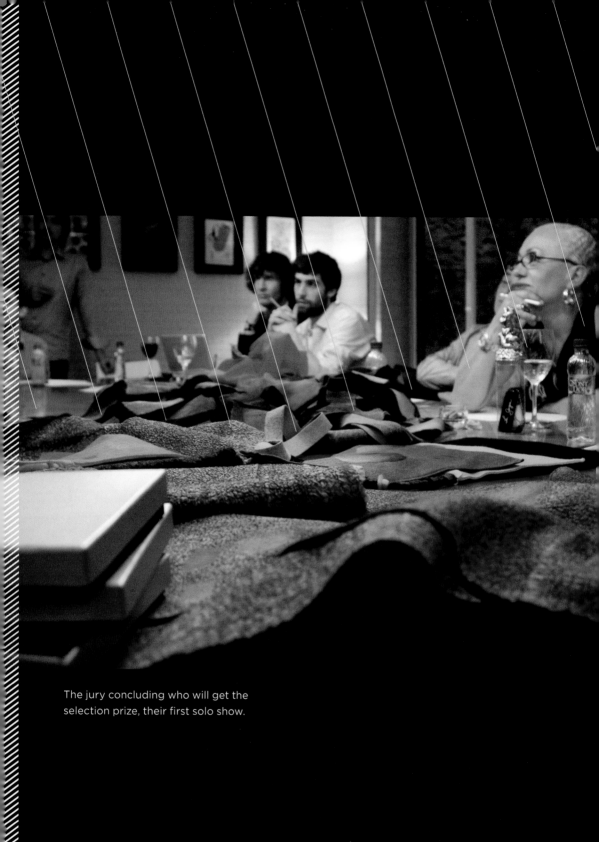

The jury concluding who will get the
selection prize, their first solo show.

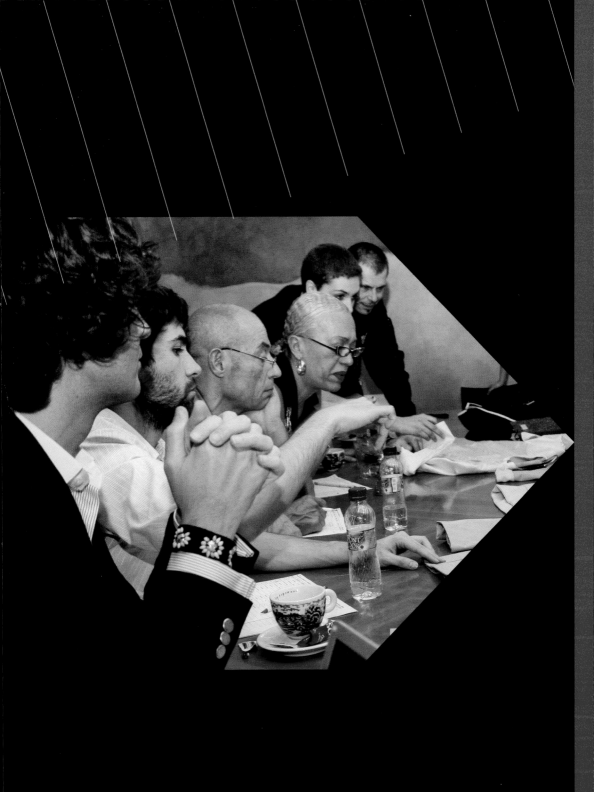

LAUNCHING THE MODAFAD TALENT

Participants have time to build the preliminary project of their collection* execution of a Sketchbook and 5 garments and are called again before a jury constituted by stylists, photographers, fashion journalists, other relevant professionals and agents of the sector on the MODAFAD board.
The presentation before the jury will be oral and personal, where the creator will present its project and will defend in court their line of work.
During this selection marathon process the jury filters the most interesting projects and after careful deliberation candidates are presented to the edition.
Once known the list of participants, they are compromised to make a mini collection and present it at the date set by ModaFAD.
Once the collections are received the jury gets together again, and award the best collection, both male and female who will be able to have a solo show in the next edition and a cash prize and counselling during an entire year.
With the physical presentation of all the collections, the ModaFAD team of stylists, select garments of all the participants and raises the PasaFAD, a whole parade under the theme raised by ModaFAD in each edition.

The days preceding the show, members of ModaFAD team cast the models, prepare the styling and the fitting. Each ModaFAD edition is divided on two acts, the first day for the fashion shows and the second for the market.

PASAFAD + WINNERS PARADE OF PREVIOUS EDITIONS + GUEST PARADE.

The act of the first day is closed by the awards ceremony and the party. The next day the creators showroom is introduced, where participants show and sell their collections, Twelve hours of their first business contact with the public.

PRIZE

STYLING

FITTING

SHOW

AWARD

FIESTA

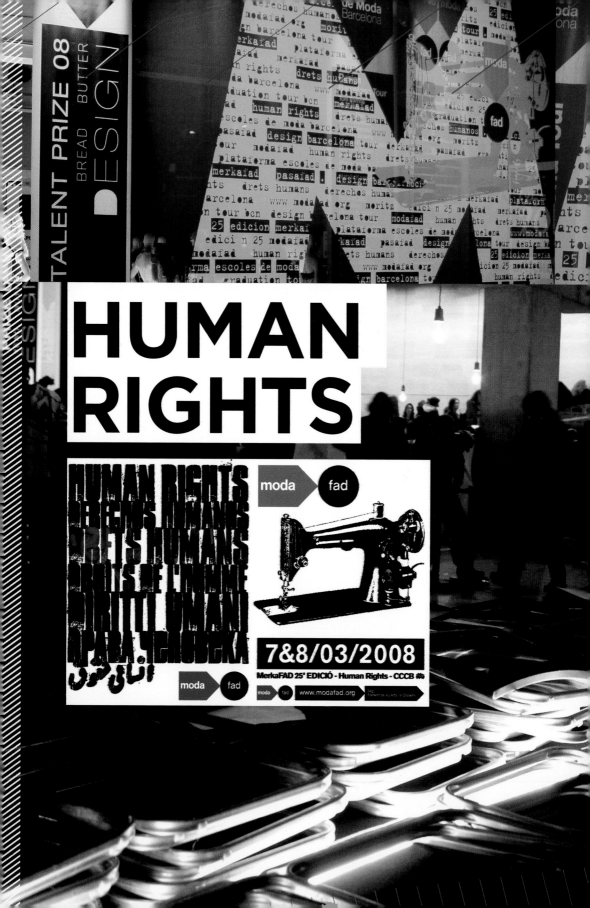

25. HUMAN RIGHTS
>

March 2008 at the CCCB
Winners. Best Male Collection Award: Ida
Johanson & Lucrecia Lovera (Twist). Best
Women Collection Award: Isabel Uribe &
Gloria Lladó (Bigoteprimerizo).
Winners of the Young Talent Prize 08
(Bread & Butter King Size & plataforma of
Schools): Carolina Caralt, Xavier Fernández.
Architects: xnf.
Lightning: Josep Maria Civit.
Graphic design: Guillem Pericay.
Video: Juanjo Onofre.
Photography: La Fotográfica, Xavi Padrós
and Lomographic.
Hairdresser: Marcel & team.
Make up: Neus Tutusaus & team.
Stylists: Asier Tapia, Jaume Vidiella, Juan
Vidal, Malaspina, Txomin Plazaola.
Editorial: Bcn.Urb.
Subvention: Generalitat de Catalunya
y 080 Barcelona.
Main sponsor: Moritz.

The 25th edition was a reflection on
human rights. The designers who
paraded and sold their clothing in
MerkaFAD weren't the only ones who
worked with this theme, they joined two
hundred artists who participated in
project *Guantánamo no!* which the
foundation Signes promotes as
international complaint to the prison of
Guantánamo. The documentary "China
Blue" was shown, it denounced the
exploitation of children in Chinese textile
factories. In this edition the solo shows
were Anna Galbana, Icaro Ibáñez and
Bente Borj.

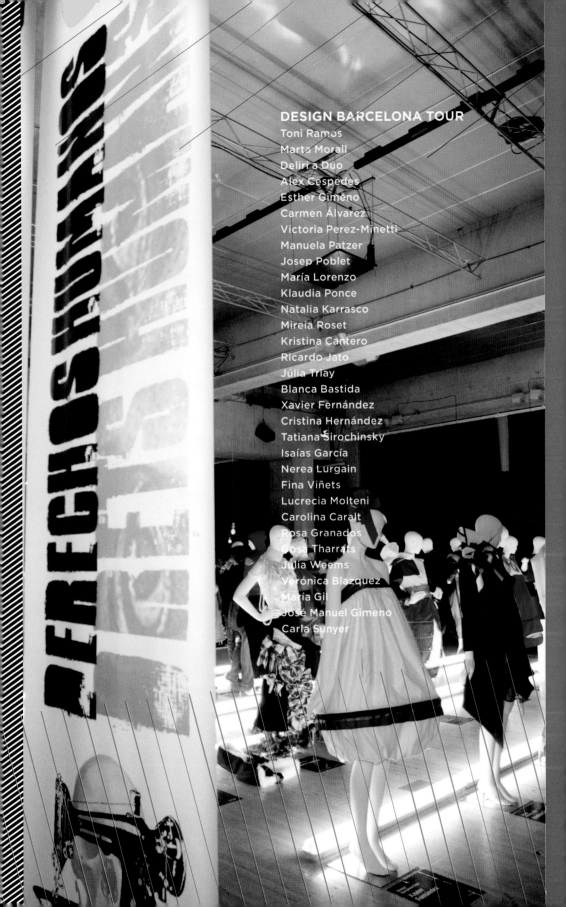

DESIGN BARCELONA TOUR

Toni Ramos
Marta Morall
Deliri a Dúo
Alex Cespedes
Esther Gimeno
Carmen Álvarez
Victoria Perez-Minetti
Manuela Patzer
Josep Poblet
María Lorenzo
Klaudia Ponce
Natalia Karrasco
Mireia Roset
Kristina Cantero
Ricardo Jato
Júlia Triay
Blanca Bastida
Xavier Fernández
Cristina Hernández
Tatiana Sirochinsky
Isaías García
Nerea Lurgain
Fina Viñets
Lucrecia Molteni
Carolina Caralt
Rosa Granados
Cosa Tharrats
Julia Weems
Verónica Blazquez
María Gil
José Manuel Gimeno
Carla Sunyer

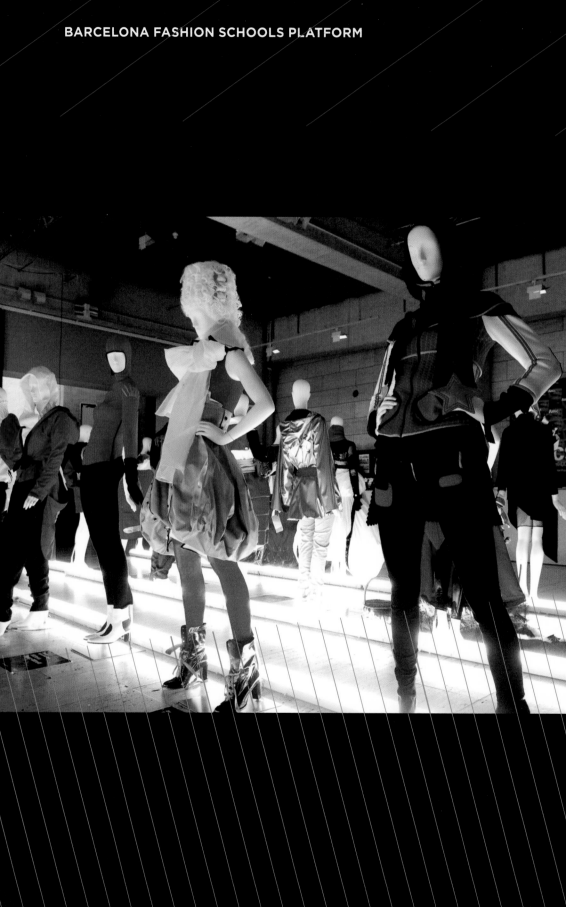

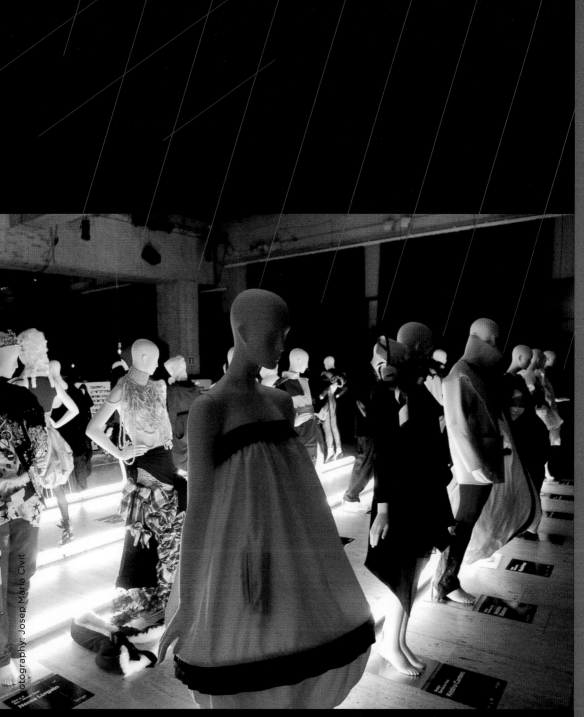

Photography: Josep Maria Civit

Young Talent Prize 08 Bread & Butter
King Size & Schools platform.

Sometimes, design makes me sick

Carlos Rolando

Un nuevo módulo del centro de detención de Guantánamo. Las zonas comunes no serán utilizadas por seguridad.

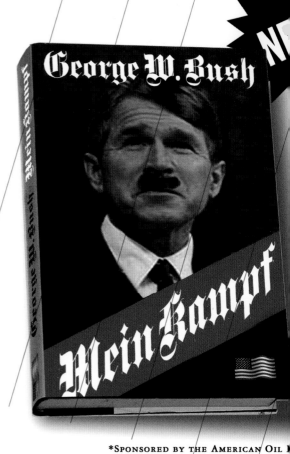

George W. Bush

Mein Kampf

*SPONSORED BY THE AMERICAN OIL

GUANTÁNAMO / END TORTURE NOW

SOONER OR LATER THERE WILL BE A NEED TO CLOSE GUANTÁNAMO. HOPEFULLY AS SOON AS POSSIBLE
TARDE O TEMPRANO EXISTIRÁ LA NECESIDAD DE CERRAR GUANTÁNAMO. ESPERAMOS QUE SEA LO ANTES POSIBLE

estados unidos de américa
próximas elecciones presidenciales
noviembre de 2008

introduzca
aquí su
pataleta

The Signes foundation promotes an international graphic report against the prison of Guantánamo. The call to participate is open in: www.fundacionsignes.org/gno. There is not deadline, but think that tomorrow will be too late.

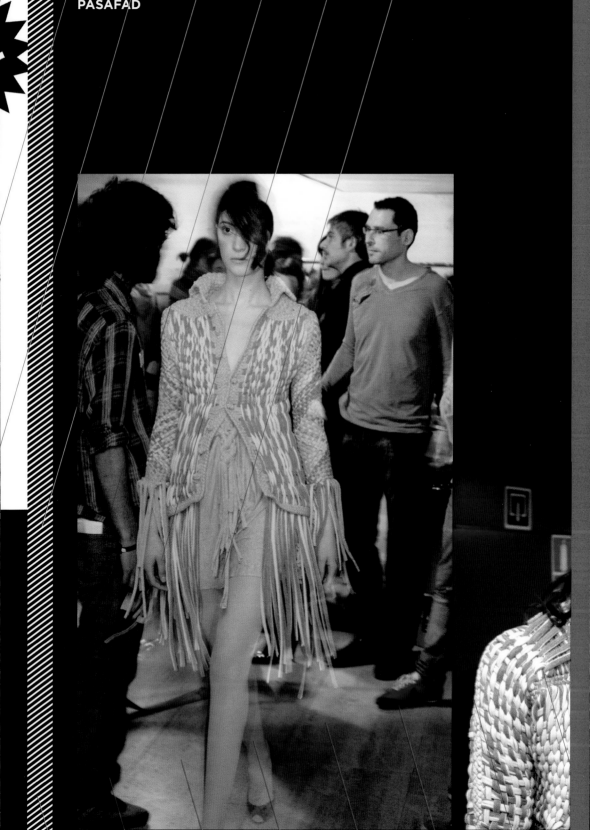

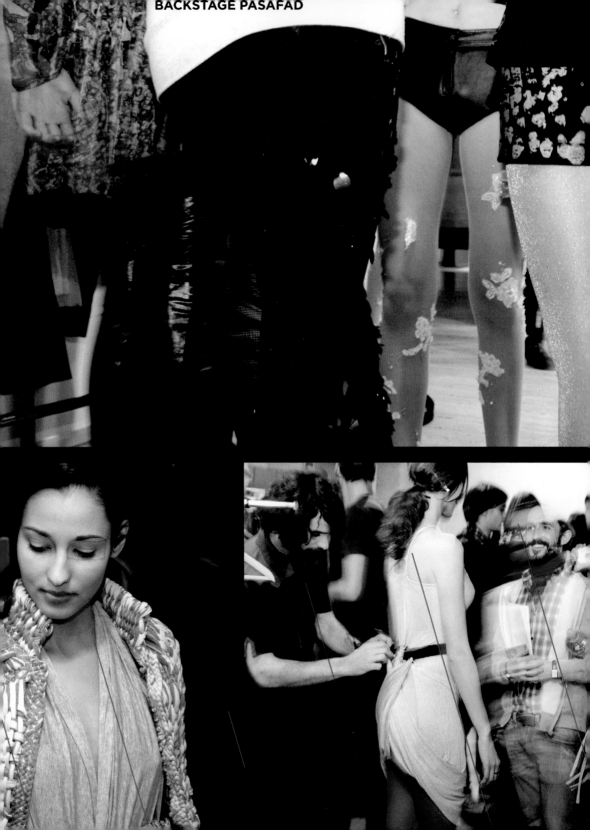

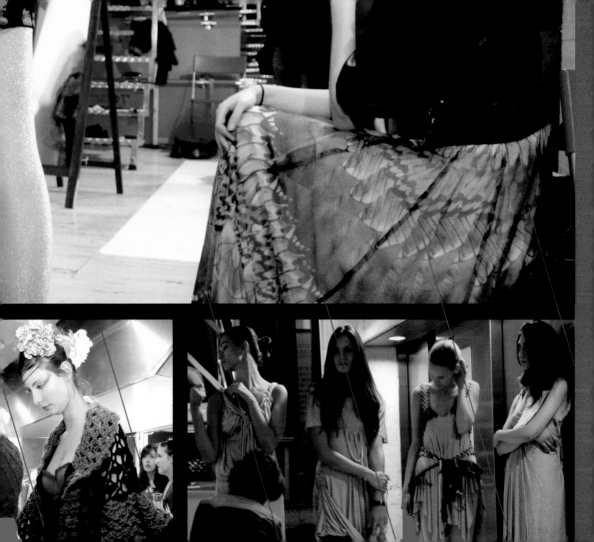

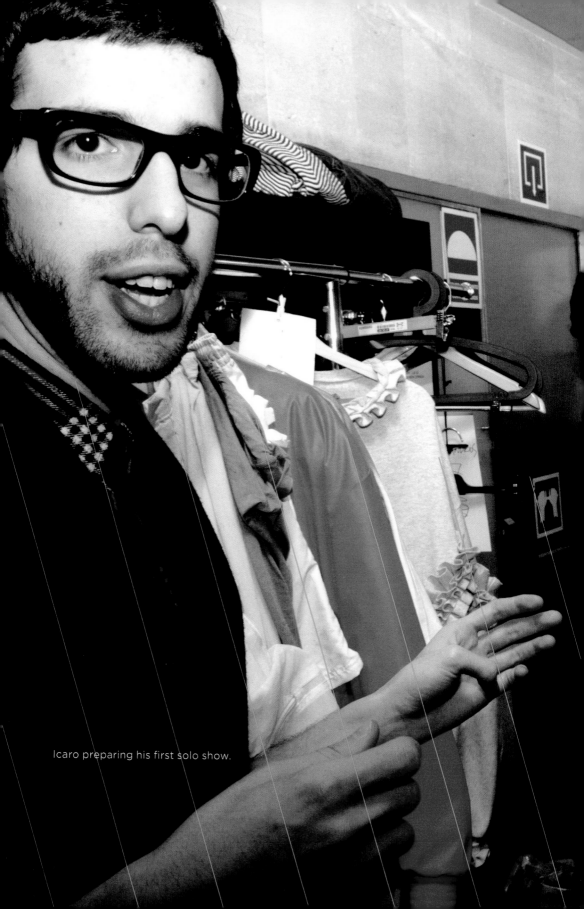

Icaro preparing his first solo show.

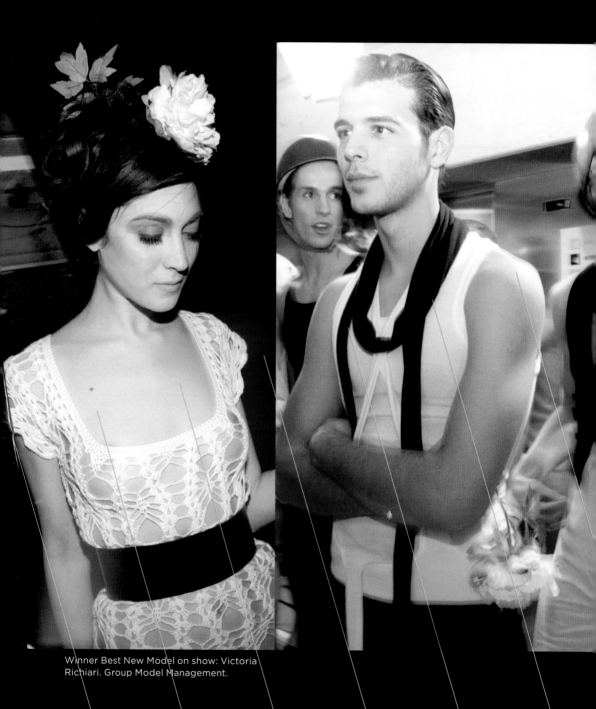

Winner Best New Model on show: Victoria Richiari. Group Model Management.

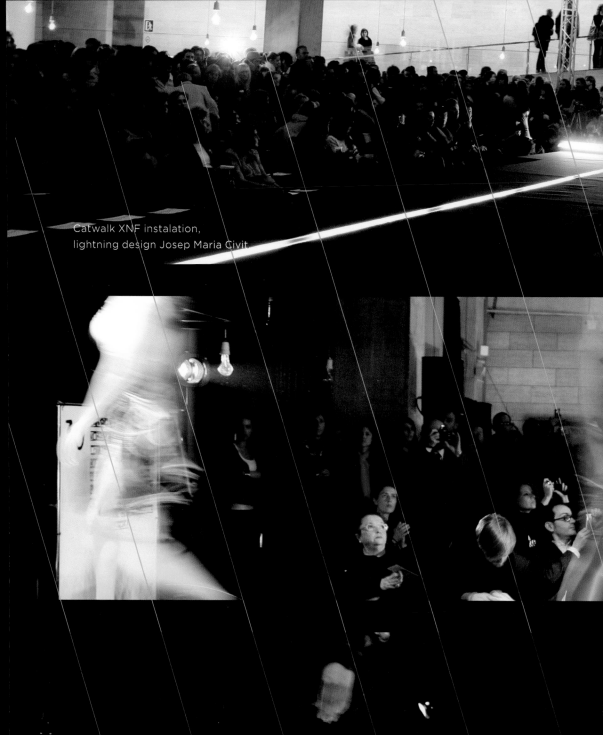

Catwalk XNF instalation,
lightning design Josep Maria Civit.

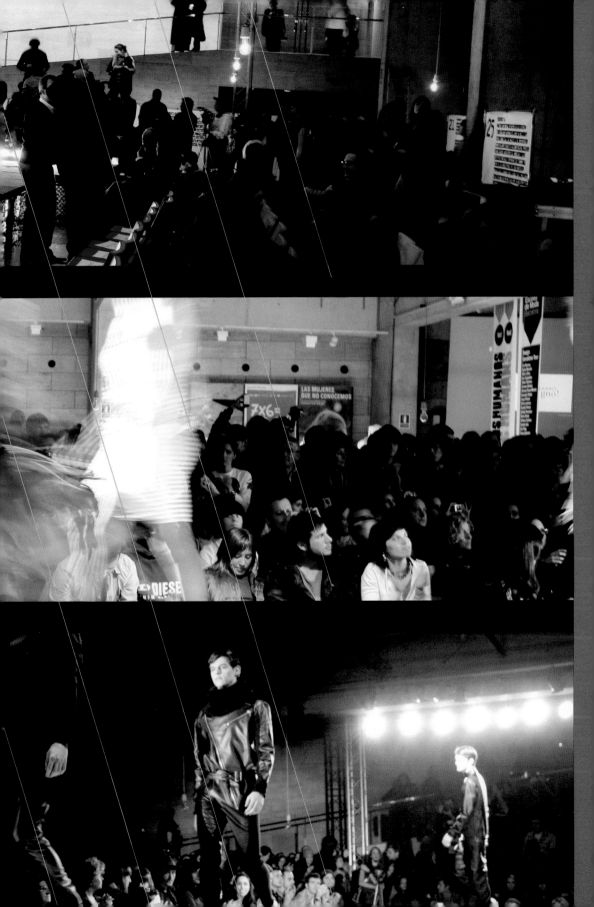

LOMOGRAPHY

23

DJ Manetti

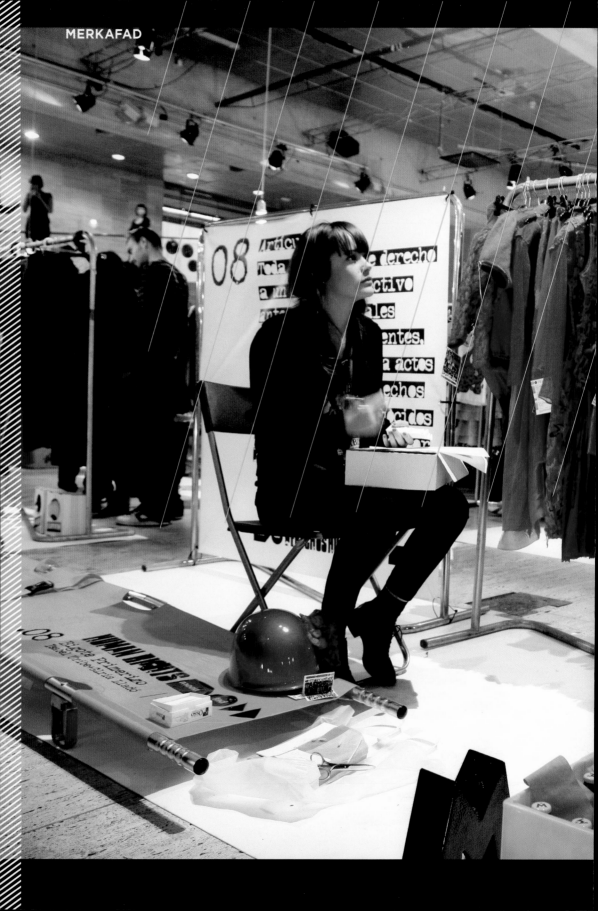

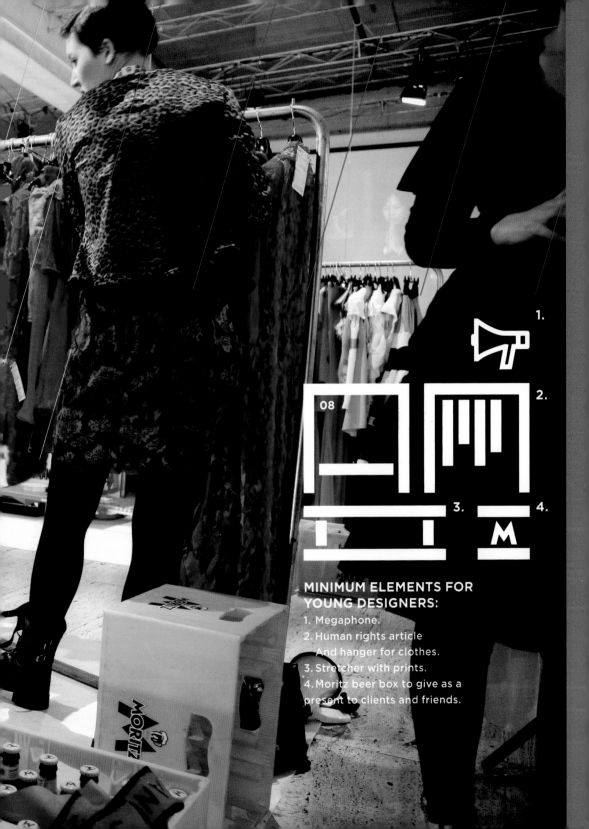

08

1.

2.

3. 4.

MINIMUM ELEMENTS FOR YOUNG DESIGNERS:
1. Megaphone.
2. Human rights article
 And hanger for clothes.
3. Stretcher with prints.
4. Moritz beer box to give as a
 present to clients and friends.

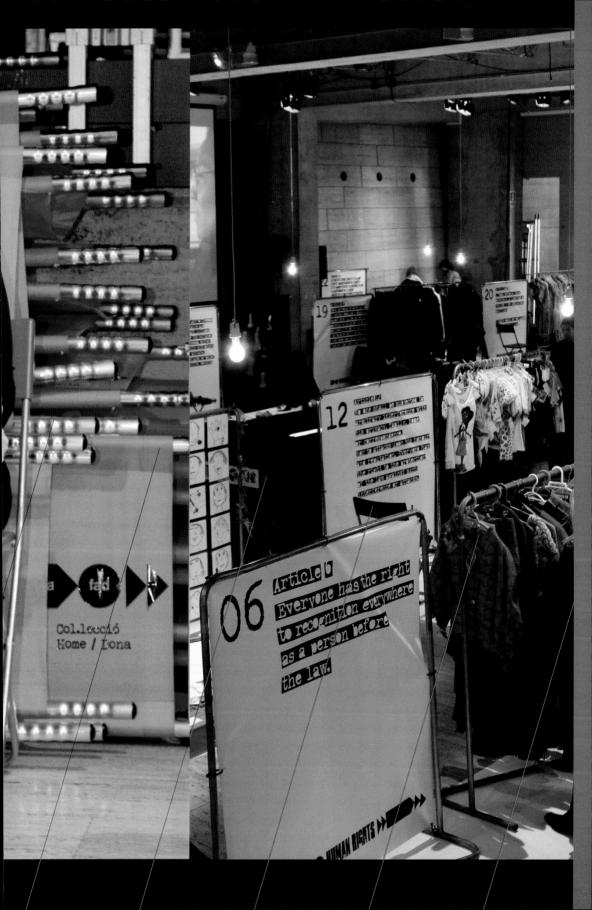

BIGOTEPRIMERIZO

>

Gloria Lladó (Barcelona, 1986) and Isabel Uribe (Logroño, 1984) are the designers of Bigoteprimerizo, which won the prize in the 25th edition of ModaFAD for Best Collection. They say their brand "arises from the need to create and have fun doing what we like." The collection, called El Partido, tu ignorancia es la fuerza, was inspired by George Orwell's book *"1984"*. They define their work as a "laboratory research, in which we give free rein to the imagination, always in constant experimentation with materials, textures and colours."

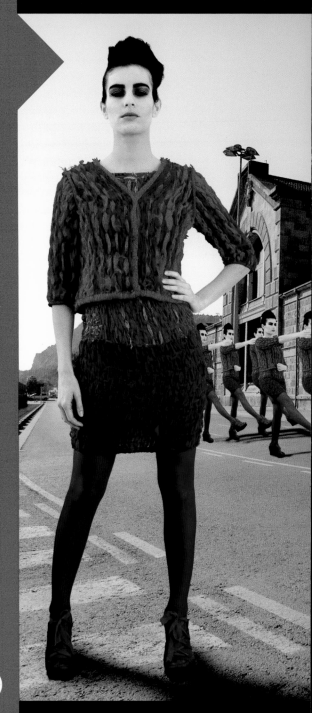

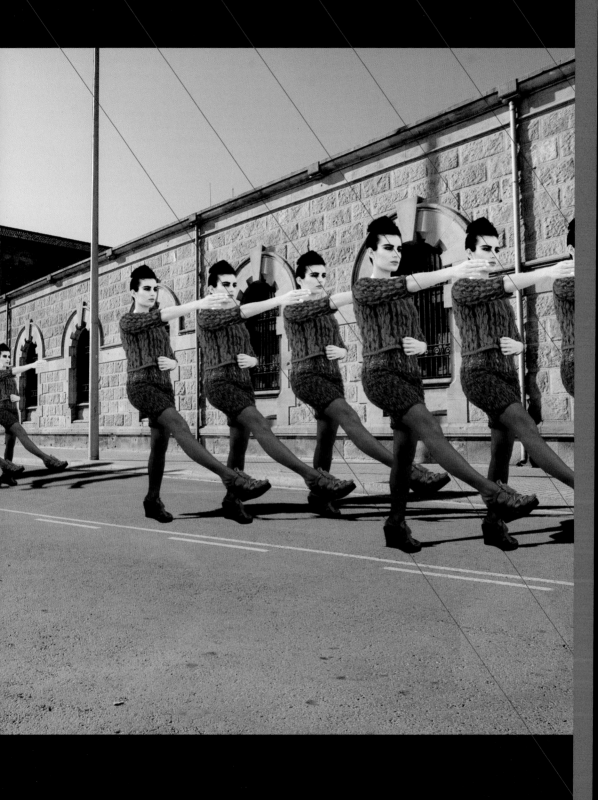

CATERINA FOLETTI

>

Caterina (Bellinzona, Switzerland, 22 years old) works especially with "the materiality of the garment", that is to say the fabric. His collection of Fall-Winter 2008/09 was born from thinking that "the man needs myths, that has an innate need for spirit, it is not pure meat, not a single body. After all, the soul and the animal resemble (both are essence of instinct). I dedicate this collection to the old people, those closest to return to the world of myth, where earthly life is an interruption, designing for them has been a necessary gesture of respect and attention, today more than ever", says the designer, winner of the first prize of the Movistar New Designer IED 2008.

JAUME VIDIELLA
>

Jaume Vidiella (Tarragona, 1970) began as a fashion designer after going to the EATM school, but then decided to quit because "I felt that the process was too long ". And since then his work is focused on topics related to trends, style, and visual merchandising. Professor in IED and EATM, has worked for big companies like Armand Basi and Colcci and is a regular contributor to *b-Guided* magazine. He has worked as a stylist with photographers like Paco and Manolo, Tatiana Donoso, Marta Amorós and the artist Carles Congost. Has been linked to ModaFAD for many years as a board member where he participates in organizational issues as part of the jury, selecting the participants of each edition or working on the parades stylism.

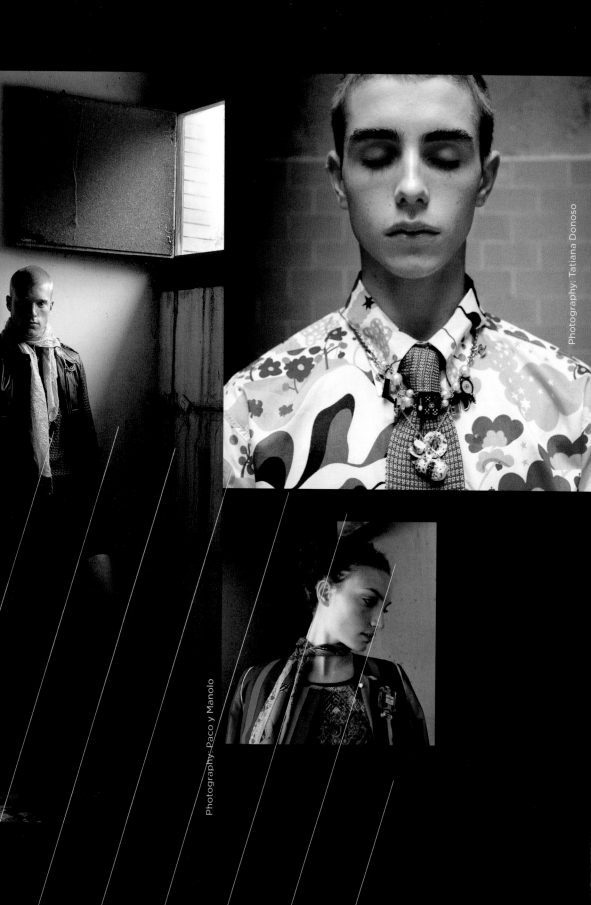

Photography: Tatiana Donoso

Photography: Paco y Manolo

ICARO

>

Krizia Robustella is not alone in his passion for tracksuit. She loves the 90's tactel, Icaro (from Zaragoza studying at Antwerp Royal Academy of Fine Arts, after passing through Barcelona) defines the collection that he paraded in the latest edition of ModaFAD as "Victorian tracksuit." That's it. And explained: "The collection is inspired on the ornaments of the nineteenth century clothing that burst into simple and functional sport clothing" (www.elfashionista.net). In fluoresent orange and yellow, white and beige, one might say. He has been in Paris working with Bernhard Willhelm, looking at his work he could not have begun with a better designer.

IDA JOHANSSON
AND LUCRECIA LOVERA
>

The Swedish Ida Johansson and
Argentinian Lucrecia Lovera won the 25th
edition the Prize for Best Collection of
Men with Twist, a collection that mixes
point, elastic tissue and volumes, which
the designers have used to create an
illusion of dynamism.

winner! M

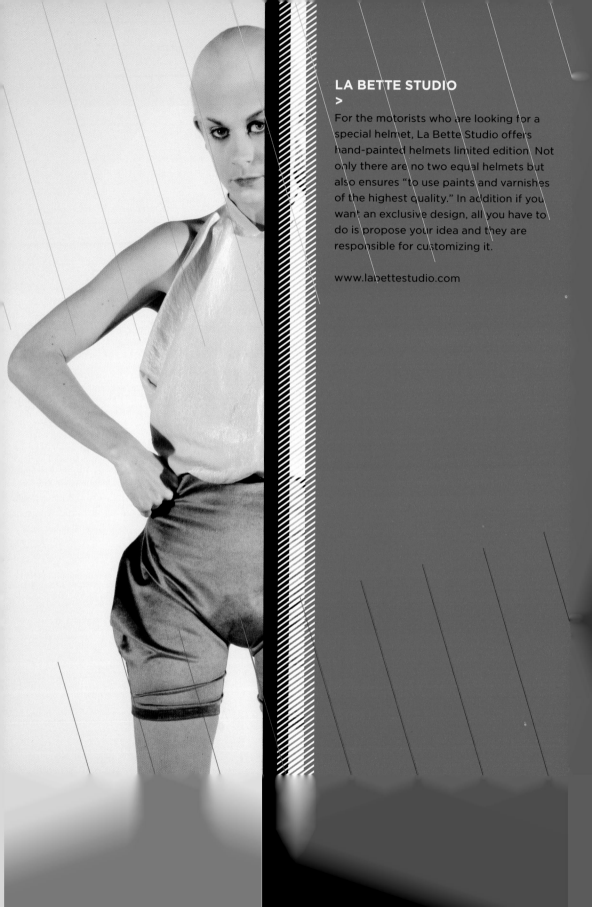

LA BETTE STUDIO

>

For the motorists who are looking for a special helmet, La Bette Studio offers hand-painted helmets limited edition. Not only there are no two equal helmets but also ensures "to use paints and varnishes of the highest quality." In addition if you want an exclusive design, all you have to do is propose your idea and they are responsible for customizing it.

www.labettestudio.com

BENTE BJOR
>

Despite his youth she was unable to start better, this Norwegian 28 year old, from the last promotion of IED, has shifted from internships with designers such as Cecilia Sörensen, Martin Lamothe or José Castro, to work as an assistant of John Richmond, a task which has been doing since November 2007. In the last PasaFAD she presented the only collection that she has designed till now, inspired as she says "in small tribes that still exist in different parts of the world." She is also currently working on a project of stuffed animals for adults along with Julia Weems, "which we hope to produce."

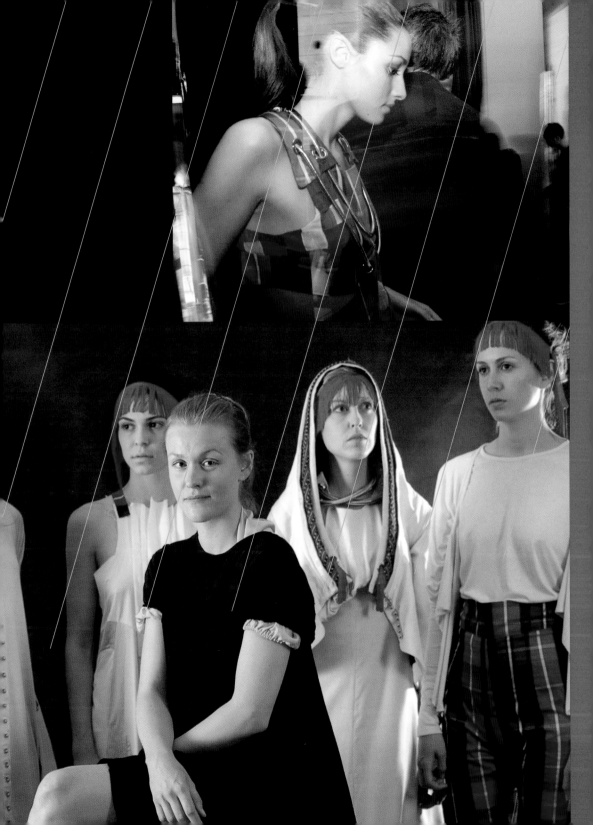

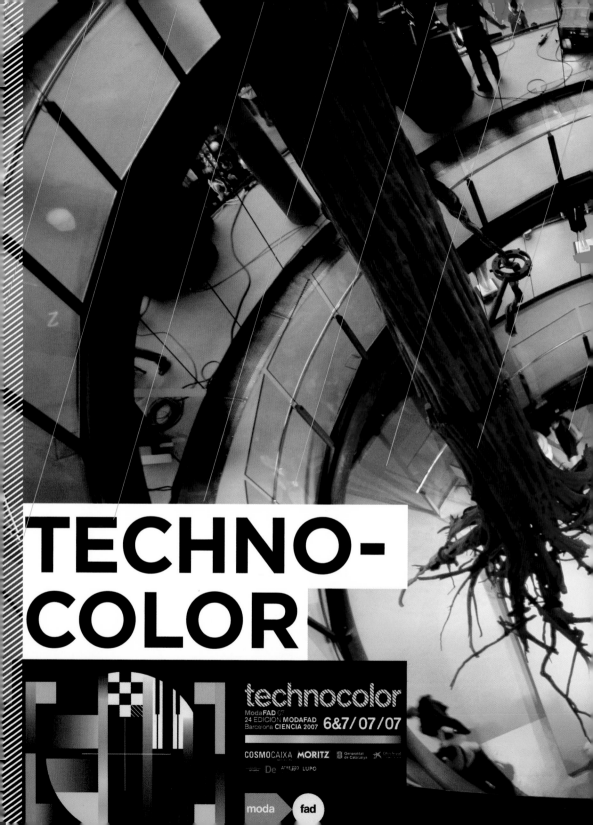

TECHNO-COLOR

technocolor

ModaFAD 07
24 EDICIÓN MODAFAD
Barcelona CIENCIA 2007 6&7/07/07

COSMOCAIXA MORITZ Generalitat de Catalunya

De ATREZZO LUPO

moda fad

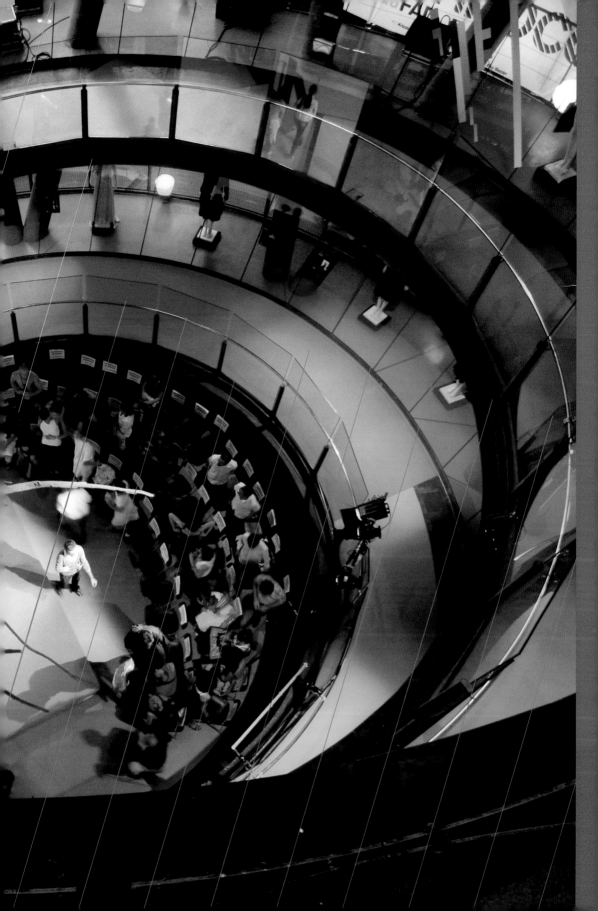

24. TECHNOCOLOR
>

July 2007 in CosmoCaixa
Winners. Award for Best Designer:
Sebastián Berneche (Cascara); Award for
Best Collection: Georgina Vendrell
Galbany (Cocoloco by George); Lupo
Award: Olivia Niebling & Cécile Raizonville
(Multivilles Clothing); Audience Award:
Laura Mengíbar (Project T).
Architects: La Granja.
Graphic design: Guillem Pericay.
Video: Ojo Móvil.
Video T Project: Juanjo Onofre, Nico Zarza.
Photography: La Fotográfica, Xavi Padrós.
Hairdresser: Marcel & team.
Make up: Neus Tutusaus & team.
Stylists: Asier Tapia, Jaume Vidiella, Juan
Vidal, Malaspina, Txomin Plazaola.
Subvention: Generalitat de Catalunya.
Main sponsor: Moritz.
Sponsor: Lupo, Réplica, Línea De General
Óptica, Scholler Textile, Cosmocaixa.

The technology involved in fashion and
textiles was the subject that the designers
who participated in the 24th edition of
ModaFAD had to confront: winning in
functionality through technology without
forgetting the aesthetics. A big challenge
of what the participants on the lectures
"Technoteixits" knew a lot. Josep Abril
Moritz Waldemeyer, Manel Torres, Madre
Mía del Amor Hermoso and LEITAT
Center, among others, gave a review of
fashion history, from its origins to the
trends of the future through out the
revolution of technological tissues.
Krizia Robustella, Eunate Vivanco, Eva
Bazán of El Diamantista, Arturo Carlos
Martínez and Christine Kolnberger & María
Roch lead the solitary-parades.

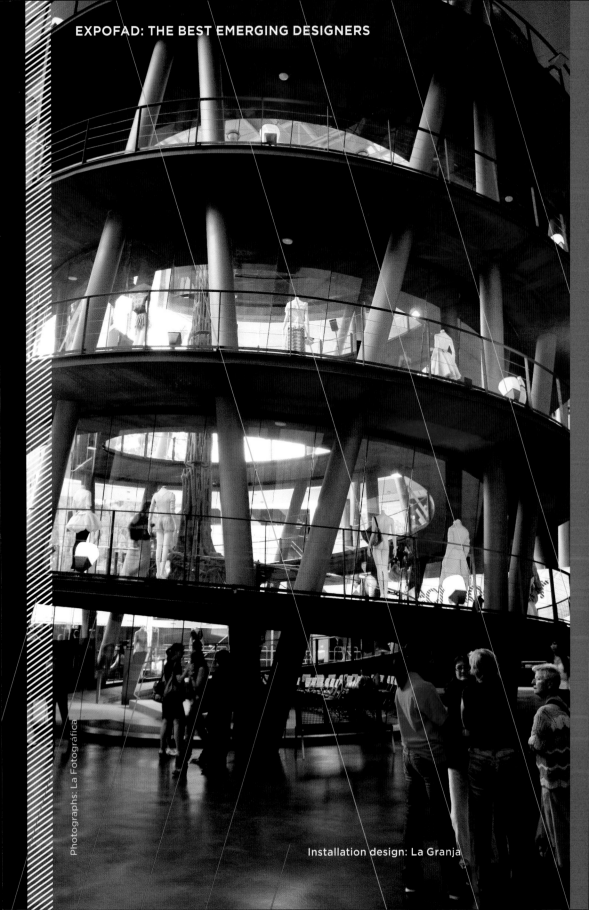

Photographs: La Fotográfica

Installation design: La Granja

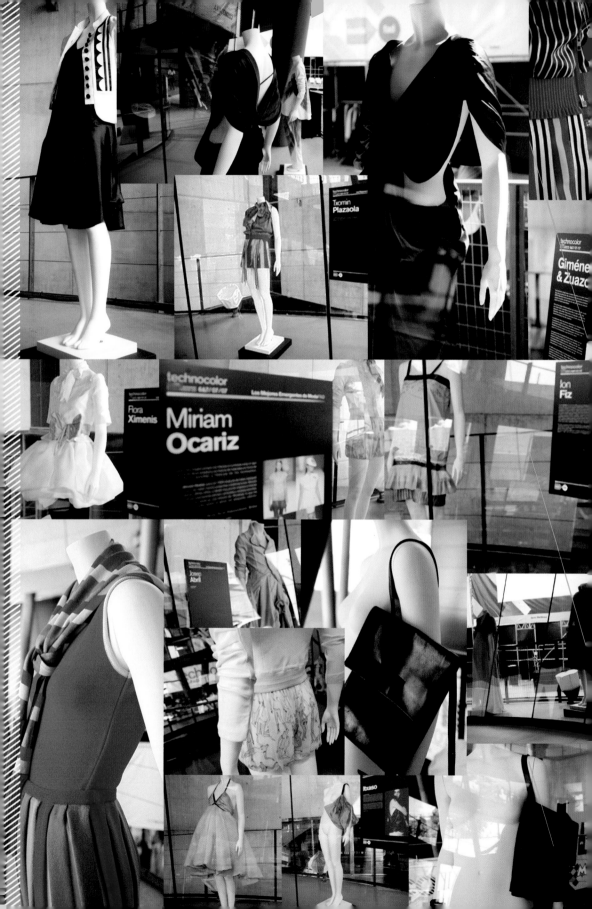

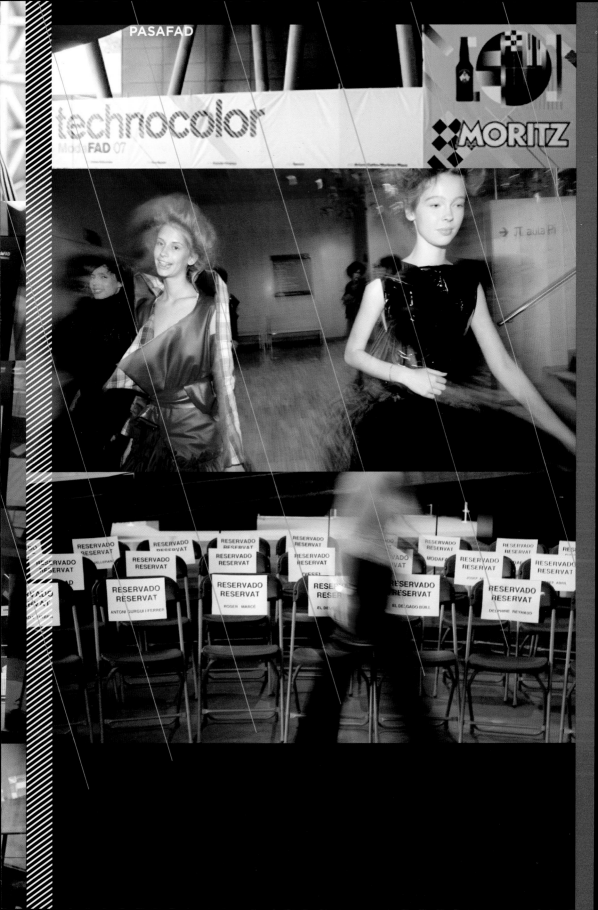

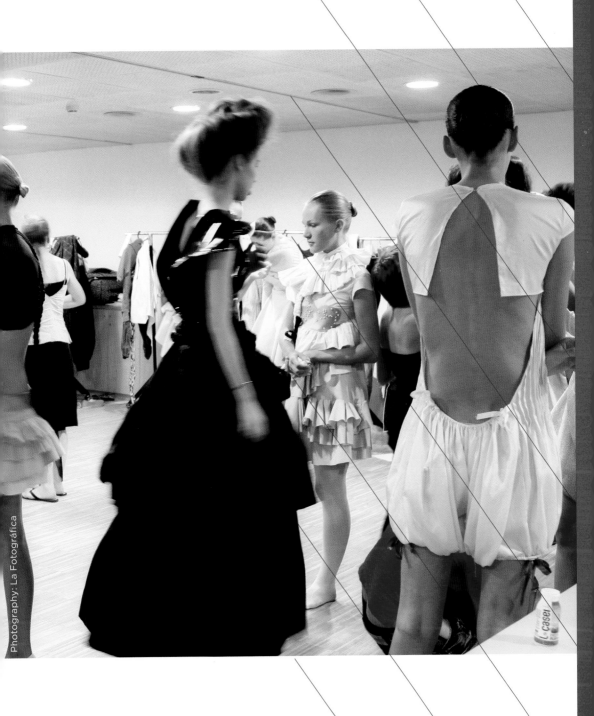

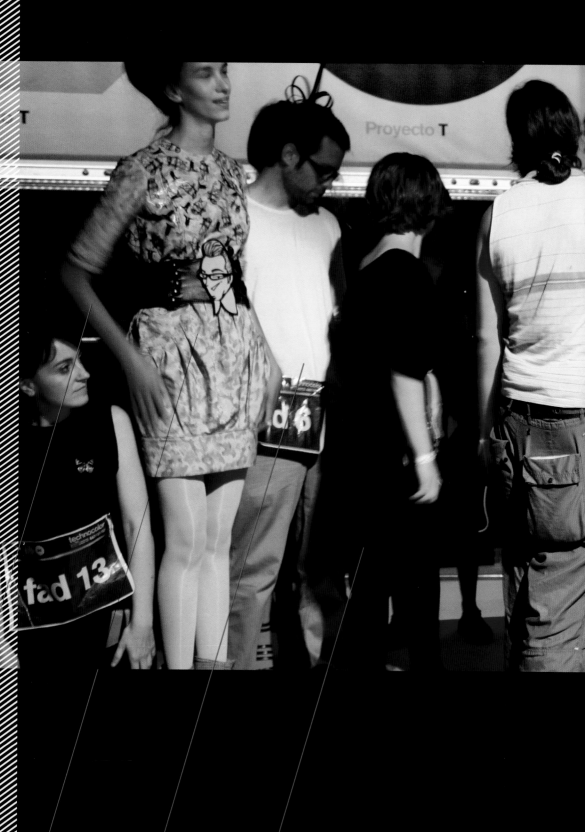

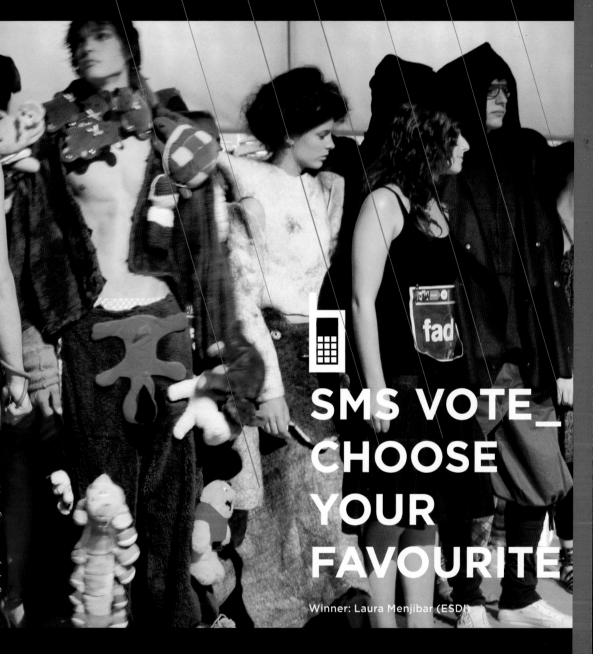

SMS VOTE_
CHOOSE
YOUR
FAVOURITE

Winner: Laura Menjibar (ESDI)

T PROJECT

Coinciding with the 25 anniversary of MerkaFAD, ModaFAD now pretends to strenght its conection with fashion schools in Barcelona and their students, capturing the various academic biorhythms and linking to their syllabus. The result of this approach, T Project is a compilation done through new digital support of the best dissertations from the platform of fashion schools in Barcelona. Again and as always, ModaFAD bet on the "emergency", a concept that today is already too used and it's almost hard to pronounce. But if this is so, maybe it's because it is used too lightly as flag of too many initiatives that for being, clonical, dispersed and (especially) unthoughtful, always end up being ineffective, as several platforms that have copied our formula with more resources (Ego and others of our own city), who have just managed to disperse the goal of turning Barcelona into a real platform of the emerging design.

MORITZ WALDEMEYER

>

After an edition focused on black, in July 2007 ModaFAD gave a turn of 180 degrees with the theme Technocolor, an edition where fashion, colour and technology were going to be the main characters. Alongside the usual gateway and market, this time ModaFAD hosted a cycle of conferences on CosmoCaixa. Various speakers, Josep Abril, Manel Torres, Madre Mía del Amor Hermoso, the center LEITAT and Moritz Waldemeyer delve into their lectures on the topic Technotextiles, one of the biggest areas of research in fashion.

We stay with this last mentioned designer, who is specialized in applying technology to his designs. He has worked for Nike and Phillips among many other companies, but one of his most outstanding projects is the one that took place during two seasons with Hussein Chalayan: the collection of dresses that thanks to some complicated mechanisms could move and transform itself almost as magic art. Under the title "Mechatronics, fashion and dresses in motion" Waldemeyer explained in front of a crowded audience how this work was developed. One year later we have contaced him again.

Your conference was about the dresses you designed with Hussein Chalayan, what was the most difficult in this project? The most difficult element was the lack of time. The fashion world is turning ideas around in a much shorter time frame than we do in product design. The short time frame made the projects very risky, specially given the fact that we only had one chance to make them work when the girls were out on the catwalk.

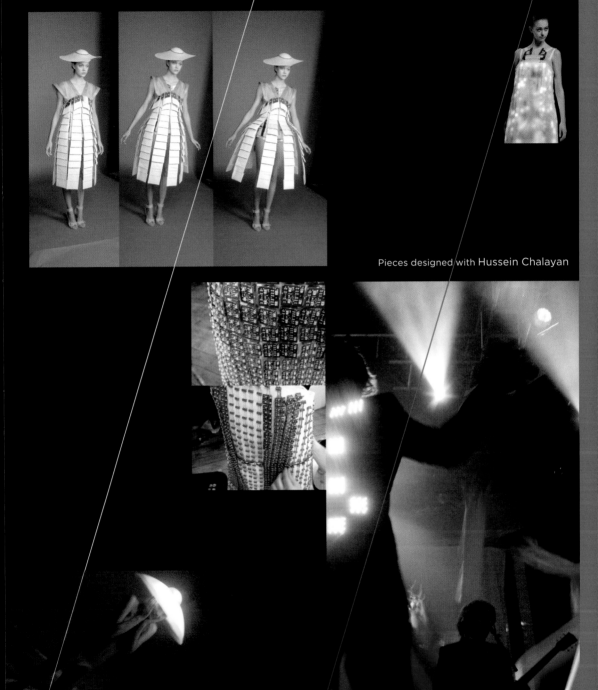

Pieces designed with Hussein Chalayan

These were some of my most anxious moments during my career.

In one project like this, aesthetics and technology are equal important or technology is more important? The aesthetics has to be the top priority, the technology only serves the aesthetics. It would be tragic to show a perfectly engineered dress in Paris on the catwalk if it was not visually beautiful.

Had you worked in other fashion projects before you meet Chalayan? Is fashion something you like or not specially? I was part of the wearable electronics team at Phillips for a while where we investigated electronics in sports wear. That was very interesting research and taught me a lot about the integration of electronics in fashion.

Technologically speaking, which is the greater challenge you have faced? The biggest challenge so far was probably the creation of the video dresses. Not only was it a technical challenge, but the limited development time of 4 weeks nearly turned the project into insanity.

In which projects are you working now? Right now I'm working on a collection of products for the Italian lighting company Flos and a few larger scale lighting installations. If you would like to stay up to date, I regularly publish news updates on my blog.

www.waldemeyer.blogspot.com
www.waldemeyer.com

ROSA LÓPEZ
>

She is Venezuelan, 27 years old and in love with the city of Barcelona. That's how Rosa Lopez defines herself, who just right now finished studying Fashion Design in IED. Defines her clothes as structured pieces: "The basis of my work is the pattern, I play with the lines that form the garment uncontextualizing, mixing and playing with the parts that make the clothing. Actually I feel myself like an architect within the fashion design. Still she does not has points of sale but is confident that "there are people who want to bet on any change on the way they dress."

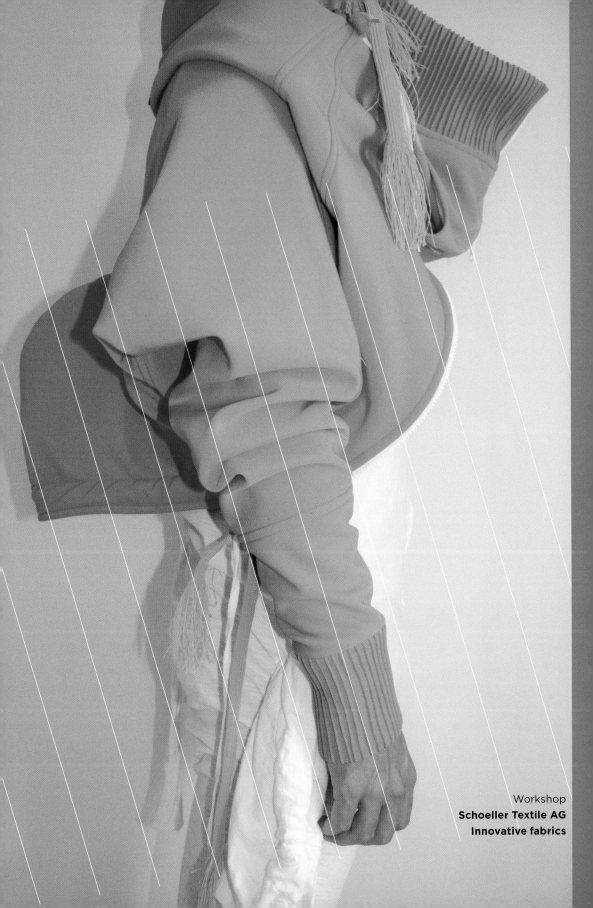

Workshop
Schoeller Textile AG
Innovative fabrics

PABLO GÓMEZ

>

After his passage through Eina school to study interior design, Pablo decides that his passion is fashion, so he leaves Eina and goes to Milan to study in Stituto Marangoni, studies that he finished in Barcelona on Felicidad Duce. After working as a design assistant of Asier Tapia in the female line of Antonio Miró, and later with Estrella G for Farrutx, in April 2007 he began Bluff, his project on male fashion, and shows the first collection in July in ModaFAD and September in El Ego de Cibeles. Earlier this year he presented the first collection of a new project, Cuirture, this time a line of women in leather, whose second collection could be seen in the last Bread & Butter. "With Bluff I design male clothes with streetwear character," says Pablo, "but prominent for quality materials, tailoring resources and large dose of irony. But in Cuirture I try to offer differentiation within the world of luxury and leather. The product is handicraft, elegant, sophisticated and high standard but with a sport character, urban and young."

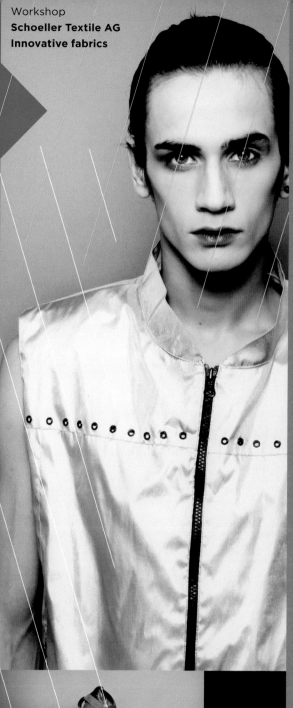

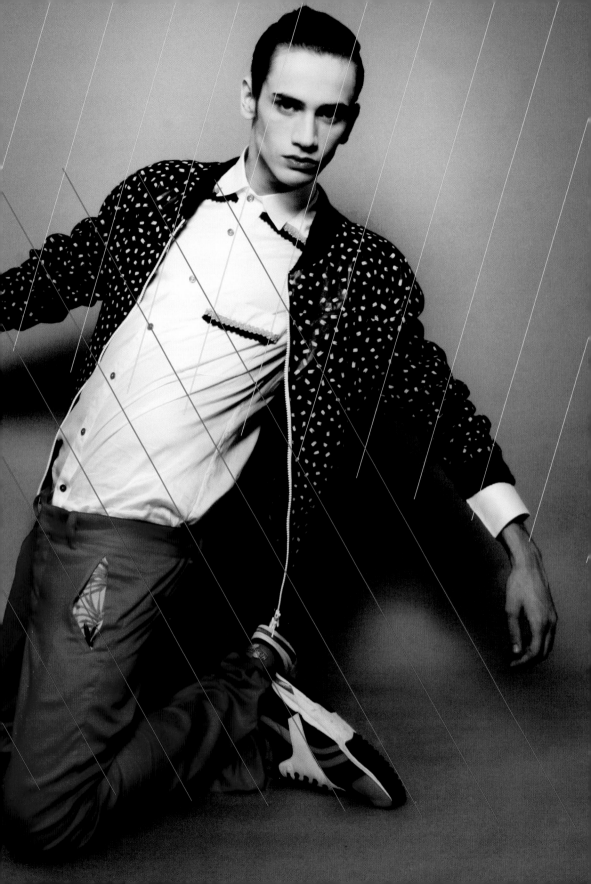

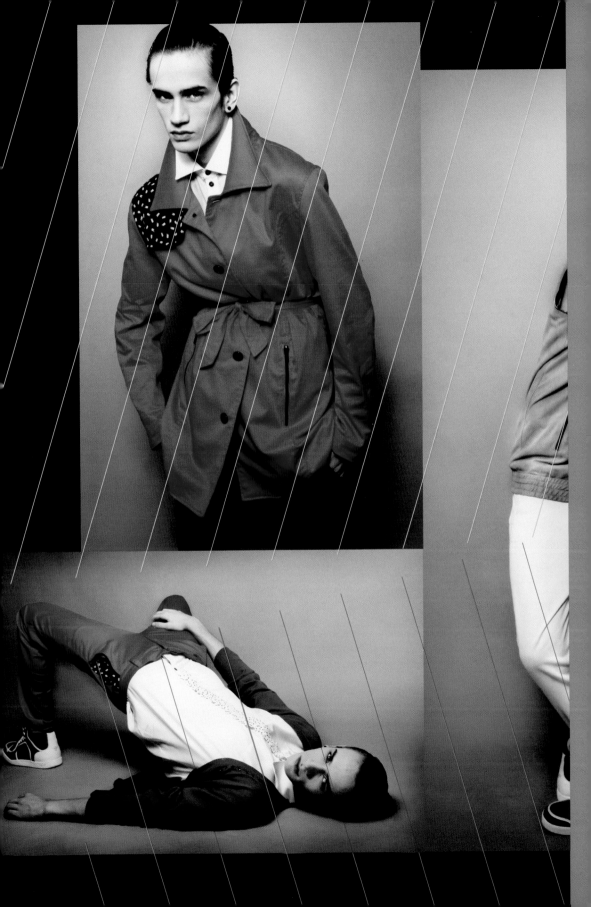

GEORGINA VENDRELL
>

She participated in the 24th edition with Bad Boys obtaining the Prize for Best Collection. Besides parading in PasaFAD she has also done it in El Ego de Cibeles and has presented his work in the latest edition of Changing Room. Defines her clothes as sober, dark, with risky patterns but not so much garishness and with a variety of tissues, "which gives coherence and personality to the collection." With the collection that she is going to present in the next Ego almost ready, Georgina is now working on a new collection that she will present at the next edition of Hyères.

winner!

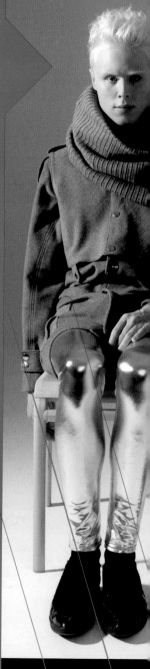

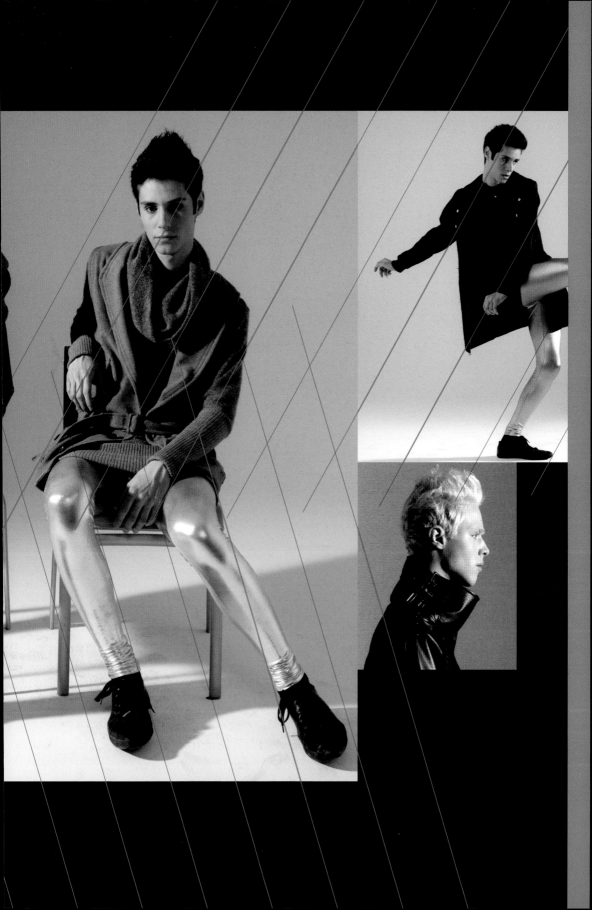

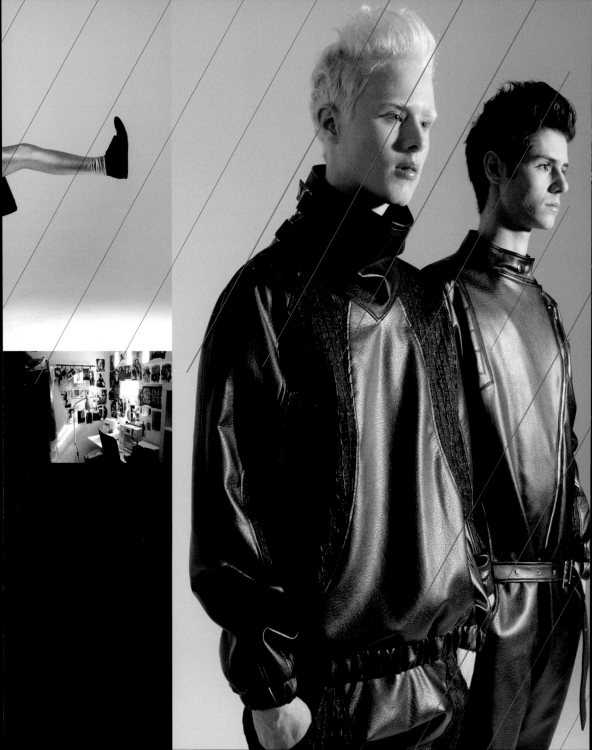

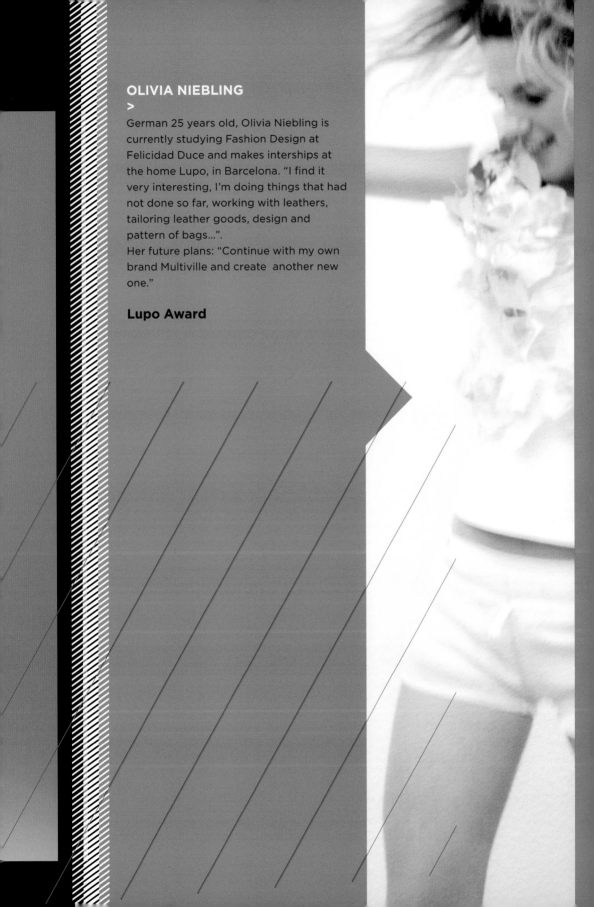

OLIVIA NIEBLING
>

German 25 years old, Olivia Niebling is currently studying Fashion Design at Felicidad Duce and makes interships at the home Lupo, in Barcelona. "I find it very interesting, I'm doing things that had not done so far, working with leathers, tailoring leather goods, design and pattern of bags...".
Her future plans: "Continue with my own brand Multiville and create another new one."

Lupo Award

EUNATE

>

Defines her clothes as sober but feminine, with simple patterns and cuts, she likes to work on them later cloth by cloth to get a unique and handmade touch. This 31-year-old designer who was born in Pamplona has worked for different companies and is currently designing small collections of hand-made and unique garments that she sells in the store Min's of Pamplona, work that she combines with the wardrobe design in dance and theatre plays.

Photography: Xavi Padrós

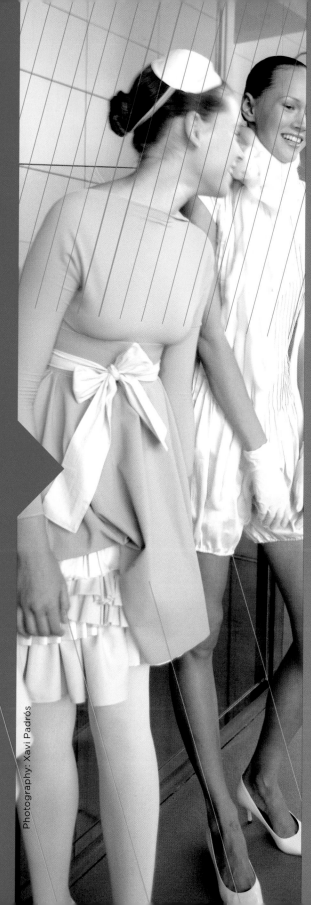

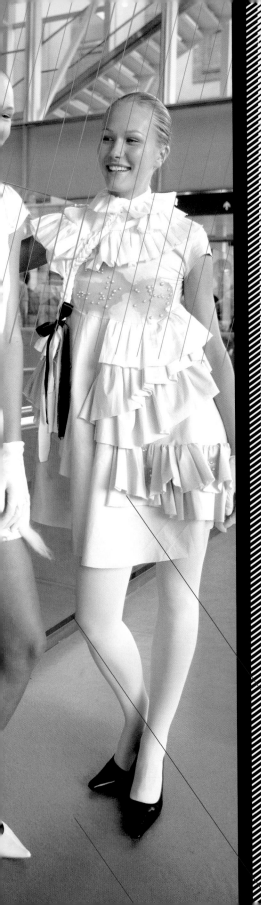

EL DELGADO BUIL

>

Anna Figuera Delgado and Macarena Ramos Buil are the members of The Delgado Buil, usually collaborators of ModaFAD. Since they began their journey in the 11th edition of Circuit, in February 2005 where they presented the collection "Crazy Kids", the career of these two designers has taken off so explosively. After two more parades in Circuit (one in Lisbon), they begin to parade in Cibeles in February 2007, where they presented the collection of Fall-Winter 2007/08 "My family goes to Oklahoma", which made them won the Prize L'Oreal for Best Novel Designer. Award that they won again on the next edition of the catwalk of Madrid. Their work was also recognized with the Grand Prix de Marie Claire in November that year. Initially men designers, since they came into Cibeles they also designed for women under the same parameters: be creative and personal without forgetting the marketability of the garments. Their latest collection "Bunker sisters Yates brothers" can be purchased at their shop on Lledó street in Barcelona.

www.eldelgadobuil.com

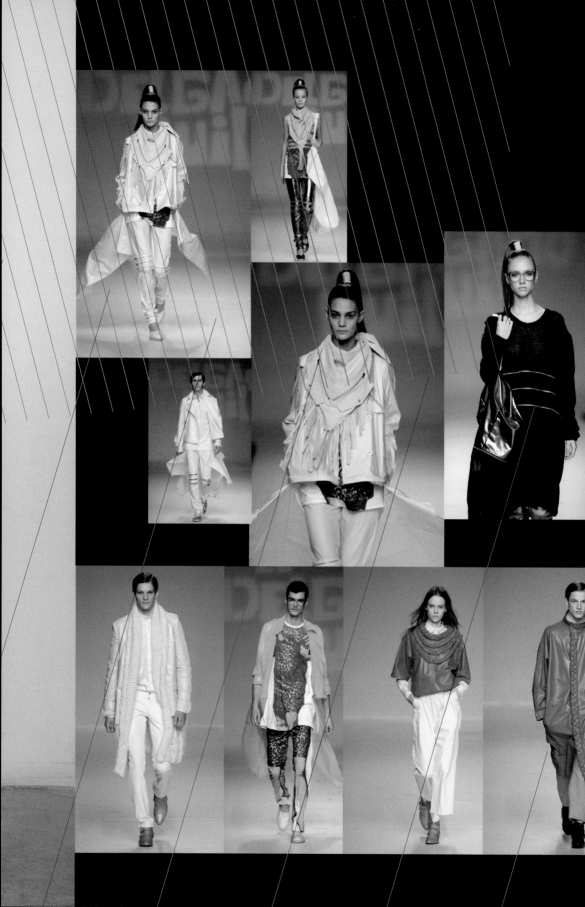

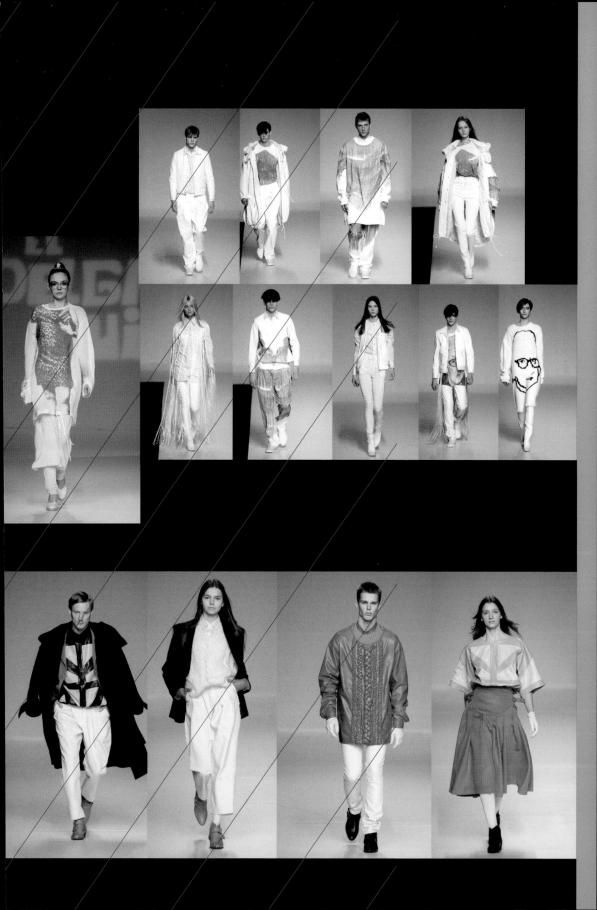

TXELL MIRAS

>

This designer from Barcelona born in Sabadell accumulates a good handful of awards for her 32 years. Formed at the Universidad de Bellas Artes of Barcelona in the Llotja and the Domus Academy in Milan, and renowned for her impeccable work pattern and her own universe as personal as consistent throughout his career, Txell besides her own brand, which she launched in 2004, also designed for the female line for Neil Barrett since 2003. Among her awards are: Barcelona Es Moda in 2006 for Best Professional in the sector in Barcelona, Lancôme Prize in 2005 for Best Young Designer of the Gaudi catwalk, and the First Prize in 2001 in the annual competition of the Domus Academy. In addition, in 2007 was a finalist in the Mango Fashion Awards El Botón and the GenArt New York Fashion Awards, in 2006 was chosen by Unit F to represent Spain in the European Young Fashion Summit in Vienna and the Camera della Moda Italiana considered her the most promising student of Italy in 2003.

How do you define your clothes, for what kind of woman is it directed? Nowadays I could say that my style is like a sober and strong constructivism. I work a lot on details. I focus on any woman although most customers are people between 25 and 50 years generally involved in design but who appreciate the piece itself rather than the brand.

When did you present your work for the first time in ModaFAD? In 2001 or 2002. I presented the work I was doing at that time. In MerkaFAD I mainly sold T-shirts with illustrations. I will make again some for summer.

What is fashion for you? One way of expression, a territory where I can develop my creative concerns. And more prosaically: it's my means of living.

Have you ever considered designing for man? In Milan I'm too close to a male brand and I think that I could design for men but probably I wouldn't enjoy it that much. When I design my line I think a lot on me.

What is the difference between designing your own collection and work on the design team of Neil Barrett? Is it difficult to combine both? To create my collection I work alone, without schedule and in my space, I have absolute freedom. I go to Milan one week per month and it's a process of negotiation of ideas and suggestions under guidelines. It is interesting to combine both. Now, with Neil it's easy we know each other for some time and he's a very good boss, demanding but generous. I would be overwhelmed if I had to work only for another brand but I enjoy a lot with collaborations.

Why did you decide to design a single collection per year instead of the two usual? I saw myself choked in an outer loop in which I was not comfortable. I like designing and I did not want to hate it in three seasons. My work is very personal and highly absorbent. I need space to recover energy and be able to enjoy those things that help me generate more ideas. Now, for summer I will propose a collection made of my favourite pieces, with new fabrics and some new loose pieces. I am very self demanding and in the rush I've made collections that did not satisfy me entirely.

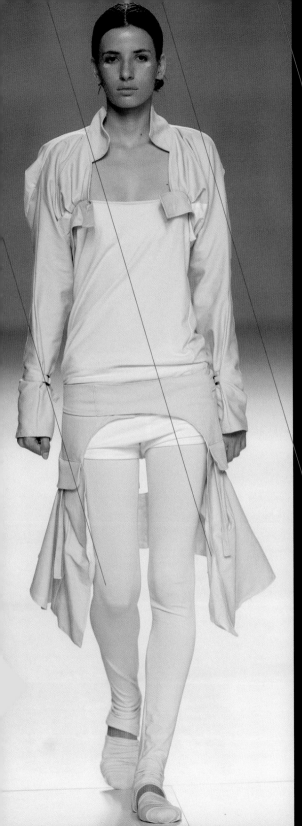

Where can we buy your clothes? Right now I sell in Spain, France, Holland, Hong Kong, New Zealand and the United States. The business issue is very complicated. We are looking for showrooms in Paris and Tokyo. Soon we will open an on-line shop and a showroom in New York begins to move the brand in the US

What's your opinion about the work of ModaFAD? It is an encouragement and an opportunity for students. I think it's a very valid work to promote the younger generations. In fact, any initiative to helps as a "springboard" for the quarry is always beneficial.

Plans for the future. Continuing to grow without hurry, keep the creative freedom and maintain a manageable dimension.

Recommend a place in Barcelona that you particularly like. I've always liked the Raval district, in fact Ciutat Vella in general. I think it is the most cosmopolitan and nutritious part of the city. I live outside of Barcelona and I live it less every day, but I feel it as if it was mine.

www.txellmiras.eu

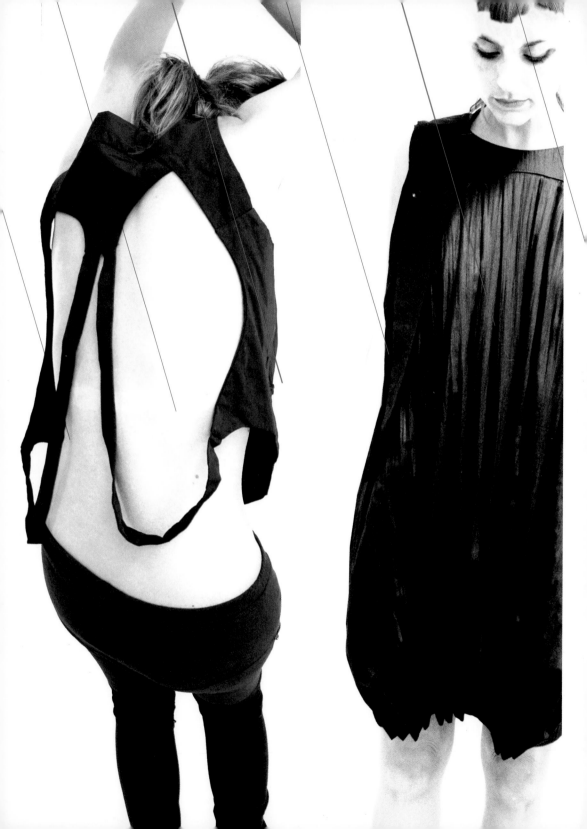

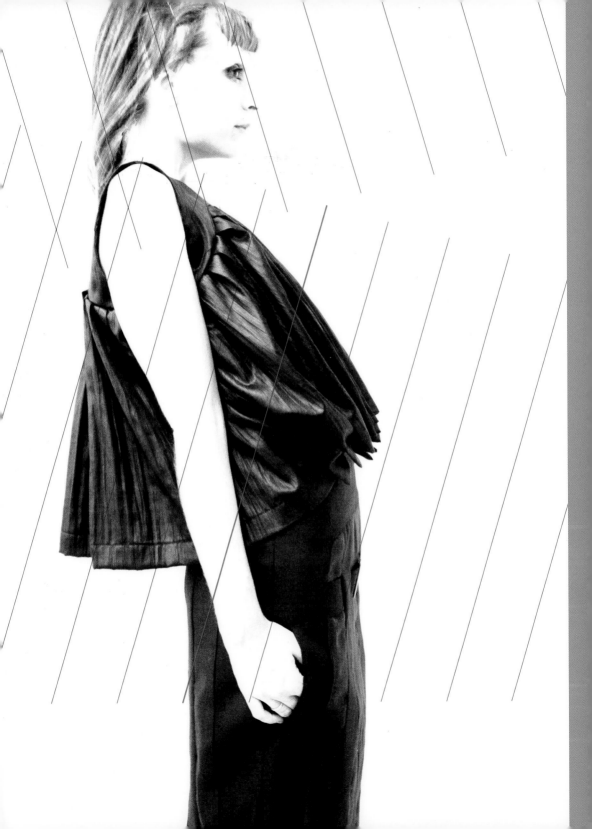

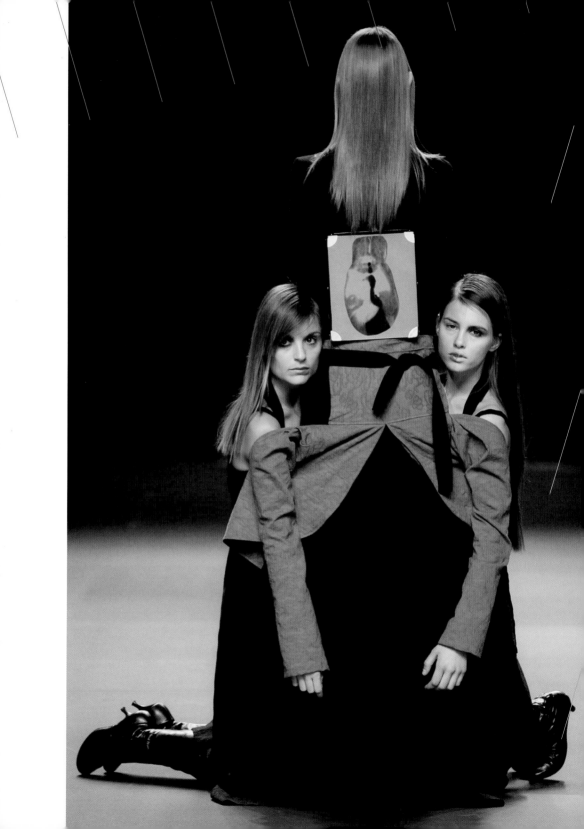

SEBASTIAN BARNECHE

>

Designer from Uruguay living in
Barcelona who won the Prize for the Best
Emerging Designer with the collection
that he presented for his brand called
Cáscara.

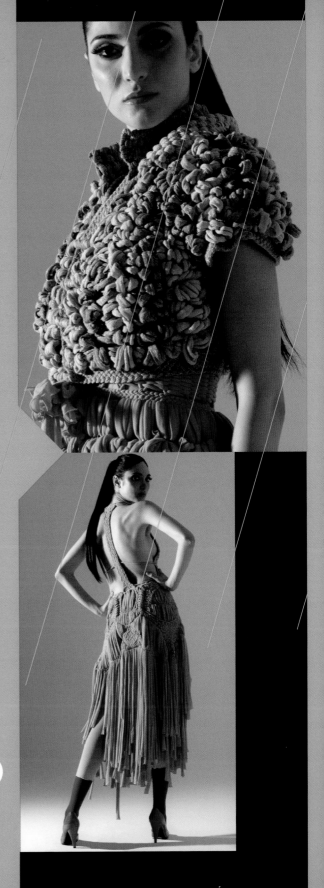

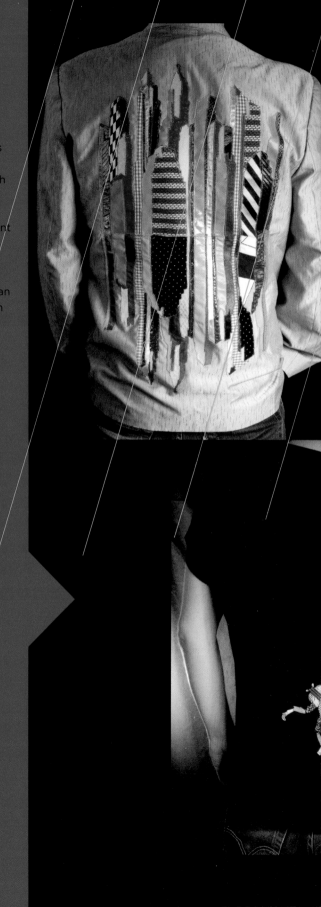

BORJA URIONA

>

With a degree in Fine Arts from the University of the Basque Country, this designer born in Gernika 31 years ago, is devoted mainly to customize clothes, both first-and second-hand, a task which he shares with his work as an illustrator. Uriona, also with a Diploma in Textile Design, has exhibited his work in different galleries and is part of the renowned illustrators that Martin Dawber selected for his books "Mark Trend" and The Big Book of the Fashion Illustration ". You can find his clothes in Intro by Otti, a shop in the neighbourhood of Gràcia in Barcelona, which he strongly recommends, and now works along the designer Barbara Masiá in a series of customized bikinis that will be called BunnySux.

www.onuri.es

ModaFad, que arranca hoy, reivindica la necesidad de apoyo institucional

ROBERTA BOSCO, **Barcelona**

Tras un año de ausencia. Moda-Fad, la asociación de imagen y moda de Fomento de las Artes y del Diseño (Fad), vuelve a organizar el PasaFad y el MerkaFad, respectivamente desfile y *showroom* con venta al público, de diseñadores emergentes. La 23ª edición de la pionera manifestación, que clausurará la semana barcelonesa de la moda, se celebra hoy y mañana en la antigua fábrica de cerveza Moritz (Ronda Sant Antoni, 41).

De hecho, el evento se puede organizar gracias a la esponsorización privada, ya que Moda-Fad, una asociación sin ánimo de lucro dedicada a impulsar la creatividad *made in Barcelona* en el campo de la moda, no está recibiendo ningún apoyo por parte de las instituciones. "Emergente es la palabra clave, una golosina que todos quieren. Sin embargo, no está mal recordar que hemos sido

los primeros y seguimos siendo la única asociación de apoyo a los jóvenes, con un programa articulado: descubrimos talentos, los guiamos y potenciamos, y organizamos exposiciones, talleres y eventos diversos", señaló Chu Uroz, presidente de ModaFad. "Hemos creado una plataforma y un modelo que está siendo copiado en toda Europa y que corre el riesgo de desaparecer por falta de recursos", señaló Pilar Pasamontes, vicepresidenta de la organización.

Los directivos de ModaFad se reunirán con representantes de la Generalitat para exponer sus necesidades y volver a proponer un programa integrador para el apoyo a la moda barcelonesa.

En la nueva dición, titulada *000 Black* y centrada en el color negro, participan 30 creadores, elegidos entre más de 80 candidatos. Hoy habrá cuatro desfiles y mañana se abrirá la venta al público.

Merkafad recupera el ritm... funde en negro con «00Bla...

E.A.

BARCELONA. Apenas 12 horas después de concluir PasaFad, la pasarela colectiva de talentos emergentes, ayer abrió sus puertas en la fábrica de cervezas Moritz el tradicional MerkaFad, «showroom» en el que pueden adquirirse los diseños escogidos por ModaFad

...ha decidido recu... nes con el lema «... nate Vivanco, pre... colección de muj... ABC su satisfacci... nomiento, aunqu... «ahora viene lo di...

La diseñadora... Pamplona, que ha... Bilbao y Lugo, r...

OOOBLACK

Modafad vuelve

ONE OF THE MOST POLEMIC EDITIONS

L. B.

BARCELONA.- Tras dos años y medio de parón forzoso, Pasafad y Merkafad (la pasarela, el *showroom* y el mercadillo donde los diseñadores emergentes de moda exponen sus primeras colecciones) volverán a celebrarse.

Será los próximos 19 y 20 de enero, coincidiendo con la feria alemana de ropa urbana Bread&Butter. «Desde que se han instalado en la ciudad, mar-

can el calendario oficial, y nosotros nos hemos acoplado», explica Silvia Aldoma, de Modafad.

El desmantelamiento de Pasarela Gaudí que llevó a cabo la consellería liderada por Huguet a finales de 2005 también afectó a las iniciativas del FAD que promovían la cantera creativa más fresca. «Nos pidieron un tiempo de reflexión del modelo, y hemos estado hivernando», explica Aldoma. Paradójicamente, esa labor de

promoción de los futuros talentos era el único aspecto que había demostrado sobradamente su efectividad: nombres hoy consolidados como Ailanto, Jordi Labanda, Miriam Ocáriz, Gimenez y Zuazo o Spastor fueron apoyados en sus inicios por el olfato visionario de Modafad. Pese al lapsus, Pasafad y Merkafad vuelven destilando la misma esencia que antaño. En esta ocasión, el *leitmotiv* del concurso, bautizado como *000Black*,

es e...

E...
la o...
mejo...
nas...
lana...
file...
mar...
año...
das...
filar...
te, a...
cida...

«Los cambios en la moda se han hecho en clave política, sin pensar en el sector»

Pilar Pasamontes—Vicepresidenta de ModaFad

ModaFad ha vuelto al agitado escenario de la moda catalana tras casi dos años de ausencia y sin apoyo institucional. Con una Pasarela Barcelona en crisis, sin Circuit y con un proyecto del Govern preparado para servir, **la organización reivindica su papel como cantera de talentos emergentes**—Su vicepresidenta, Pilar Pasamontes, pide la complicidad del Govern

POR **ESTHER ARMORA**

Después de una larga tregua solicitada por el Govern, regresa ModaFad, lanzadera internacional de diseñadores emergentes y una de las principales canteras de la moda catalana. Su vicepresidenta, Pilar Pasamontes, explica a ABC qué se ha perdido en esta larga espera que arrancó tras el desmantelamiento de la Pasarela Gaudí. «Ha sido mucho tiempo, demasiado, en el que se ha dejado perder a mucha gente válida».

Con energías renovadas, y sin apoyo institucional, la muestra demostró el viernes en su tradicional PasaFad —pasarela de nuevos talentos— que sigue estando en forma y que la savia de las escuelas de diseño es el mejor antídoto para hacer frente a los malos tiempos que atraviesa el sector. Con su tradicional Merka-Fad, ayer sirvió al público la esencia de esta 23 edición de la muestra, bañada en negro «00Black».

—¿Cómo ve la moda catalana tras ese año y medio de «stand by»?

—Pues no demasiado bien, la verdad. Si rompes con un modelo porque tienes el convencimiento de que está obsoleto es importante que tengas un proyecto con cara y ojos y lo lleves a la práctica con firmeza. Se ha perdido también la unidad. La anterior Barcelona Fashion Week (BFW) tenía una pasarela de consolidados y dos potentes iniciativas para emergentes, que eran Circuit y Moda-FAD. Todo eso unido tenía fuerza, y de eso, precisamente, adolece ahora el sector. Todo era reconvertible y reconsiderable, pero debería haberse mantenido el apoyo.

«Estamos sorprendidos»

—El Govern os solicitó una tregua a cambio, imagino, de que la institución tuviera un papel activo en el nuevo escenario de la moda catalana...¿no ha cumplido su parte del trato? ¿Cómo os sentís después de todo este tiempo?

—No diría que nos sentimos dolidos, el sentimiento ha sido de

Pilar Pasamontes pide recursos para financiar la muestra

> «Falta cultura de moda. Eso explica que algunos de los cambios planteados partan de una falta de sensibilidad»

sorpresa absoluta. A mucha gente este parón le ha hecho daño. Se ha perdido más que dinero; se han enterrado ilusiones y se ha dejado perder a gente válida. Respecto a la primera pregunta diré que sí se nos planteó una participación, más concretamente, se nos ofreció abanderar, junto a Circuit, el proyecto del Gaudí Emergentes, aunque, finalmente, como sabe, no se concretó y los repentinos cambios de escenario político han imposibilitado incluso que reanudemos contactos.

A la expectativa

—¿Cuánto tiempo hace que ModaFad no se reúne con la Administración?

—La última reunión fue, creo, hace seis o siete meses, aunqu[e] nos hemos citado para la sema[na] na entrante. Estamos totalmen[...] te a la expectativa.

—Imagino que tenéis conoc[i]miento de que el nuevo tripartit[o] ultima un nuevo proyecto centra[...]do en creadores independien[...]tes...

—Sí, sabemos lo que hemos le[í]do en la Prensa, aunque com[o] ya he dicho no nos hemos reun[i]do con la Administración.

—¿Os interesaría participar?

—Depende del proyecto.

—En esta edición no habéis recib[ido] do nada de subvención...¿quier[e] eso decir que ModaFad pued[e] subsistir sin apoyo público?

—No. Efectivamente, no h[e]mos recibido ayuda de la Gene[...] ralitat (antes nos daba por añ[...]

(columna lateral izquierda, inferior)

[...]ro.

[...]motercera edición, [...]n ha rastreado las [...]estas entre las tesi[...]uelas de moda cata[...]scogido para el de[...]anz y Astrid Nah[...], que es lo último [...]ya han sido ficha[...]tino. También des[...]idjan y María Esco[...] la escuela de Feli[...]

Primera reunión con el Govern tras siete meses

Responsables de ModaFad se reunirán esta semana con la Generalitat para exponerle sus necesidades. La organización espera poder restablecer la colaboración con la Administración catalana «en beneficio de la moda barcelonesa» según indicó a ABC Pilar Pasamontes, vicepresidenta de ModaFad. La muestra reclama más apoyo institucional para el diseño local para que éste refuerce su posición de marca y pueda relanzarse al exterior.

120.000 euros), aunque ha sido muy complicado materializar el proyecto. Hemos tenido que pagar un crédito y lo hemos tirado adelante gracias al apoyo de la cerveza Moritz, que ha costeado el 40% de la muestra, y al apoyo de los creadores.

—¿Es vital el apoyo institucional?

—Por supuesto. Sin él es imposible subsistir.

«Causa de todos los males»

—¿Falta cultura de moda en Cataluña?

23. OOOBLACK

\>

January 2007 in the Moritz brewery
Winners. Award for Best Collection of
Man: Eva Bazán; Award for Best
Collection of Women: Eunate Vivanco;
Award for Best Designer: Arturo Carlos
Martínez; Award for Creativity: Ana Boyer
& Laura Echevarría; Award for Best
Concept : Christine Kolnberger & María
Roch (Spoon); Special Jury Mention:
Debora Nájera & Inés Martínez.
Architects: Niall O'Flynn.
Graphic Design: Guillem Pericay.
Photography: Abutardarts, Xavi Padrós,
Marcel.
Hairdresser: Marcel & team.
Make up: Neus Tutusaus & team.
Stylists: Asier Tapia, Jaume Vidiella,
Malaspina, Txomin Plazaola.
Subvention: Generalitat de Catalunya.

000 is the code for the colour black. The
sum of all colours and not colour. A
starting point as good as any other to
develop a collection. Thus the brewery
Moritz, the only sponsor of this edition,
dressed in black with the proposals of the
participating designers. The solitary
parades were this time Boris Bidjan
Saberi, Maria Escoté, Susy Sans and
Astrid F. Nahmand. Along with parades
and the MerkaFAD, the main attraction
was the "Logos Mutant" project which
was presented at the compound of Bread
& Butter with the collaboration of Unit F
of Vienna: an installation in which
different television screens will broadcast
the interviews that the journalist and
fashion critic Diane Pernet conducted
over 80 professionals in the world of
fashion, among others Bless, Walter van
Beirendonck, Terry Jones, Maison Martin
Margiela and Charles Anastase.

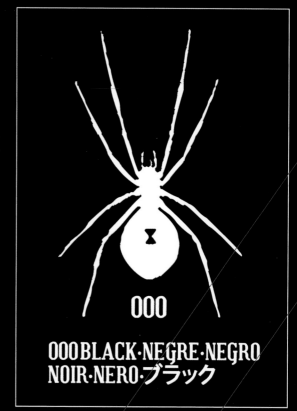

000

000 BLACK·NEGRE·NEGRO
NOIR·NERO·ブラック

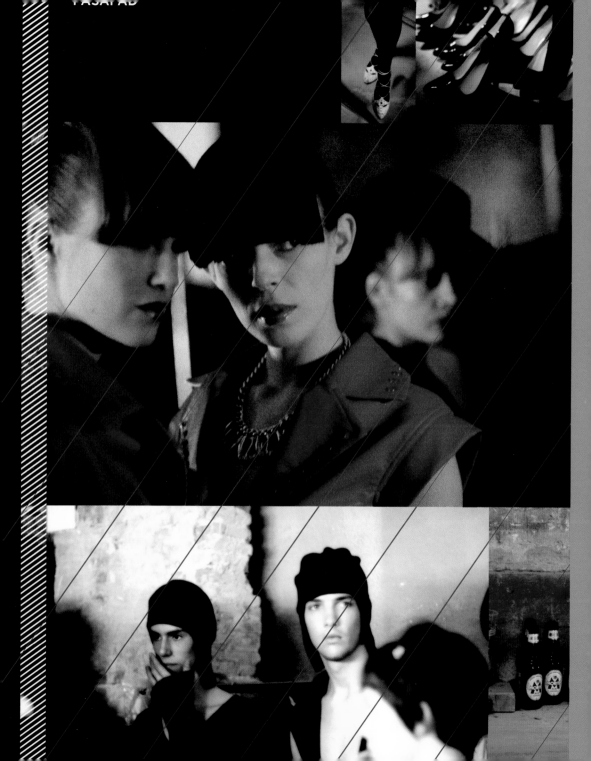

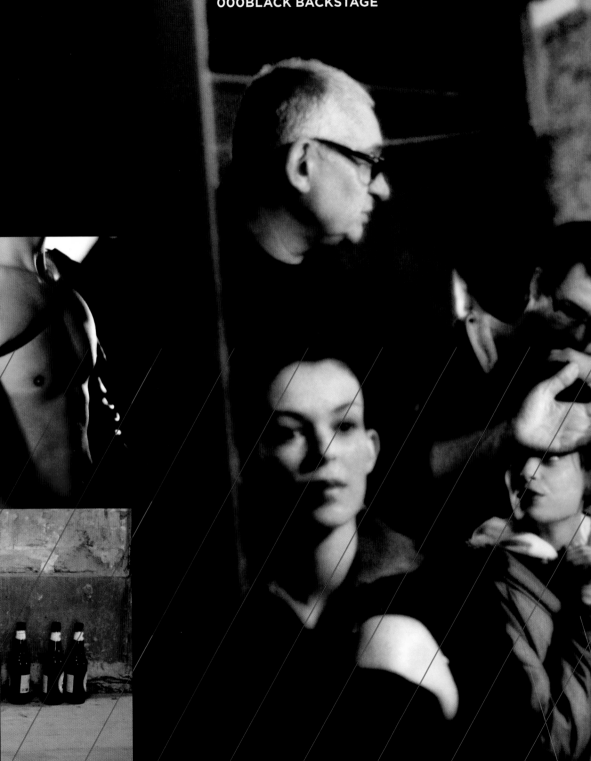

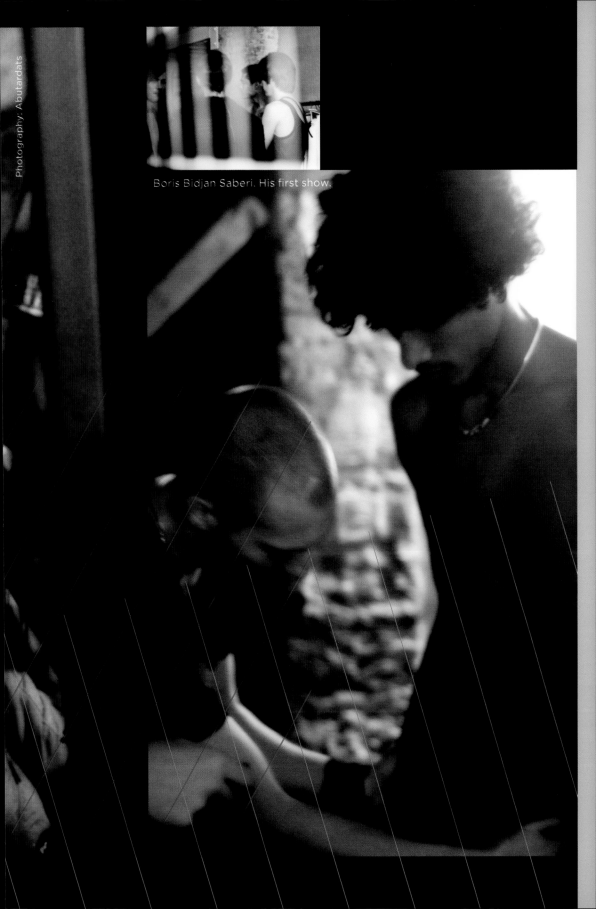

Boris Bidjan Saberi. His first show.

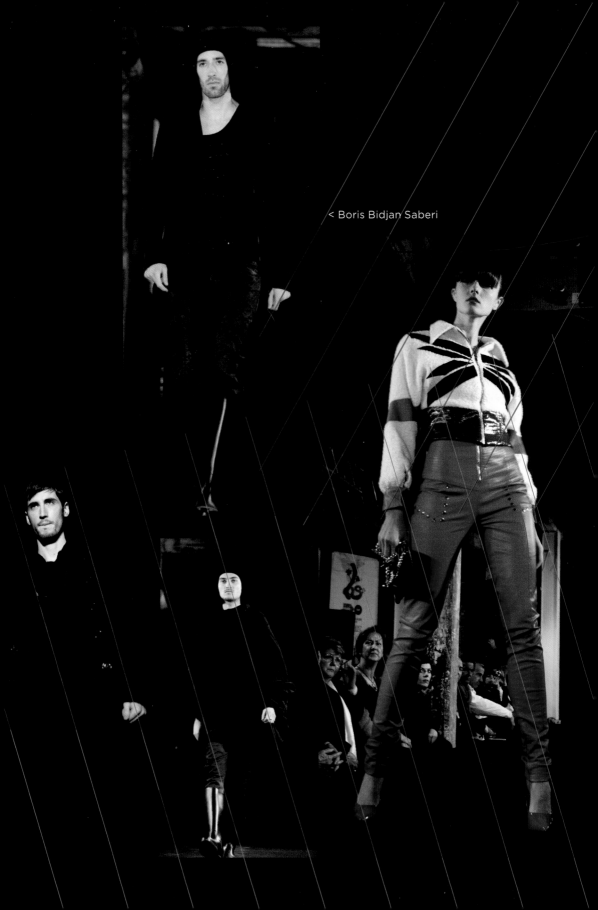

< Boris Bidjan Saberi

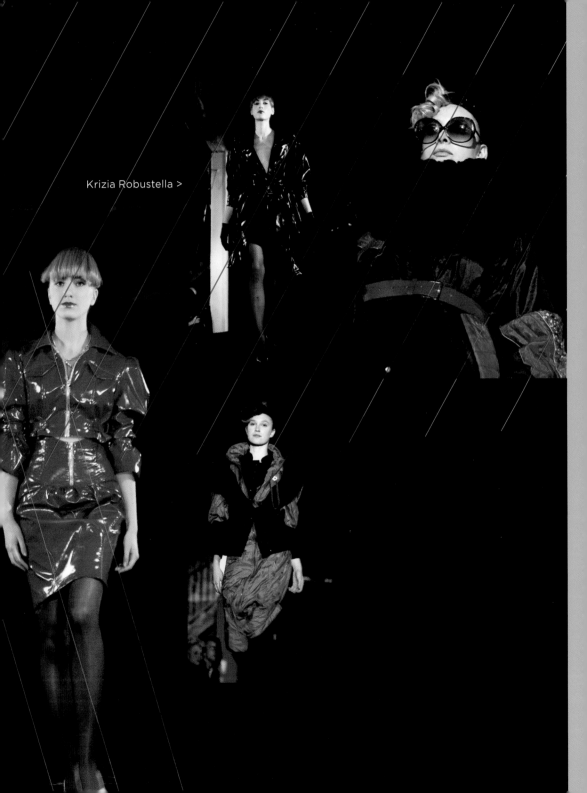

Krizia Robustella >

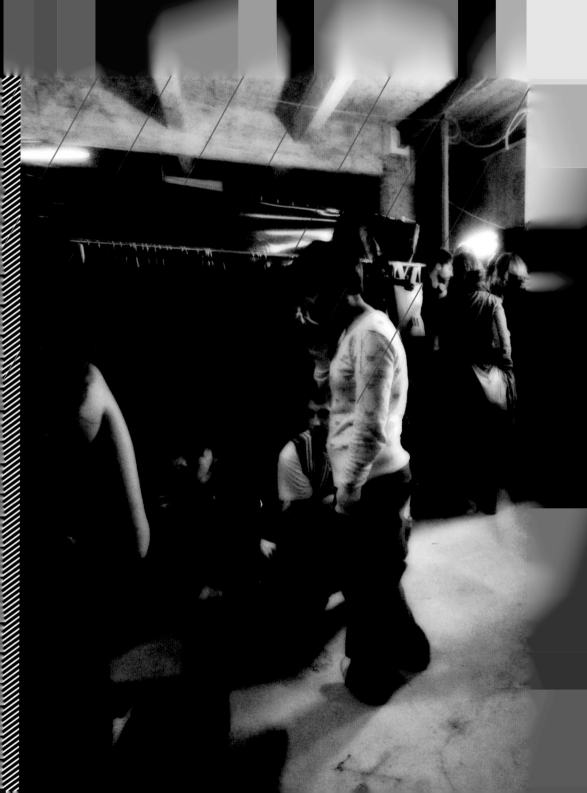

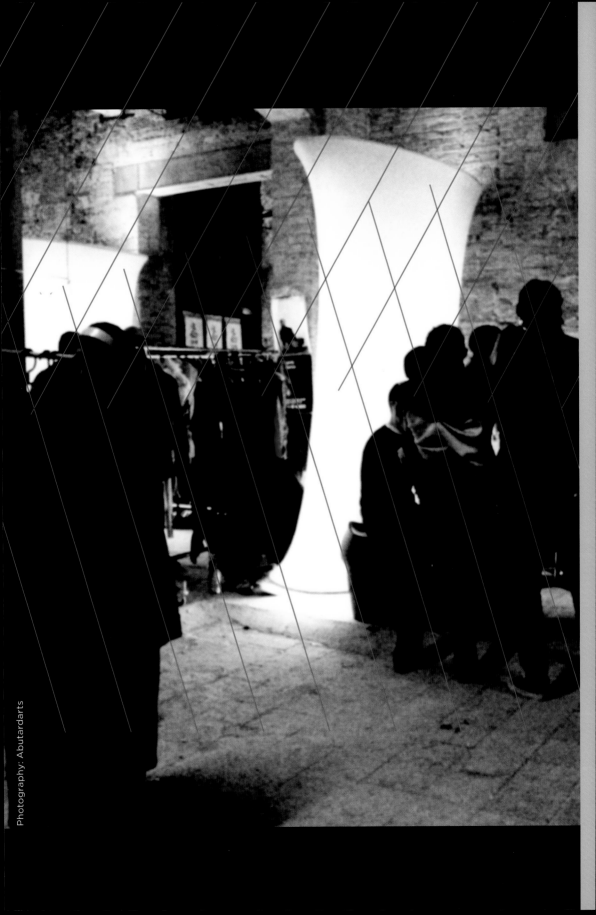

LOGOS MUTANT

DIANE PERNET

She is a really busy woman and one of the most respected professionals working in fashion world. Diane Pernet talks about "Logos Mutant" and ModaFAD.

"Logos Mutant" was thought as a work in progress, are you still working on it doing more interviews or is just what we saw at Bread & Butter? It actually should be continued because there are so many interesting personalities in the industry that we could still cover but as a project, it has not developed beyond what you saw at Bred & Butter.

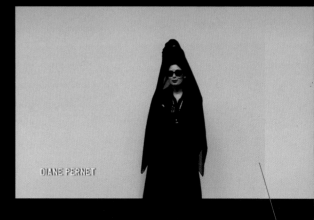

DIANE PERNET

Do you know the work of ModaFAD, what do you think about it? Do you know some designer who has participated in some edition? I was first introduced to ModaFAD when I was working on this project with **Unit F** in Vienna. I visited the headquarters and at that time was impressed by their work. The edition that I participated in included an interesting seminar with Chicks on Speed. They did a performance but also invited young artists, aspiring designers and people from the neighborhood to do a workshop with Chicks on Speed, which included painting on textiles and the fabrication of the garments. It was quite wild, raw and fun.

www.ashadedviewonfashion.com

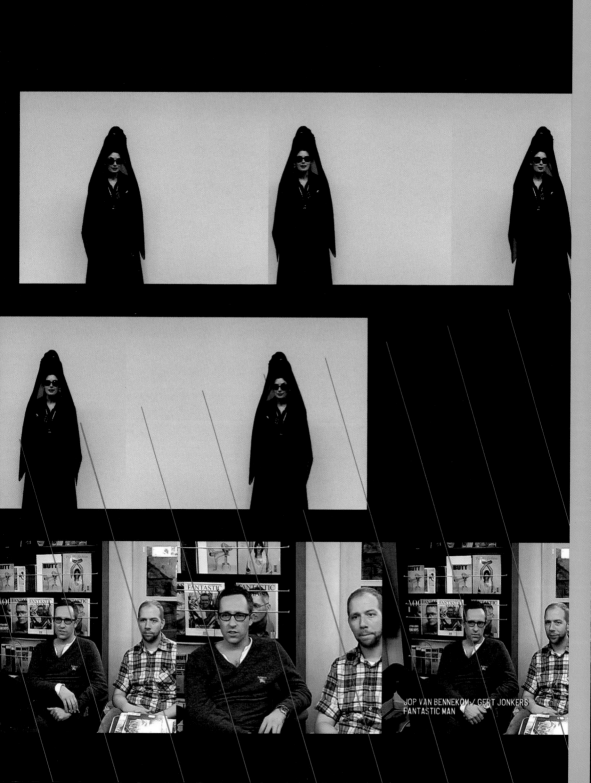

JOP VAN BENNEKOM / GERT JONKERS
FANTASTIC MAN

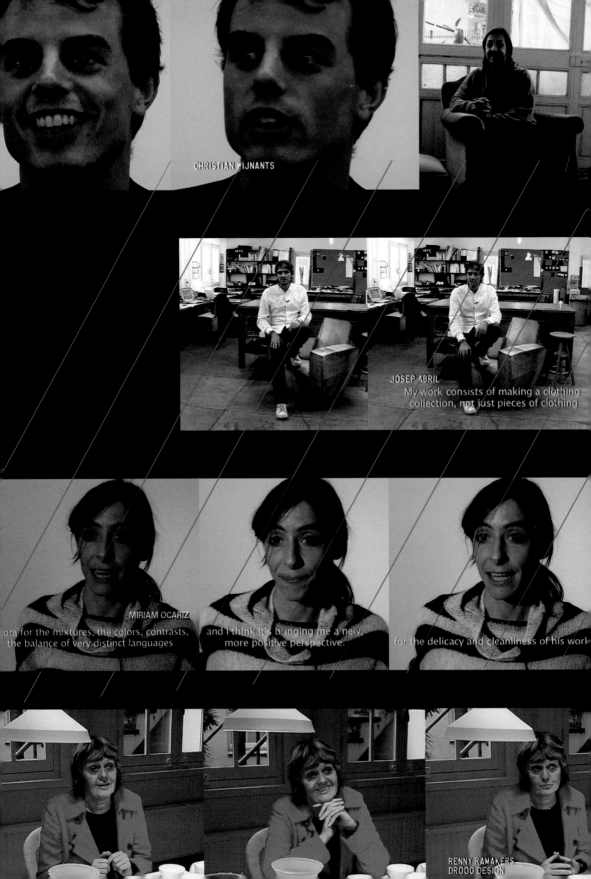

CHRISTIAN WIJNANTS

JOSEP ABRIL
My work consists of making a clothing
collection, not just pieces of clothing

MIRIAM OCARIZ
ora for the mixtures, the colors, contrasts,
the balance of very distinct languages

and I think it's bringing me a new,
more positive perspective.

for the delicacy and cleanliness of his work

RENNY RAMAKERS
DROOG DESIGN

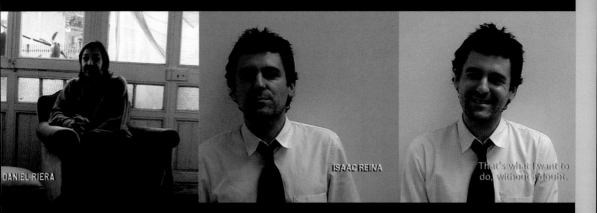

DANIEL RIERA

ISAAC REINA

That's what I want to
do, without a doubt.

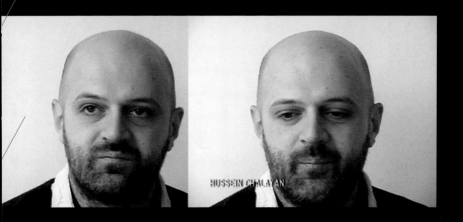

HUSSEIN CHALAYAN

"I would say that my work generally is the response to situations or behaviour and generally I would say that there we know in connection with their references to anthropological or issueless identity, displacement, dislocation, culture-politics and man made constructs. My work really is a response to things like this, but I kind of find my own way of looking at them. Lots of time I feel like I'm exploring through my work, and also at the same time, maybe, trying to create a new way of looking at something, in my own way".

HUSSEIN CHALAYAN

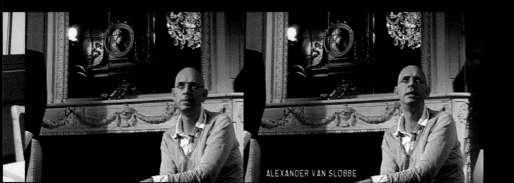

ALEXANDER VAN SLOBBE

Eighty interviews with some activists a hundred per cent cutting-edge of contemporary fashion (not celebrities) such as, to quote just three examples, Wendy & Jim, Hussein Chalayan and Maison Martin Margiela. There was the germ of "Logos Mutant", an exhibition developed for the design area of Bread and Butter Barcelona and the now disappeared Bread and Butter Berlin. Thanks an attractive private initiative we were able to experiment with the new collections in a unique setting: the Moritz factory, a house that has supported our project and with whom we share the vocation of generating activity in the emerging field of creativity.

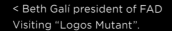

< Beth Galí president of FAD
Visiting "Logos Mutant".

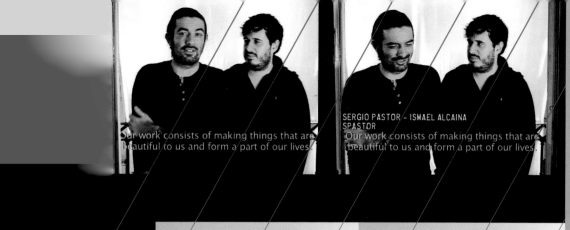

SERGIO PASTOR - ISMAEL ALCAINA
SPASTOR
Our work consists of making things that are
beautiful to us and form a part of our lives.

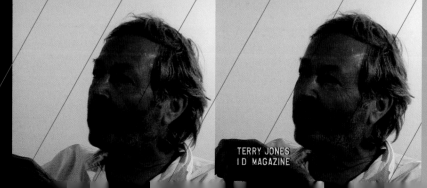

TERRY JONES
I D MAGAZINE

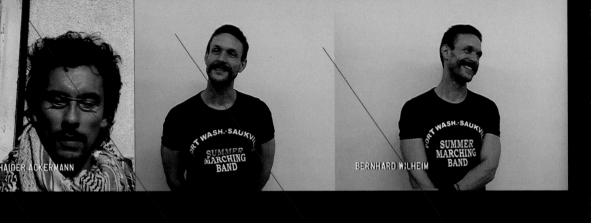

HAIDER ACKERMANN

BERNHARD WILHEIM

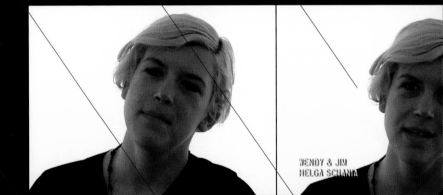

WENDY & JIM
HELGA SCHANIA

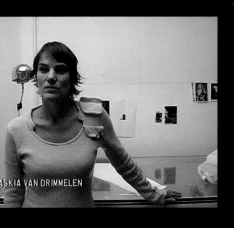

ASKIA VAN DRIMMELEN

MAISON M

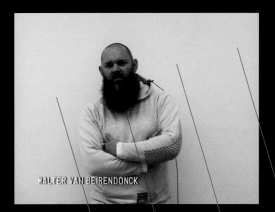

WALTER VAN BEIRENDONCK

"We are lucky to be doing exactly that which we want to do".

MAISON MARTIN MARGIELA

HERMA
WENDY

JOHANNES SCHEIGER
FABRICS INTERSEASON

AISON MARTIN MARGIELLA

ERMANN FRANKHAUSER
ENOY & JIM

OHANNES SCHEIGER
ABRICS INTERSEASON

BORIS BIDJAN SABERI

>

Son of Iranian father and German mother, Boris Bidjan Saberi is one of the best positioned designers despite his youth, 28 years old, outside of Spain. In fact when he paraded on PasaFAD, his brand leather accessories U CAN FUCK W he already enjoyed international recognition. Currently sells on L'Eclaireur in Paris and Tokyo, Dantone of Milan, Harvey Nichols and Joyce in Hong Kong, Komakino in Berlin and Podium in Moscow, to name just a few stores. Present in Paris during the last Man Fashion Week where he presented his collection for Spring-Summer 2009, "Iranian Dessert", his work is the result of his heterogenic heritage, its self-investigation and subsequent academic training in Barcelona.

The quest for perfection and a very comprehensive recreation on details are the engines of his creative spirit. In their garments he basically uses materials with a long tradition as wool, leather, silk, bamboo or cotton, but always checked by craft treatments (waxes, placing under high temperatures, crushing, etc.) which alter the appearance while maintaining its nature. Talking about covering, Boris prefers to go by Guy Calaf photographs, Andy Goldsworthy sculptures, or paintings by RH Giger. "I get more inspired by artists from other genres than from fashion designers," he concludes. Future plans? "Go ahead and improve."

www.borisbidjansaberi.com

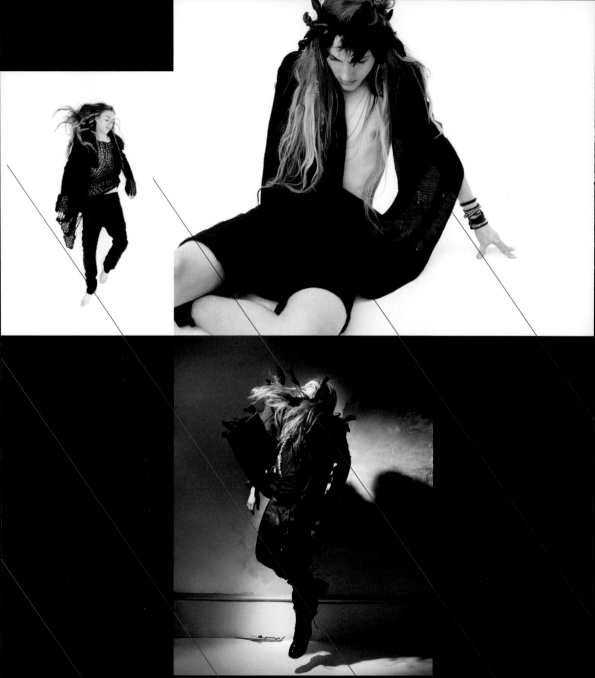

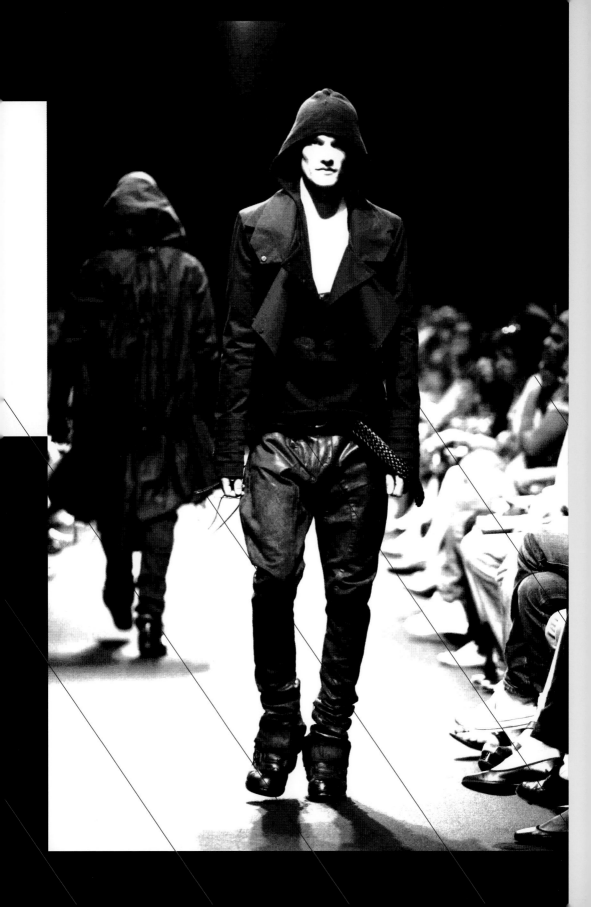

MARÍA ESCOTÉ

>

She had shows in ModaFAD and also in El
Ego de Cibeles. This 29 years old designer
from Barcelona who has studied in
Felicidad Duce and has also gone to Saint
Martins, defines her style as feminine,
colourful and slightly daring. The
collection presented in ModaFAD called
Avant-propos, "talked about eccentric
characters" in her own words. It's a
collection full of leather, vinyl, fringes and
silk laces with some provocative volumes.
His next winter collection is inspired by
that stage of age at which girls dream of
being a woman, "a collection full of colour,
with a mixture of volumes, silk fabrics and
metals." She sells at Le Swing and Blow
(Barcelona), Outlet Ballesta (Madrid) and
Taylor Room (Ibiza). Among his future
plans, obtain more retail points in Spain
and draw the collection abroad.

www.mariaescote.com

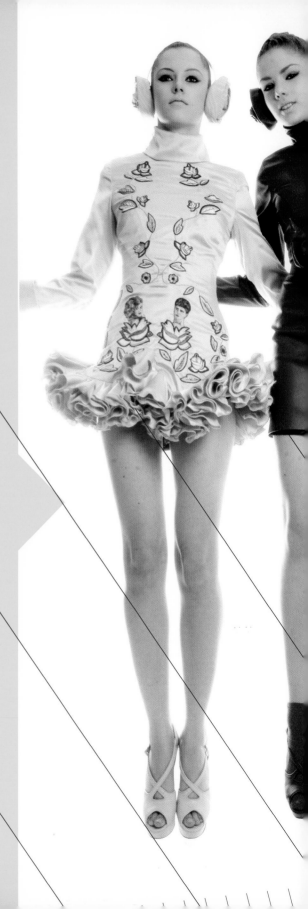

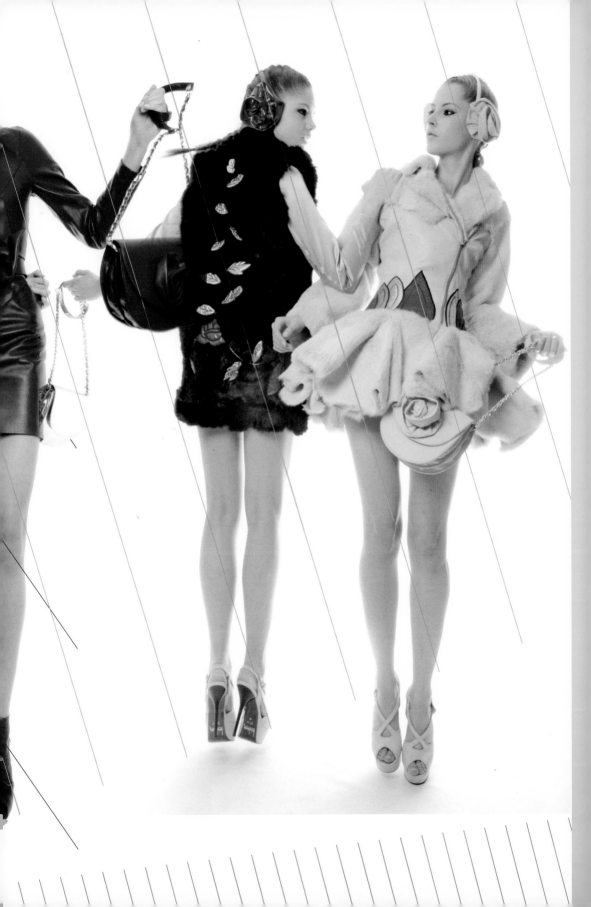

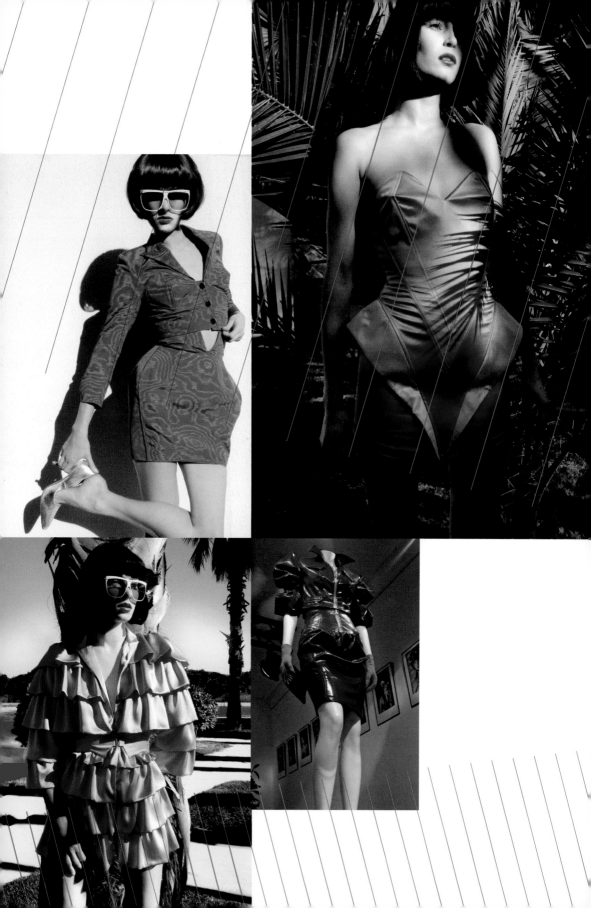

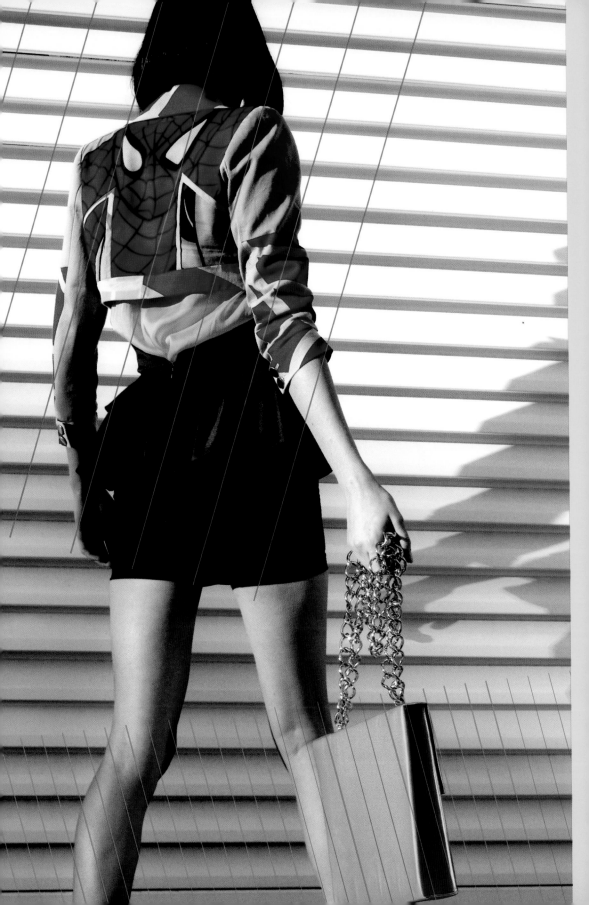

ARTURO MARTÍNEZ
>

His designs are closer to haute couture than to the prêt-à-porter. He defines his work like this: "I try to express my creative universe trying to run away from the self-censured that goes with 'the commercial'. My creations, creative and colourful, are directed to a woman who's not afraid to stand out, an elegant woman and with her own personality. My interest in haute couture is manifested in the work of the volume through the technique of modeling and on the meticulous care of detail in each garment." This 26-year-old designer from Albacete won the ModaFAD prize for Best Designer in 2007 with a collection that revolved around the black, the functional and luxury, that helped him to realize one of his great obsessions: "The checked clothing that I used in several styles." Among his future plans, "making an internship in a maison of Paris. I would like to work there some years to gain more experience and see the fashion world in all its splendor."

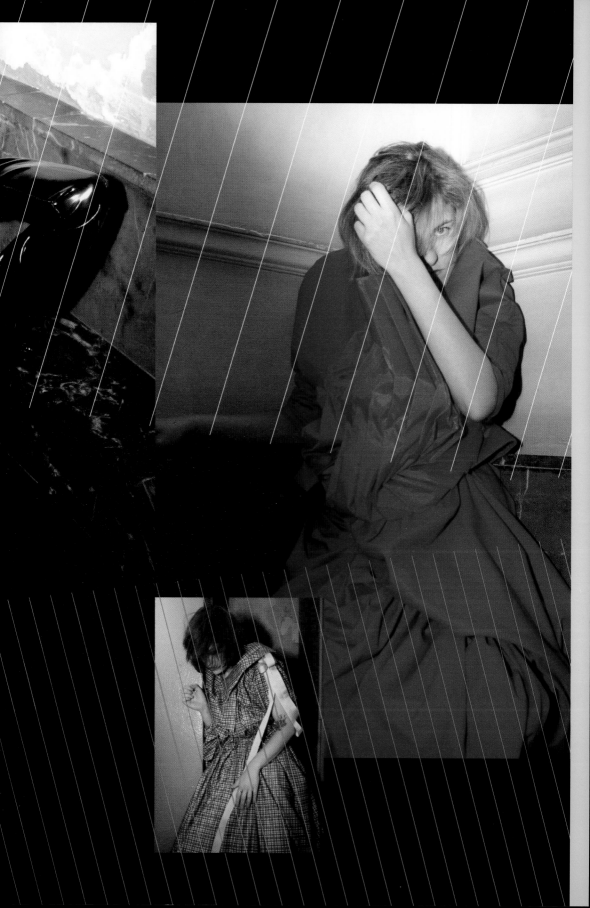

KRIZIA ROBUSTELLA
>

She has been one of the most pleasant surprises that El Ego de Cibeles has given us, her review on the tactel tracksuit of the 90s, between tacky, casual and chic did not leave anyone indifferent and it helped her to reap unbeatable criticism from the press. Now this 23-year-old Dutch, who is part of Projecte Bressol driven by the Catalan Government, just opened a workshop in Barcelona where she works to position her brand in the market. His collection for this winter is an ironic reinterpretation of the uniforms for airline hostesses, and ensures that her biggest challenge is to get her clothing reach the street.

www.fotolog.com/kriziarobustella

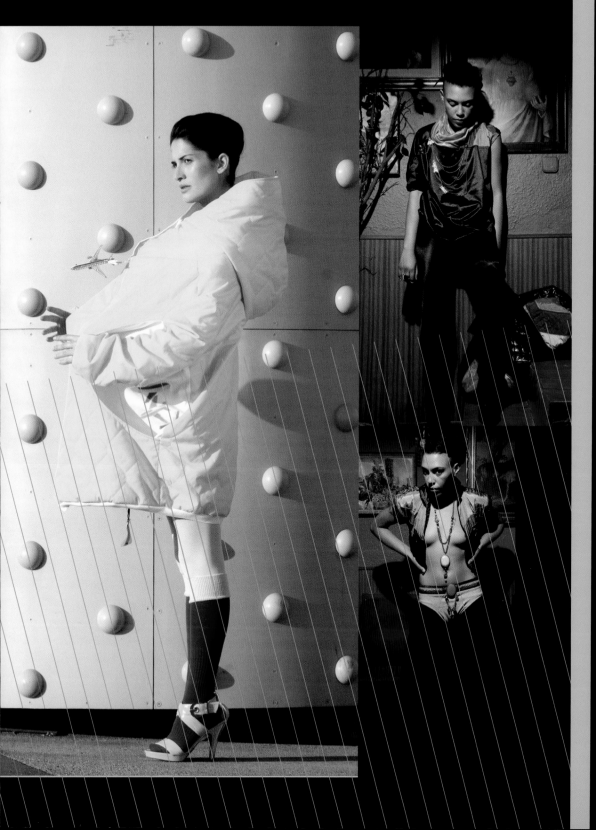

LENFANTERRIBLE
>

His name is Alex González, is twenty years old and his ideas are very clear: "I do not think I have anything to contribute to fashion with 20 years. I do not think I can surprise anyone, as I can continue with a line and go over and over again. That's it." Nevertheless his undeniable talent is not only revealed in his (few) designs, and the clothes worn by him and his friends, but also in the contributions he does. Since 2005 he writes on the blog of Diane Pernet: wwwashadedviewonfashion.com and since last year works as an assistant of the fashion journalist Charo Mora. He has also worked with Designers Against Aids and this year has begun to assist the designer Elena Cardona. The only time he has presented his work at ModaFAD was in the 000Black edition, "where I brought a collection of accessories, five or six pieces, a mask, a pair of necklaces, some belts..." Now he says he needs to dedicate to his failed subjects and especially to the degree project which he has to present next year. Although he takes it easy. "I like doing things with time, dedicate them everything they need, I don't care if it takes me a year or two to do so." He dreams to continue seeing things, to learn a lot and teach others. And if possible learn alongside designers such as Carol Christian Poell or the Maison Martin Margiela. And concludes: "Disturbing, I love this word. I enjoy working on anything that disturbs me. And if something doesn't disturb me I'm not interested. "

www.myspace.com/lenfanterrible

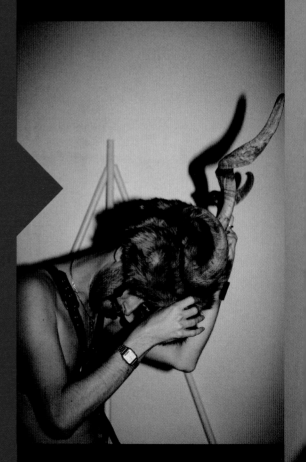

Model and photography: Sebastien Meunier

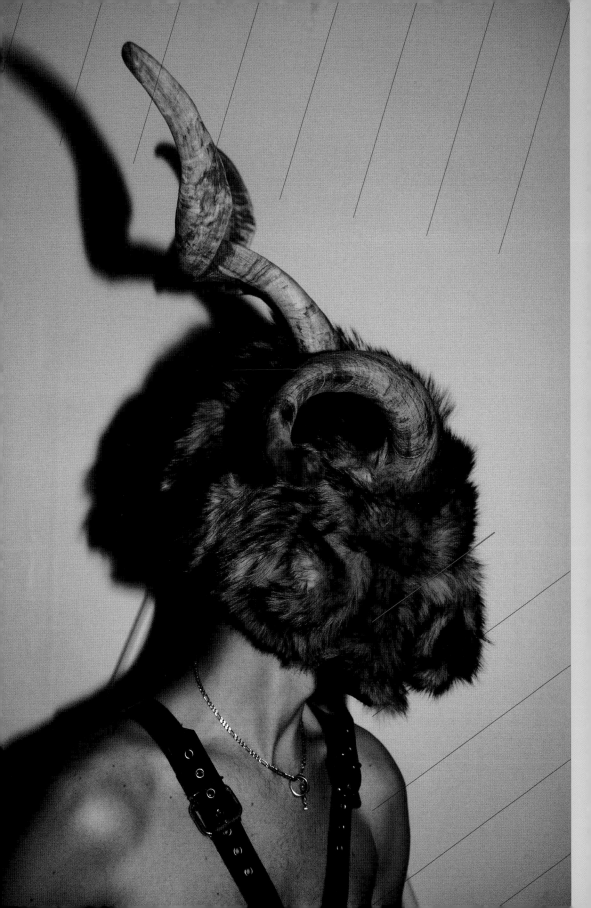

SUSY SANS
>

The Maison Mariella Burani produced the collection of My Dejàvu 1800/2007 Spring-Summer 2007 after winning My Own Show, the parade organized by Franca Sozzani, editor-in-chief of Vogue Italy. Currently living in Italy and works as a designer in the Valentino's studio.

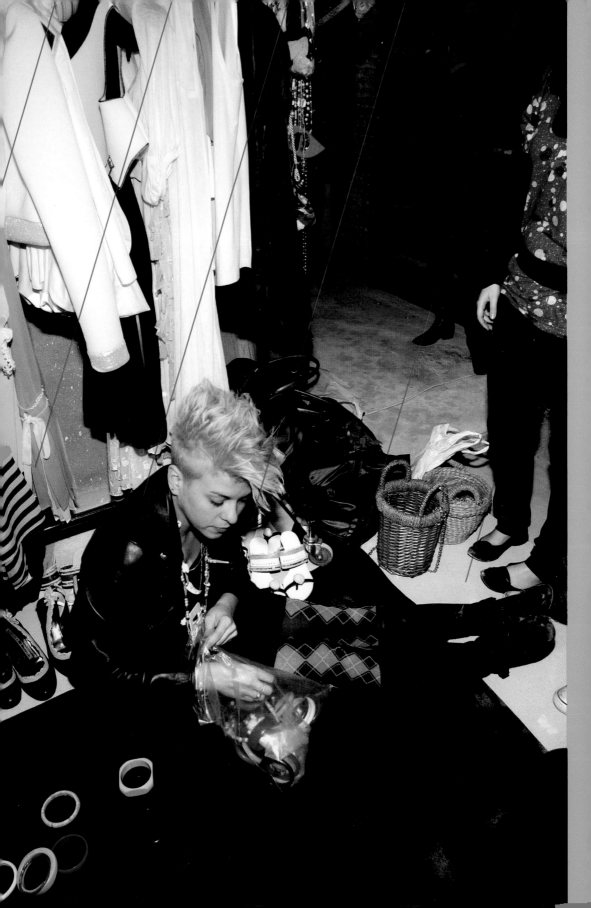

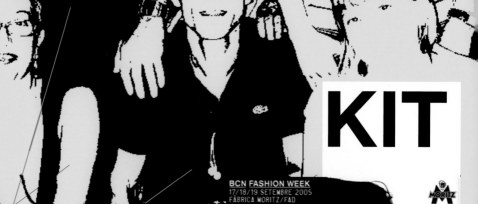

KIT

BCN FASHION WEEK
17/18/19 SETEMBRE 2005
FÀBRICA MORITZ/FAD

MORITZ

KIT

FAD 12 A 19 SET WORKSHOP EDITORIAL DE MODA SUAT PER FELIU
OLGADO AMB PROD. DANIEL RIERA I ESTUDIANTS 18 FÀBRICA MORITZ
17 SET PASAFAD + FASHION SHOWS 20'00 PIA KAHILA + POKOPINK
+ COMENTI 00 22:00 ANDREA AYALA 22'00 PASAFAD //// FÀBRICA
MORITZ 18 SET 17'00 A 21'00 MODAFAD 21'00 TEA/LOUNGE PARTY //
FAD 19 SET 20'00 DIANE PERNET 21'00 6+/+1 y OPENING //// FAD 20 SE
2 ACT EXPOSICIÓ UOVO

KIT

MODAFAD

22. KIT

September 2005 on the Moritz factory
Winners. Prize for Best Collection: Juan
Vidal; Special mention from the jury:
Ariadna Baltiérrez and Laura Navas (Así
Somos); Nobel Prize: Víctor Cardona e
Israel Frutos.
Friday 16 PasaFAD on the Moritz factory
Saturday 17 MerkaFAD on the Moritz
factory, at 21:00h Mu Tea Dance Party
Monday 19 at 21:00h inauguration in the
headquarters of FAD of the exhibition
"Grey velvet enjoy smoking political robot
fog" with Uovo Magazine. Opened until
October 1.
Architects: EING.
Exhibition's assembly: Niall O'Flynn.
Photography: Xavi Padrós, Marcel
Montlleó.
Video: Víctor Torres, Olivia Aracil
and Jordi.
Hairstylist: Marcel and team.
Make up: Tutusaus and team.
Stylists: Jaume Vidiella, Asier Tapia,
Malaspina.
Subvention: Generalitat de Catalunya,
Barcelona Fashion Week.
Main Sponsor: Moritz.
Sponsor: Nobel / Sofa Experience
Communication.

The Moritz factory hosted this edition,
which took place within the activities of
the Barcelona Fashion Week, whose topic
was Kit, understood as a set of pieces
that individually or in his totality make up
a unit. Alongside Comentrigo, Pia Kahila
and Pokopink also paraded in solitary
Andrea Ayala. On the other hand the
Italian magazine Uovo presented its latest
issue, among other content: Alejandro
González Iñárritu, Philip Lorca di Corcia,
Santiago Sierra, Anthony Goicolea and
Jota Castro. The French collective
d-i-r-t-y was in charge of the music.

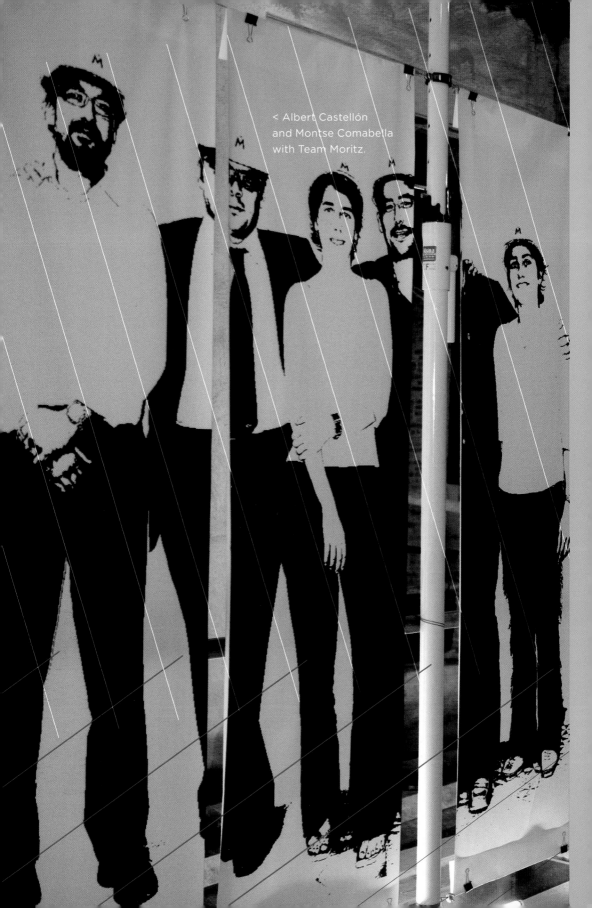

< Albert Castellón and Montse Comabella with Team Moritz.

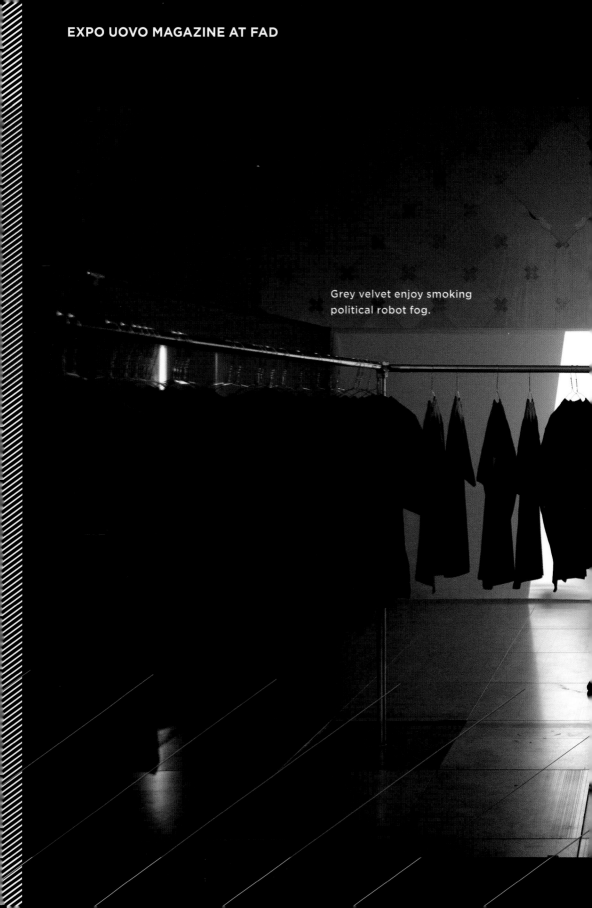

Grey velvet enjoy smoking
political robot fog.

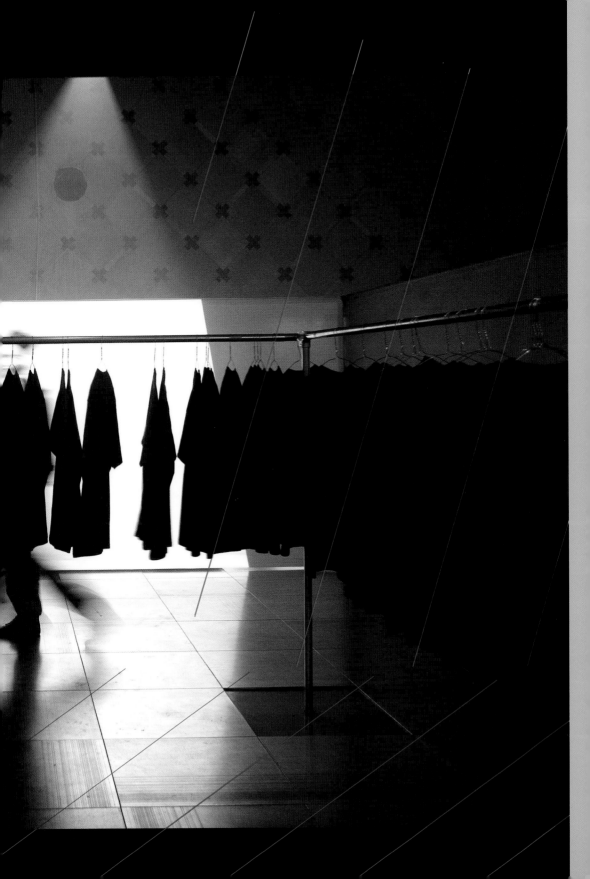

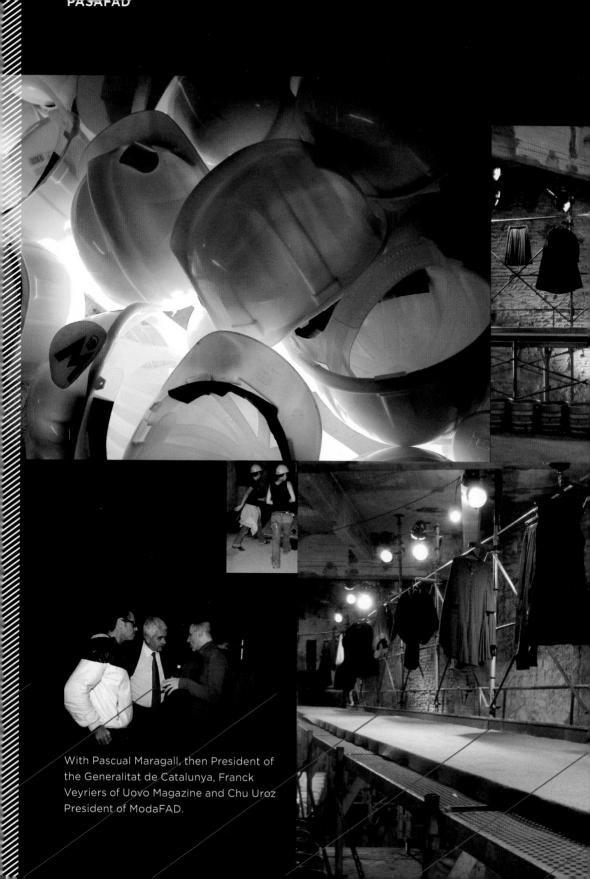

With Pascual Maragall, then President of the Generalitat de Catalunya, Franck Veyriers of Uovo Magazine and Chu Uroz President of ModaFAD.

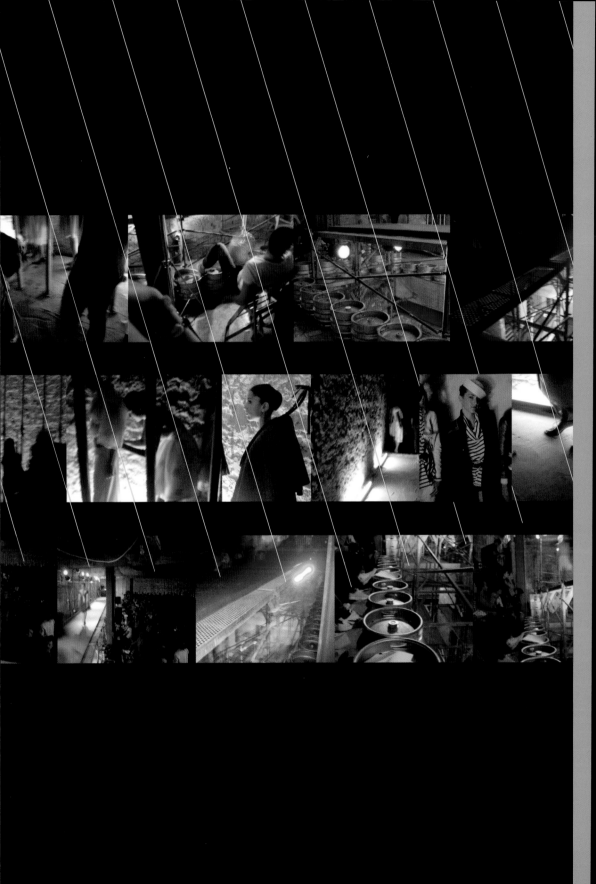

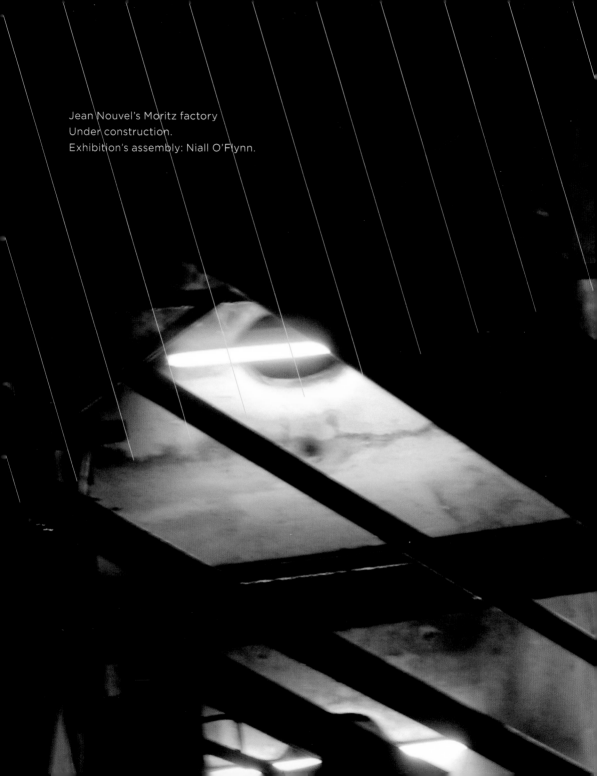

Jean Nouvel's Moritz factory
Under construction.
Exhibition's assembly: Niall O'Flynn.

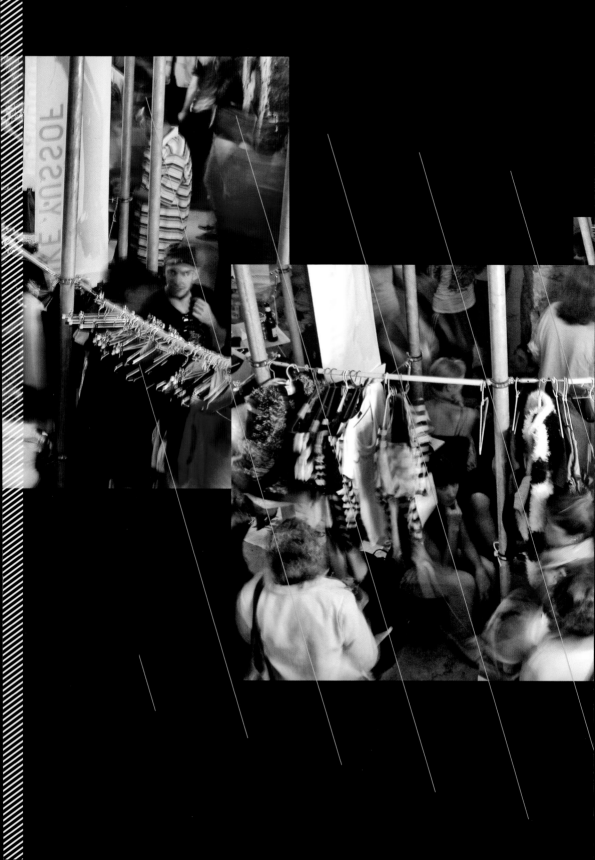

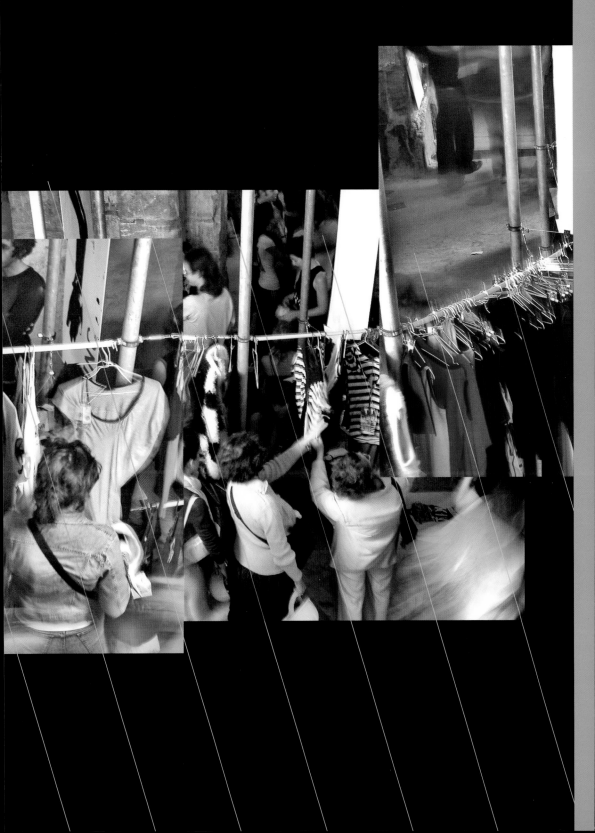

JUAN VIDAL
>

He was born in Elda (Alicante), his passion for fashion comes from his family. Son of a tailor father and a mother that owns a boutique, he began at the early age of 15 to design his first night dresses for certain clients of his mother. Now, he is 27 years old and after passing through Fine Arts and Felicidad Duce school, Juan is about to present his first collection for men in El Ego de Cibeles, but he has always been more interested on dressing women with his sophisticated and chic designs. "I like to dress spoiled women with a sense of femininity highly developed," he said, "in my collections I almost always play the theme Night but I like to combine it with other garments to achieve a more casual urban look." Juan Vidal has presented his collections at the Pasarela de Barcelona, Bread & Butter and ModaFAD, where in 2005 he won the Prize for Best Collection.

www.juanvidaldesign.com

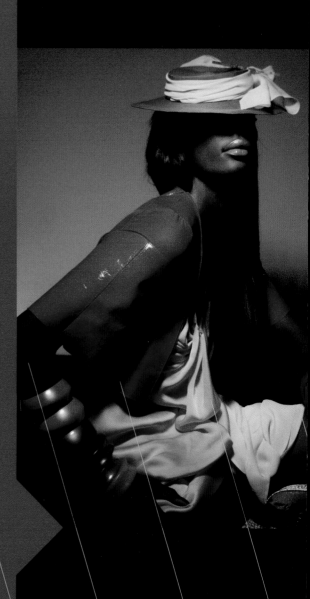

winner!

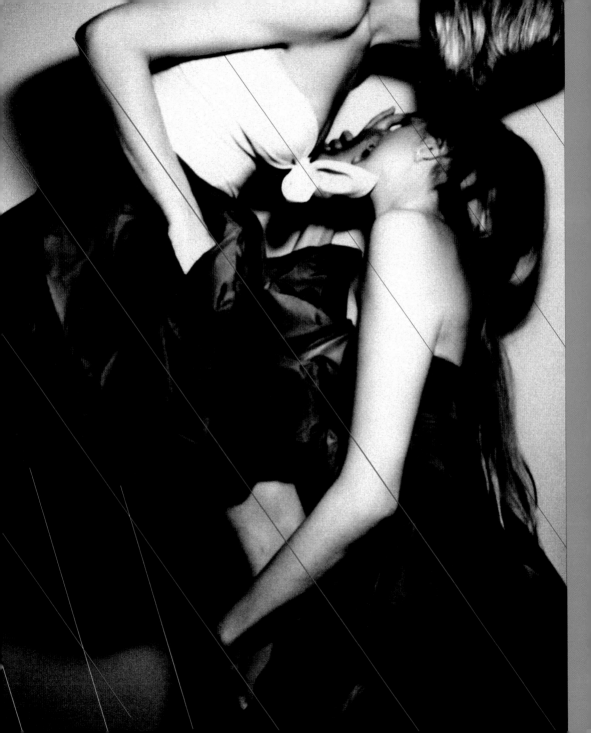

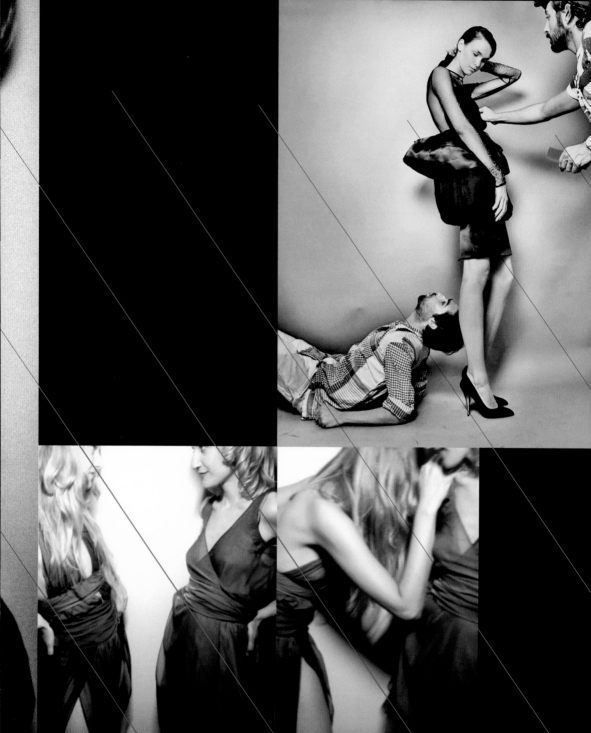

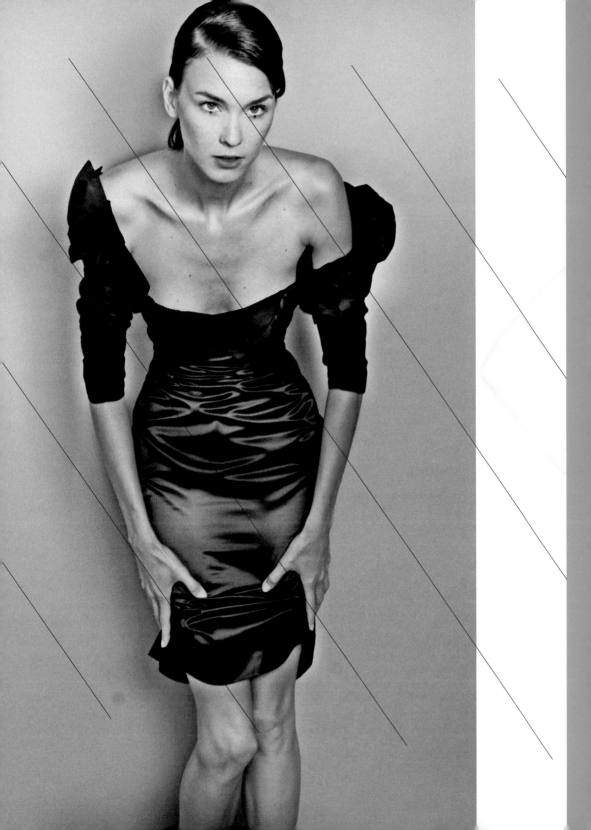

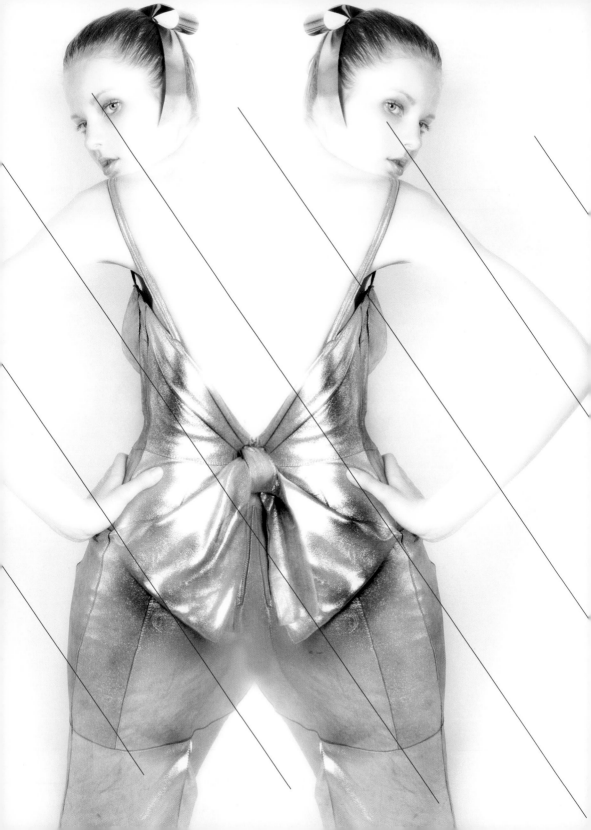

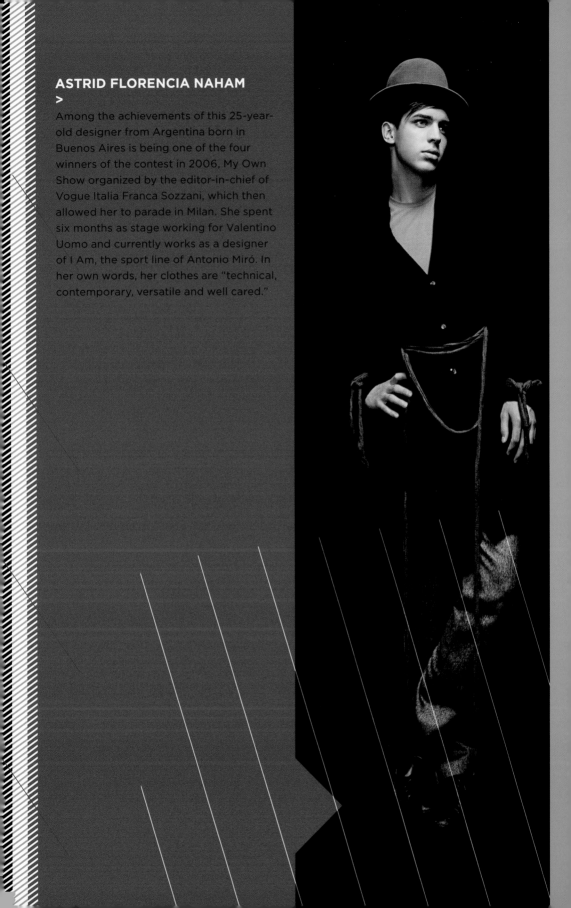

ASTRID FLORENCIA NAHAM
>

Among the achievements of this 25-year-old designer from Argentina born in Buenos Aires is being one of the four winners of the contest in 2006, My Own Show organized by the editor-in-chief of Vogue Italia Franca Sozzani, which then allowed her to parade in Milan. She spent six months as stage working for Valentino Uomo and currently works as a designer of I Am, the sport line of Antonio Miró. In her own words, her clothes are "technical, contemporary, versatile and well cared."

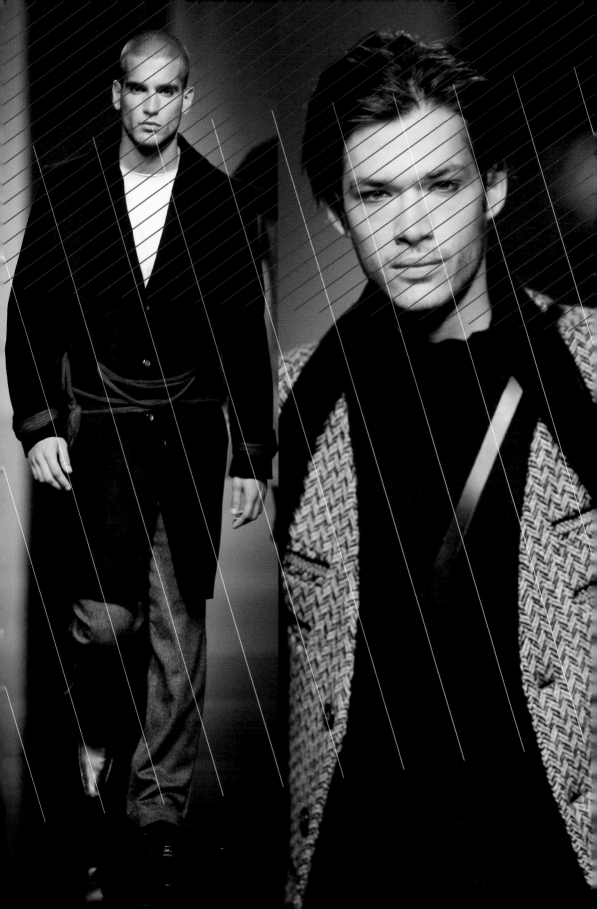

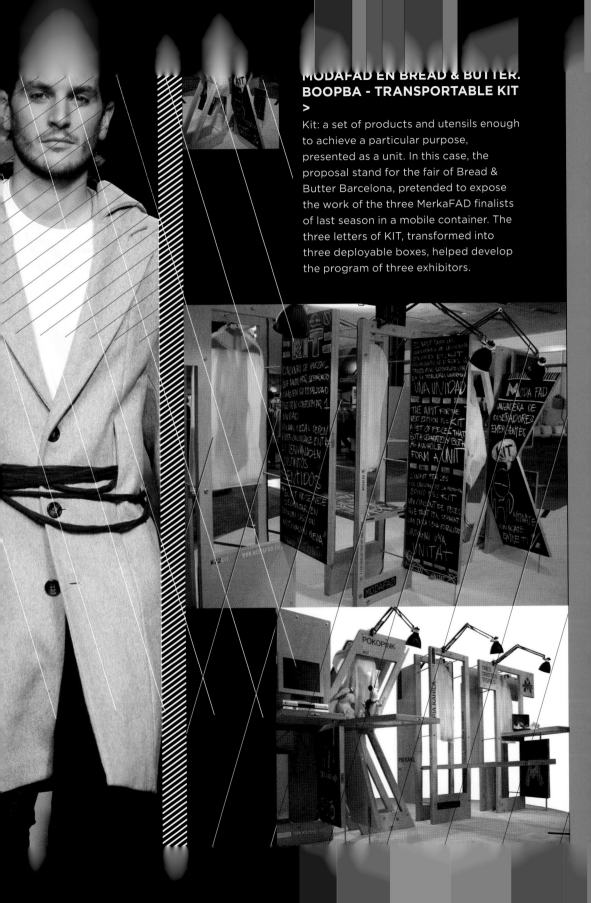

MODAFAD EN BREAD & BUTTER. BOOPBA - TRANSPORTABLE KIT >

Kit: a set of products and utensils enough to achieve a particular purpose, presented as a unit. In this case, the proposal stand for the fair of Bread & Butter Barcelona, pretended to expose the work of the three MerkaFAD finalists of last season in a mobile container. The three letters of KIT, transformed into three deployable boxes, helped develop the program of three exhibitors.

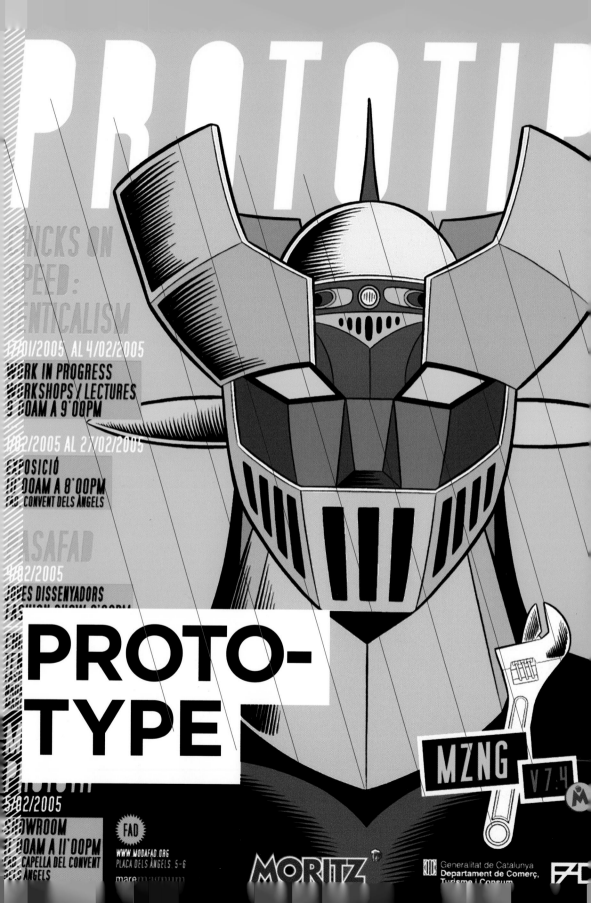

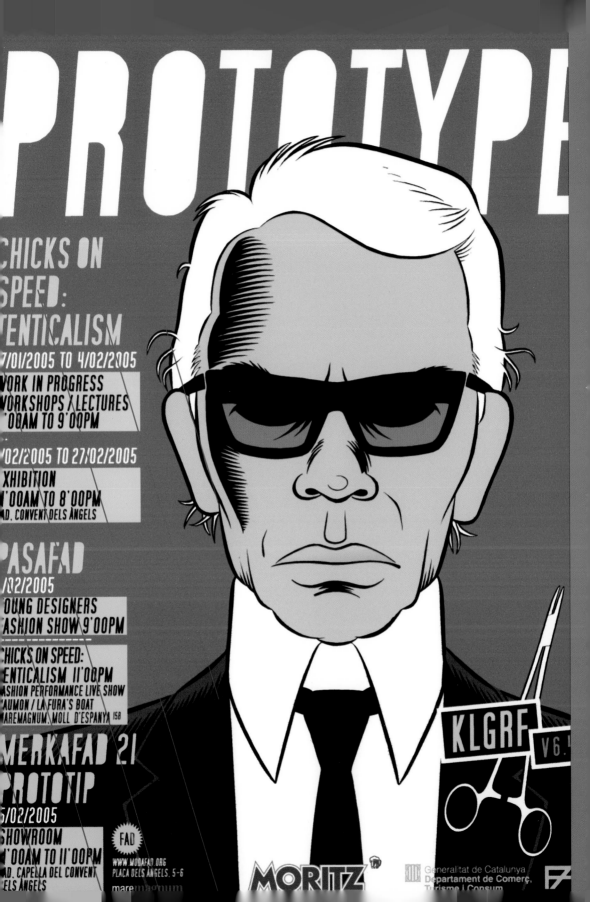

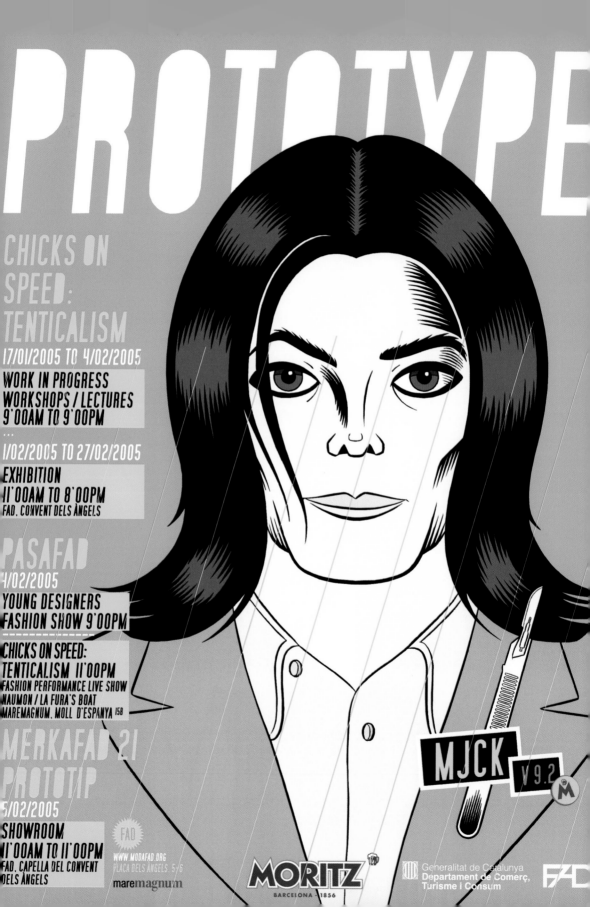

PROTOTYPE

CHICKS ON SPEED: TENTICALISM

17/01/2005 TO 4/02/2005

WORK IN PROGRESS
WORKSHOPS / LECTURES
9'00AM TO 9'00PM
...

1/02/2005 TO 27/02/2005

EXHIBITION
11'00AM TO 8'00PM
FAD. CONVENT DELS ÀNGELS

PASAFAD
4/02/2005

YOUNG DESIGNERS
FASHION SHOW 9'00PM

CHICKS ON SPEED:
TENTICALISM 11'00PM
FASHION PERFORMANCE LIVE SHOW
NAUMON / LA FURA'S BOAT
MAREMAGNUM, MOLL D'ESPANYA 15B

MERKAFAD 21
PROTOTIP

5/02/2005

SHOWROOM
11'00AM TO 11'00PM
FAD. CAPELLA DEL CONVENT
DELS ÀNGELS

MJCK V9.2

FAD
WWW.MODAFAD.ORG
PLAÇA DELS ÀNGELS, 5-6

maremagnum

MORITZ
BARCELONA · 1856

Generalitat de Catalunya
Departament de Comerç,
Turisme i Consum

FAD

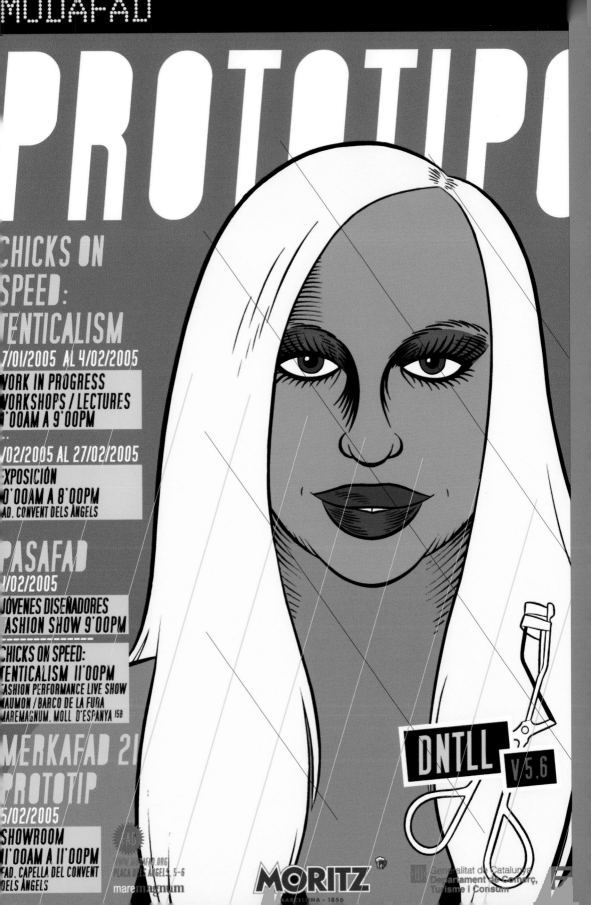

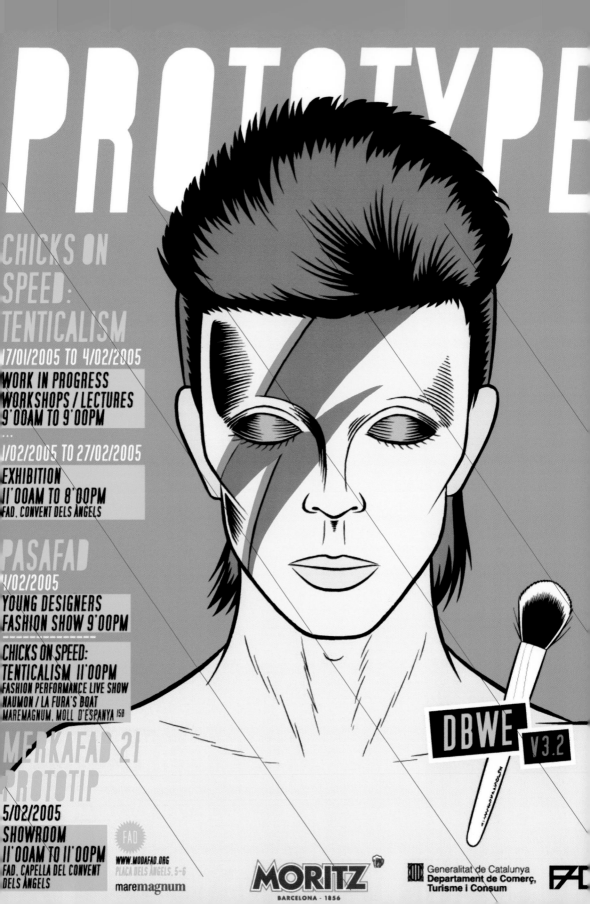

21. PROTOTYPE
>

February 2005. Opened workshop of Chicks on Speed in the FAD's laboratory, between the 18 of January and the 4 of February.
PasaFAD and the show of Chicks on Speed "Disaster" on the boat Naumon de La Fura dels Baus the February 4.
Chicks on Speed exhibiton "Tenticalism" at FAD from February 1 till February 26.
MerkaFAD February 5 at la Capella dels Àngels.

Winners. Prize for Best Designer: Trestristestigres (now Comentrigo); Special mention from de jury for Pia Kahila and Pokopink by Dana Evron.
Participants of "Tenticalism": The No-Heads, Alex Murray-Leslie, Anat Ben David, Ann Sentón, A.L. Steiner, Bruno Enrich, Chu Uroz, Deborah Schamoni, Jonni Dogday, Kathi Glass, Kiki Moorse, Melissa Logan, Rosa Cortana, Roman, Lisa Walter, Lucy Fol, Cristian Vogel, Jean Charles de Castelbajac, Kai Knappe, Diego Albanell, Mark Hunter, Sofa Experience, Halma, Menkes, Carlos Padrisa, Anna Mir, Emili Padrós, Asier Tapia, Ailanto, Bernat Lliteras, Curro Claret, Custo Dalmau, Josep Abril, Jordi Labanda, Mireya Ruiz, Miriam Ocáriz, Silvia Prada, Txomin Plazaola and the students of Elisava, Eina, e Istituto Europeo di Design.
Hairdresser: Marcel & team.
Make up: Tutusuaus & team
Stylists: Txomin Plazaola, Asier Tapia, Malaspina, Jaume Vidiella.
Subvention: Generalitat de Catalunya, Barcelona Fashion Week.

Main Sponsor: Moritz.
Sponsors: Comodynes.
Collaborators: Paï Thio, Abcdesign, Maremagnum.
Instalation BOPBAA.
Graphic: Bernat Lliteras from Sofa Experience.

"Prototype" was the topic for this edition and the illustrator Bernat Lliteras was responsible for the campaign drawing a series of iconic characters, Karl Lagerfeld and Donatella Versace among them. But if there is anything that marked the 21 edition of ModaFAD was the workshop of the Chicks on Speed. They called Tenticalism (a term coined by themselves and by the designer Jean Charles de Castelbajac to define their way of working that combines unprejudiced any form of creative expression) and for two weeks they kicked up a fuss on the FAD Laboratory, in the Convent dels Àngels, on a work in progress in which they designed garments and accessories in collaboration with designers both from here and from the outside. Miriam Ocáriz, Jordi Labanda, Anat Ben David, Amy Steiner, Silvia Prada, Bernat Lliteras, Lucy Folk and Deborah Schamoni were just some of the creatives who participated in the workshop whose outcome could be a double, an exhibition and a show that the Chicks presented at the Naumon, the boat of the Fura dels Baus.

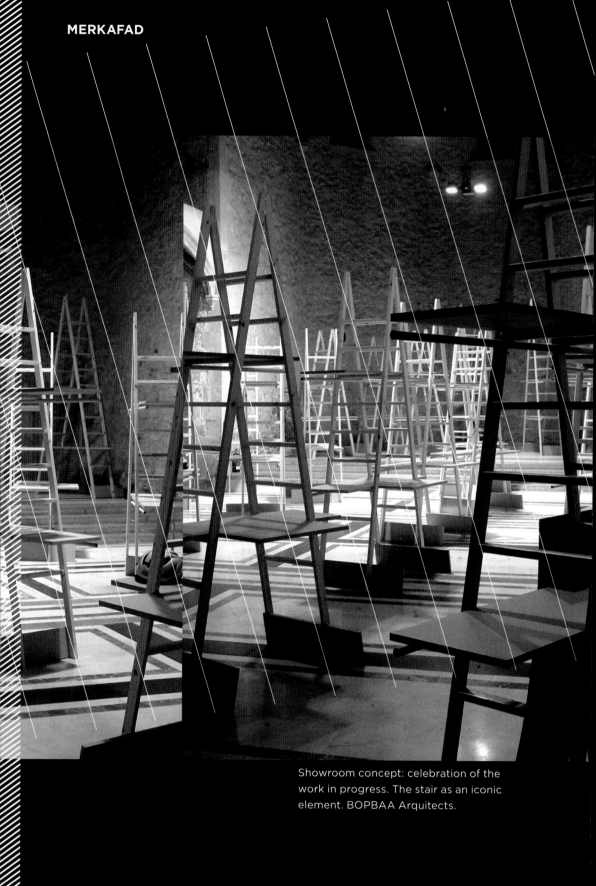

Showroom concept: celebration of the work in progress. The stair as an iconic element. BOPBAA Arquitects.

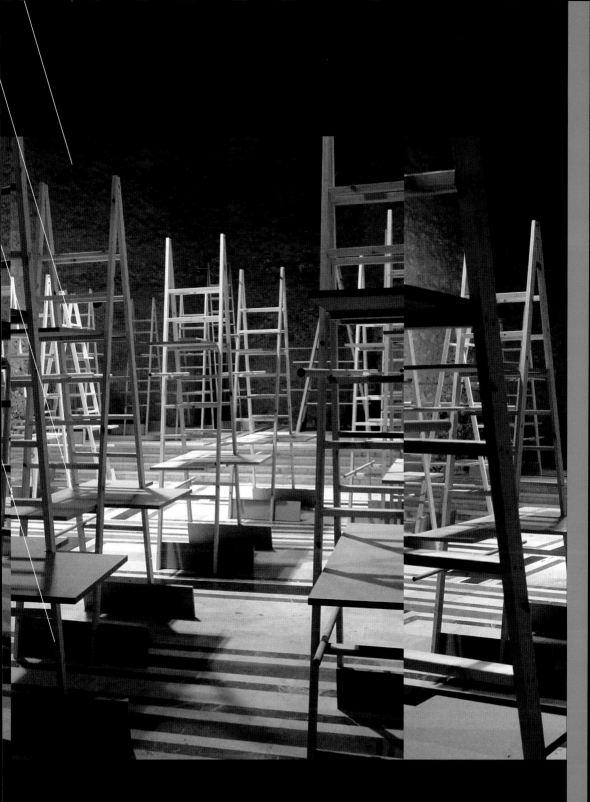

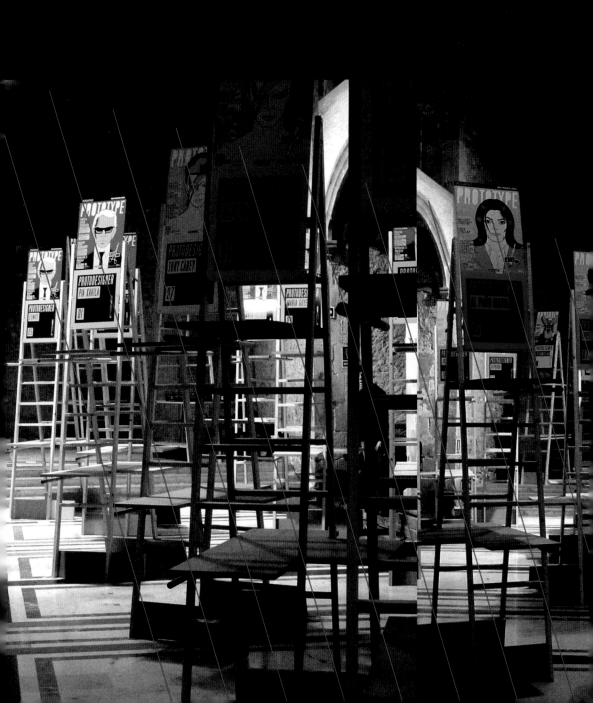

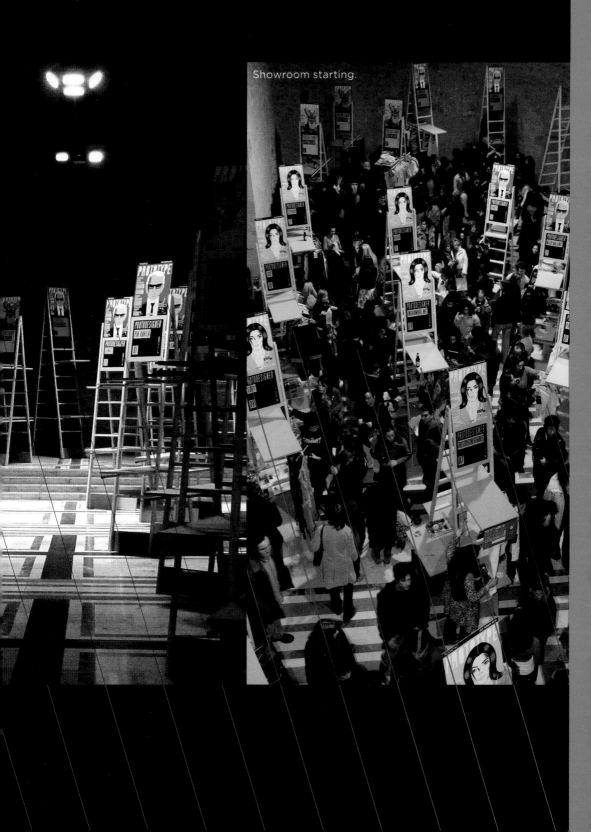

Showroom starting.

CHICKS ON SPEED

Work in progress activities. >

PEOPLE WHO WILL BE WORKING UPSTAIRS AND WHEN THEY DO

>>>FROM TUE 18th TO FRI 21st or SAT 22nd

>mornings 9'30h to 14'00h
>>Beatriz Alberti
>>Marc Graells
>>Alex Barrau
>>Roser Estelrich
>>Berta Fernández
>>Isabel de Miguel
>>Maria Novelles

>>Mer... ...nzo
>>Adriana Fernández
>>Jordi Marin
>>Anna Taules

WEDNESDAY

7.? BIGAS LUNA

THURSDAY.

12.00 PRESS CONFERENCE
1.00 VISIT LOFT
NORK IN PROGRESS
"FULL-ACTION!!"

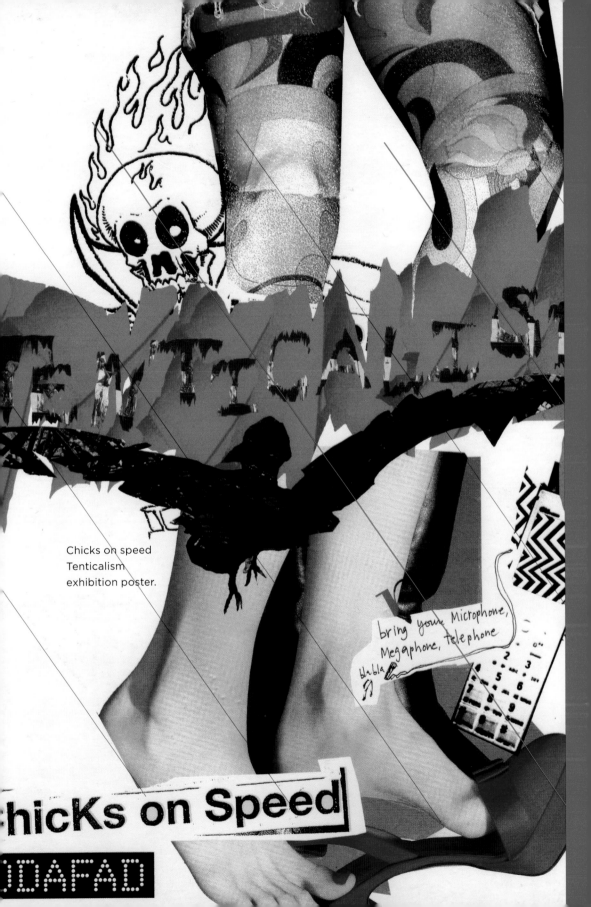

Chicks on speed
Tenticalism
exhibition poster.

bring your Microphone,
Megaphone, telephone

blabla

hicKs on Speed

IDAFAD

CHICKS ON SPEED WORKSHOP
ALEX MURRAY INTERVIEW

Creativity without limits and standards during two weeks by the hand of Chicks on Speed. Music, art, fashion, film, graphic design, any discipline is good on what they called Tenticalism, "a kind of virus that spreads through the city and can take any creative form." The one speaking is Alex Murray-Leslie, one of the members of the band. We'll remember with her those days of frenetic activity and take a look at their new projects, which are not a few.

You made a multidisciplinary workshop where a lot of people were involved, how do you remember the experience? It was a unique opportunity for us to collaborate with some of our favourite artists in Spain and meet a load of new friends and collaborators with whom to be partners in crime.

How did you get involved with this people? Chu introduced us to most of the collaborators, Jordi Labanda, Rosa Cortana, Custo, Ailanto...

Did you remember some collaboration specially? We remember collaborating with Rosa Cortana very fondly and the piece she made from our fabric was super fresh. A funny story Rosa told us that the needles were braking on her sewing machine, during the sewing, as our fabric was so rough and textured with screen printed paints. Collaborating with The NO-Heads was fantastic, we rehearsed in the space everyday, after sewing and screen printing was done, this was the first time we worked together with a live band to develop a live fashion show with a band and "real" instruments. Roberto Enrich introduced us to Menkes and we became friends instantly, creating many

collections of shoes even after the FAD project, we're still working together, doing way out printing on leather and wild designs and having Menkes transform them into wearable shoes. Ailanto was very challenging, they gave us this wonderful piece of butterfly fabric, we didn't make anything and still have the fabric in our archives, it was such a work of art itself that we didn't dare to touch it till an amazing idea came along. I hope one day we can surprise and delight the boys.

Which was the objective of the workshop? Our aim was to work with students from different art and fashion schools and practicing with artists and designers from Barcelona, to bring different people together with different artistic backgrounds and make collective pieces, learning by doing, like one big creative melting pot. At the end of the two weeks the aim was to put everything on stage in some way, most things were worn on the body. The general rules always applies, stretch an ideas as far as you can, exploiting it in everyway possible, through textiles, stage performance, video, sound, and contemporary jewelry. There are no rules, and if there are any, then we try our best to break them.

What can you explain about the new projects with Chicks on Speed? We're currently working on pieces for our exhibition "Viva La Craft" Objektifications by Chicks on speed and Collaborators, at Craft Victoria in Melbourne, Australia, March 09, a similar project to Tenticalism, where we collaborate with all sorts of artists and scientists and programmers to produce new arts and crafts works; A collection of stage clothes with Martin >

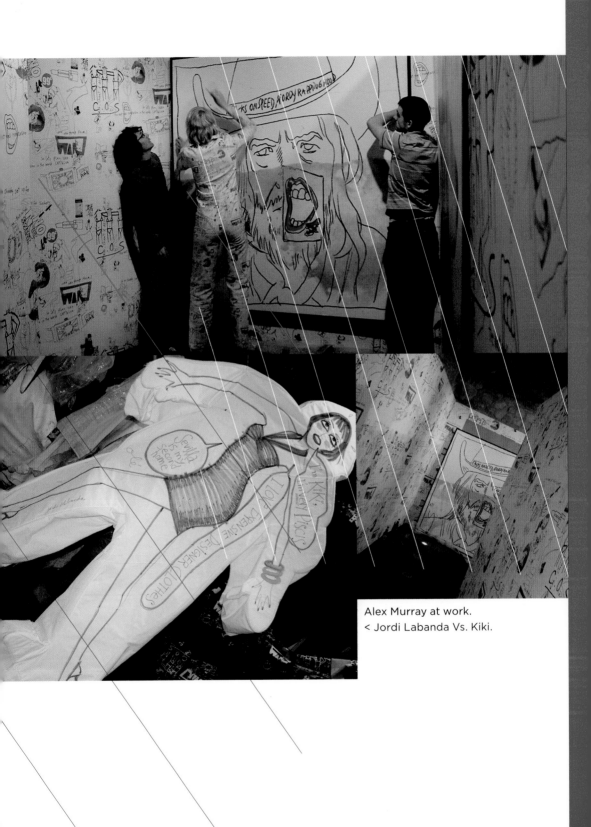

Alex Murray at work.
< Jordi Labanda Vs. Kiki.

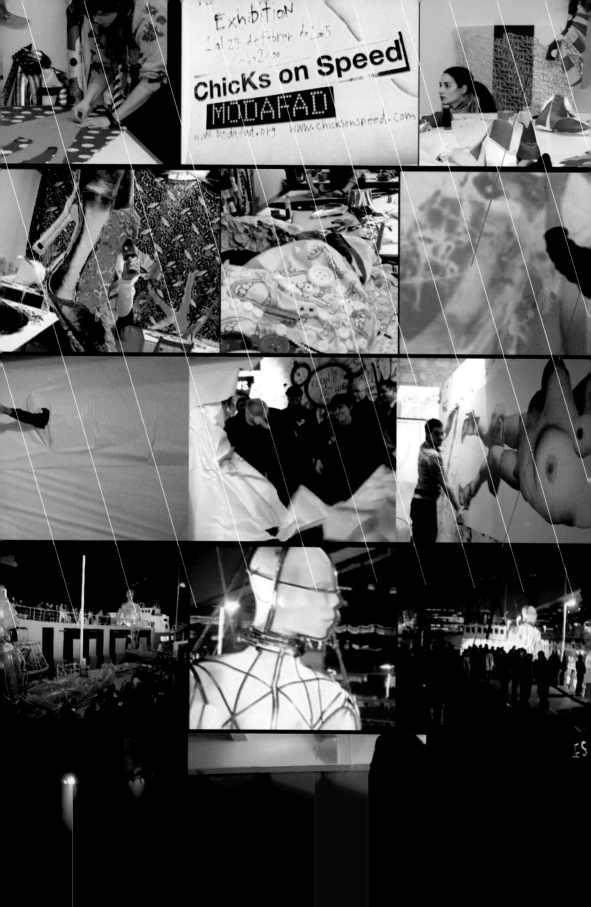

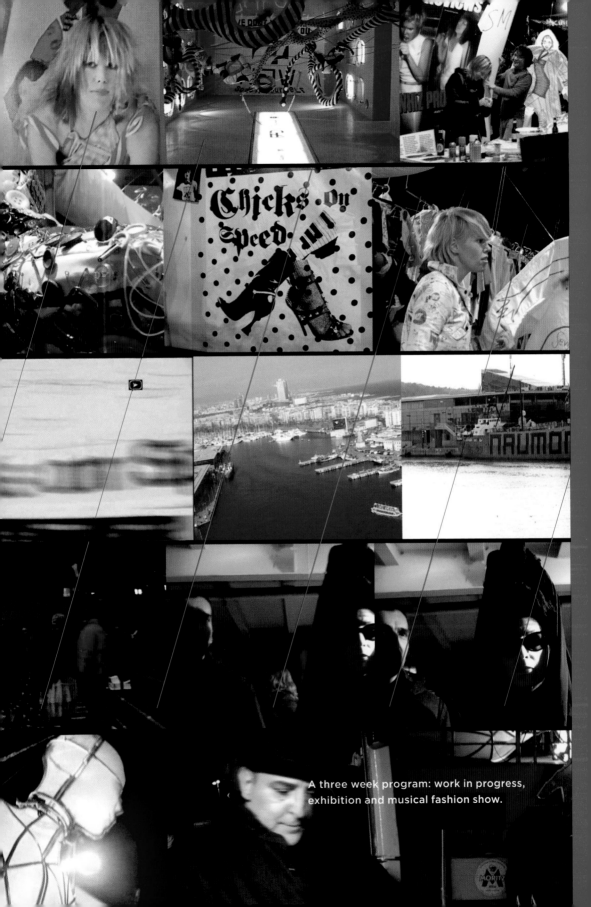

A three week program: work in progress, exhibition and musical fashion show.

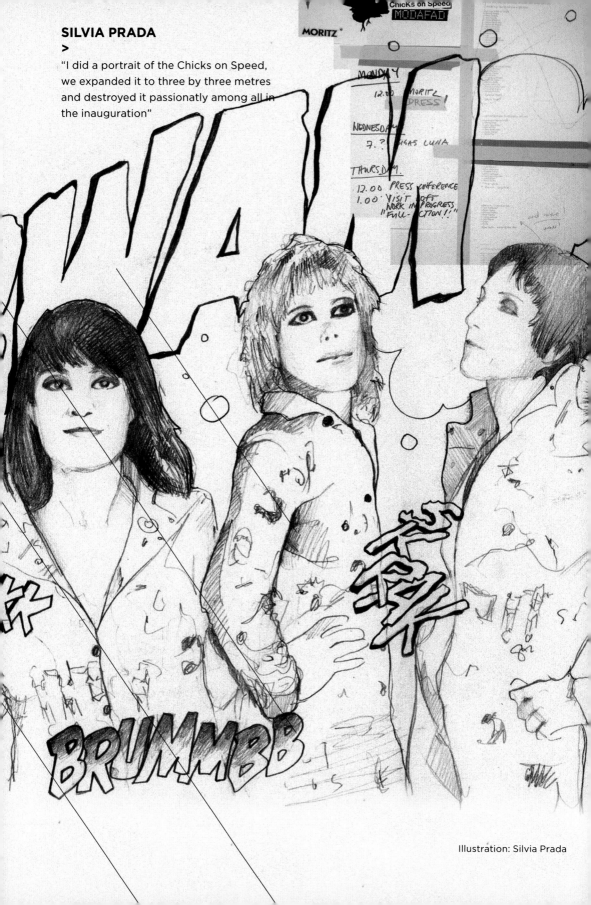

SILVIA PRADA
>

"I did a portrait of the Chicks on Speed, we expanded it to three by three metres and destroyed it passionately among all in the inauguration"

Illustration: Silvia Prada

Lamothe, Barefoot in the Brain, from Tokyo, is making the Art Warrior boots with our textile designs, Modul8 is collaborating with us on Super Suits, which are high tech stage outfits, where the instrument becomes fashion, and fashion is invaded by technology. Each suit hand crafted and patchworked, able to send our signals to trigger audio and video, we'll be working at Hangar on this project in September. Other collaborators include Jeremy Scott and a collection of hats with Christophe Coppins. Besides that COS releases the 5th album of Chicks on Speed Records in December 08

Fashion always has been important for Chicks on Speed, right? What means fashion for you? The surface of the fashion industry, is high gloss and quite boring, most companies are running behind trends, traveling to Tokyo three times a year for inspiration or buying the latest Prada suits to copy, all to get ahead and make more Money!? We see fashion as having a greater responsibility; socially, politically and culturally. We aspire to Elsa Shiaparelli, in love with fashion, having fun and taking risks, she made progress and posed a lot of questions through her fashion, making people active, instead of passive and at the same time, she was able to run a business.

What do you think is important (or not) in our lives? I think greed is a very bad thing. Happiness is the most important and that you can only get it through honesty and hard work of course! As an artist you need to be busy and challenged by your work as possible, more is more!

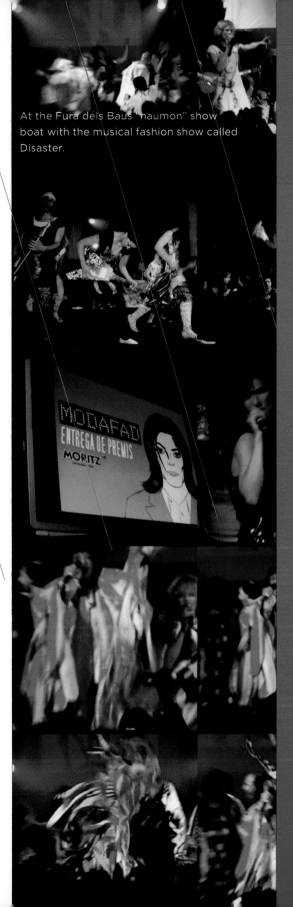

At the Fura dels Baus "naumon" show boat with the musical fashion show called Disaster.

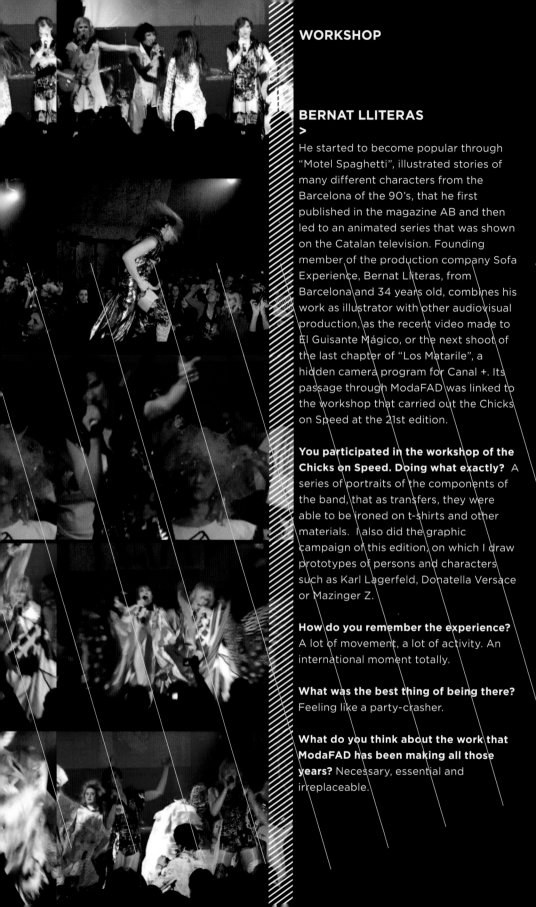

WORKSHOP

BERNAT LLITERAS
>

He started to become popular through "Motel Spaghetti", illustrated stories of many different characters from the Barcelona of the 90's, that he first published in the magazine AB and then led to an animated series that was shown on the Catalan television. Founding member of the production company Sofa Experience, Bernat Lliteras, from Barcelona and 34 years old, combines his work as illustrator with other audiovisual production, as the recent video made to El Guisante Mágico, or the next shoot of the last chapter of "Los Matarile", a hidden camera program for Canal +. Its passage through ModaFAD was linked to the workshop that carried out the Chicks on Speed at the 21st edition.

You participated in the workshop of the Chicks on Speed. Doing what exactly? A series of portraits of the components of the band, that as transfers, they were able to be ironed on t-shirts and other materials. I also did the graphic campaign of this edition, on which I draw prototypes of persons and characters such as Karl Lagerfeld, Donatella Versace or Mazinger Z.

How do you remember the experience? A lot of movement, a lot of activity. An international moment totally.

What was the best thing of being there? Feeling like a party-crasher.

What do you think about the work that ModaFAD has been making all those years? Necessary, essential and irreplaceable.

Are you used to go to parades and to the MerkaFAD? Go to MerkaFAD is always a cause for happiness.

Have you ever bought something? I don't. But my girlfriend, her two sisters and her mother, all in group and at the same time, they loot. I drink a few mojitos.

Recommend an interesting place in Barcelona and say why. Freaks, because neither in London nor Paris nor New York I found a shop with more and better material on cinema, photography, design, comics... Lost & Found, another market purchase, sale and exchange of objects with a quality and approach that makes it unique and special. The Bar Ramon, because I find an unusual combination of really good food, interesting company and the best music.

FELIPE SALGADO PHOTOGRAPHY WORKSHOP
>
CARLES ROIG
SERGI PONS
DANIEL RIERA

Fashion Editor for a few years of the magazine *b-Guided* and responsible for some of the most interesting showrooms in Barcelona (with designers like Bless, Raf Simons and Maria Cornejo), Felipe Salgado in the 21 edition took part in a photography workshop in which the photographers Sergi Pons, Carles Roig and Daniel Riera participated. The objective: that students could experience a few hours how is the work in a real sitting of fashion photography.

DANIEL RIERA

>

Bachelor of Fine Arts and three years in EMAV, the municipal school of cinema in Barcelona, photographs of Daniel Riera can be seen in magazines here as *B-Guided, Hércules, Fanzine 137,* Architectural Digest and Vanidad, but in recent years he has focused primarily on the international market. Monocle, (England), Purple Journal, *Mixte and Double* (France), Teen Vogue and Elle USA (United States) are some of the publications that have always embraced his excellent work, along with Butt and *Fantastic Man* where he is a regular contributor. Away from the parameters of commercial photography and with a look between intimate and close, theirs are also some of the best catalogues that have been set up recently as the Fall-Winter 2008 Adidas or the Spring-Summer 2007 of Pull & Bear.

You participated with a few other photographers in the workshop that Felipe Salgado set up in the 21st edition, what was it about exactly? It consisted on having a direct experience on a photo session for people who were studying, and for that they selected several photographers with very different styles so that they could see the motivation and thoughts that there may be working behind a fashion work, and how through fashion we can tell stories or at least support them.

How was the experience? What do you like the most? I liked the involvement of everybody, we tried to photograph several teenagers fallowing the sport-fashion and new designers guidelines, each one of us looked for a certain look or idea to capture, could be from shaving for the first time to eat a bollicao, I tried to transmit a determined humor from the sitting and many photos finally were set up in an almost endless sequence of portraits, making a loop eighty images.

What do you think of the work in ModaFAD? I think it has always been a good platform for that transit that is to move on from ideas and work of school to seek a disclosure or professionalism of what one does, applied to a "market", hence the value of all these initiatives.

What are your plans for the immediate future? I sound like a broken record, but I still want to publish my work in a book format somehow still coming off. And as always transfer ideas to movement, on short format or video.

www.danielriera.com

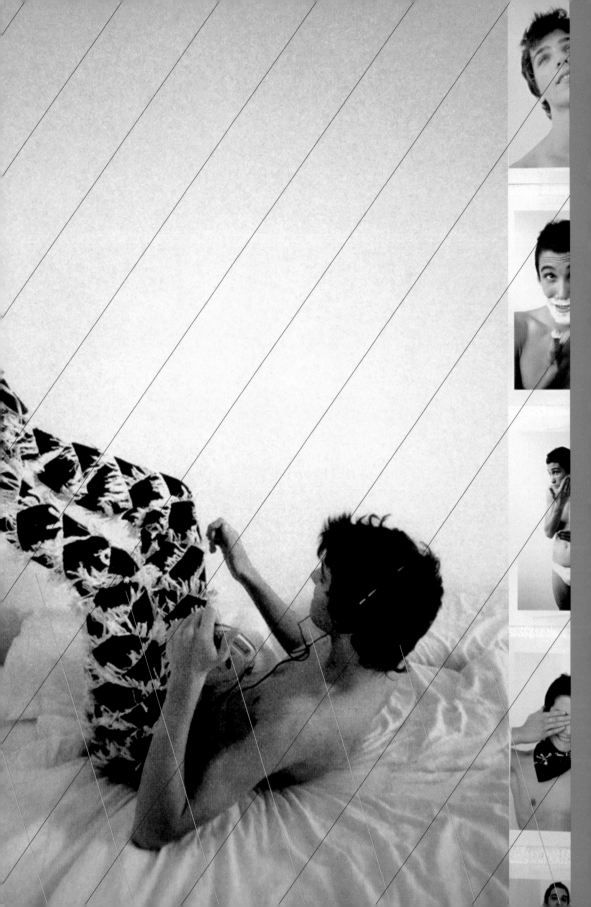

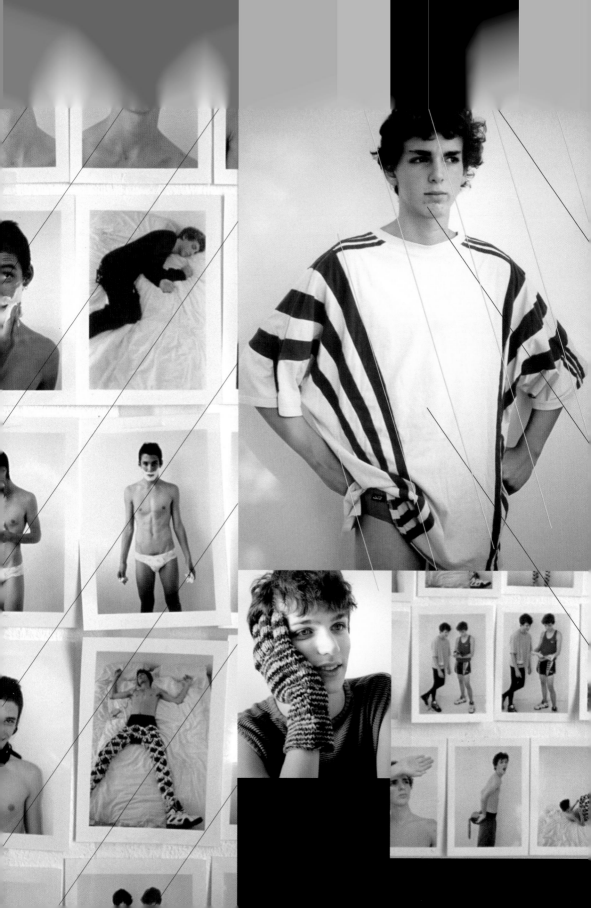

COMENTRIGO
>

Now they are two, Aura Chaves, 24 years
old, and Elena Maggi, 25, both former
students of IED, and call themselves
Comentrigo, but on there passages
through ModaFAD in February 2005 they
were three (Anna Prellezo turned down
the project) and were called
Trestristestigres. With that twister name
won the prize for Best Designer and have
been invited to present their work on
different platforms since, but they are
now focused on the most complicated
part: "Convert creativity into something
profitable, laying the groundwork of the
company, managing what in the beginning
was a brief essay collection in our way of
life, something that is very complicated".
But there's no lack of enthusiasm. Among
their future plans, "visiting all the fairs that
we can, sell the impossible, find a patron,
collaborate on interesting projects,
receive tempting offers and keep working
to get it!" That's the attitude.

www.comentrigo.com

winner! > (M)

PIA KAHILA
>

She arrived in Barcelona in 2001 for an
Erasmus in EATM and returned to Finland
in 2003 to work in the women
department of Burberry. And she
continues there. But this 35 years old
Finnish since 2004 also has her own
brand that sells in the shop of Barcelona
Comité (Notariat, 8). She participated
with her second collection, inspired on
children's clothing at the beginning of last
century, in the 21st edition of ModaFAD
where she won a special mention from
the jury. As she tells, her inspiration
usually comes from the past. In her own
words: "I love the old photos, flea market
objects and antique fairs. I pay a lot of
attention to details and try to take
maximum care of them to achieve special
pieces with personality and soul." Her
creations are sold along with Comité in
L'Armari de Sant Pere, Bingoshop and 40
de Mayo all of them in Barcelona. Since
summer Pia also designs a small
collection for girls.

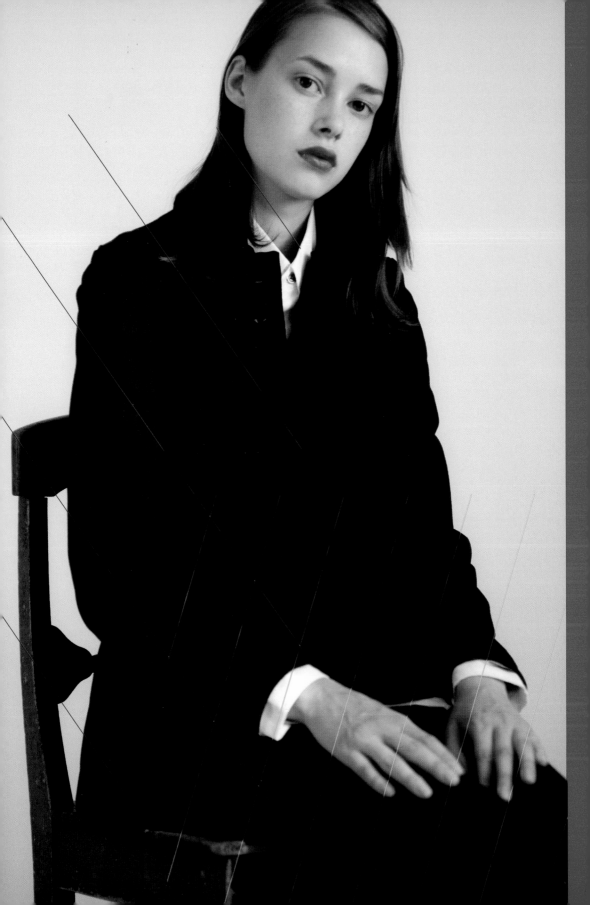

VICTOR CARDONA
AND ISRAEL FRUTOS
>

Right now they are in Antwerp and they make clear where their tastes go when they speak of two of the designers with whom they are currently working with or have worked (Bruno Pieters and Christian Wijnants). Victor Cardona (Mahon, 25 years old) and Israel Frutos (Barcelona, 24 years old) met studying Fashion Design at Felicidad Duce and since the third day of class they began to share friendship and ideas. "Victor Cardona Israel Frutos were born in 2005 in ModaFAD, they have done well to this day," they tell. On that edition the subject was Kit and what they did was design a kit in denim on three detachable garments so that from different variations new garments could be created. They say they design for women because "being men, we feel more comfortable by not finding many creative limitations as with man." And their method to work is always the same: "We focus on a very specific concept and plan, it can be an object, a form, a colour, and we develop the whole concept from this basic beginning."

www.victorcardonaisraelfrutos.com

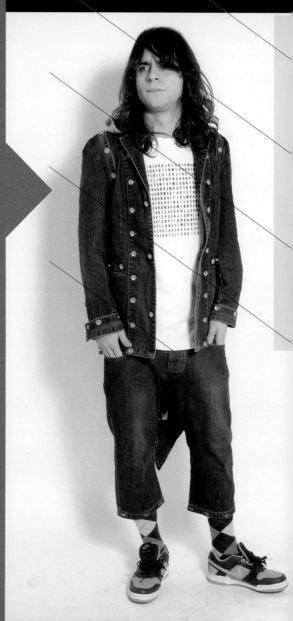

winner! M

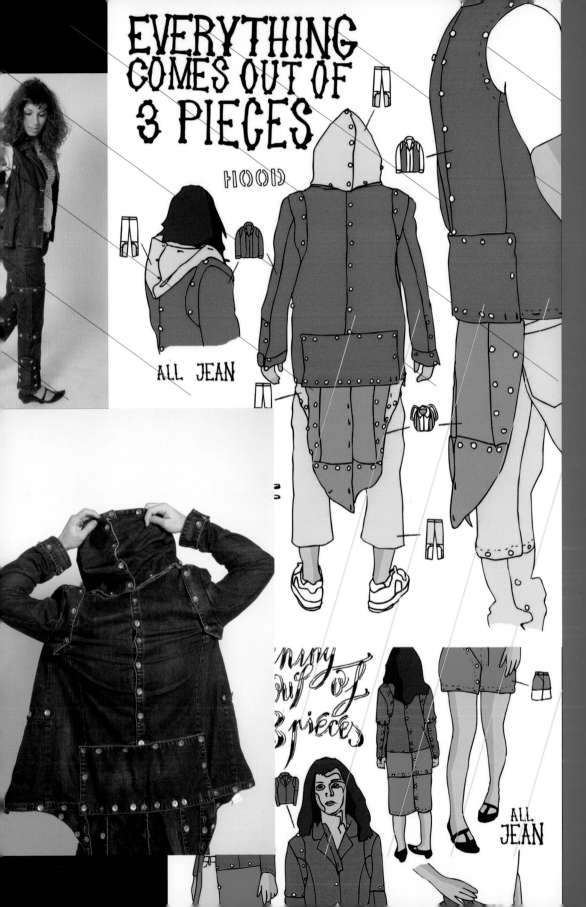

EVERYTHING COMES OUT OF 3 PIECES

HOOD

ALL JEAN

ALL JEAN

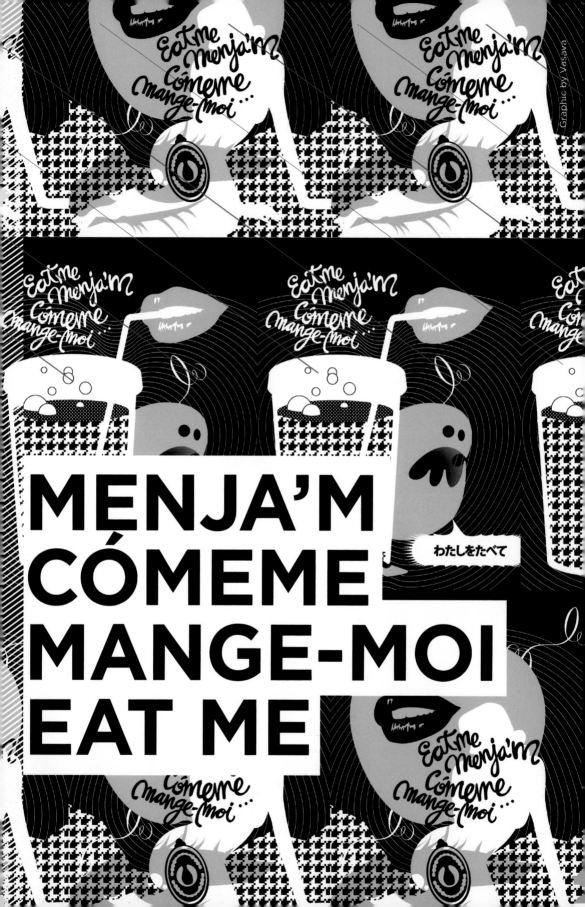

20. MENJA'M! CÓMEME! EAT ME! >

September 2004 in the Moritz factory.
Winners. Prize for Best Collection: Quim González, with his brand El Señorito;
Creativity Prize: Anonymus (Mary Sellaryt and Marcel Pujol).
PasaFAD Friday 10 in Convent dels Àngels.
MerkaFAD Saturday 11 in Convent dels Àngels.
Exhibition ModaFOOD, from 7 until 11 of September in Convent dels Àngels.
Au.Expo From 7 until 11 of September in the Maremagnum.
Graphic design: Vasava.
Photography: Xavi Padrós.
Installation: Niall O'Flynn.
Hairdresser: Marcel & team.
Make up: Tutusaus & team
Stylists: Txomin Plazaola, Jaume Vidiella, Asier Tapia, Malaspina.
Subvention: Generalitat de Catalunya, Barcelona Fashion Week.
Collaborators: Martini, Maremagnum, Casanova, Sumarroca, Fresh Ready, Vueling.com, La Sixtina, FAD.

Edition that celebrates the relationship between fashion and food, between everything that is cooked and the sewing workshops. Next to the MerkaFAD and parades was also presented the exhibition ModaFOOD, a sample in which creatives from different disciplines, Ferran Adrià, Marti Guixé, Bigas Luna, Antoni Miralda, Boris Hopek and Carles Congost, provided his personal view on this relationship. However this was not the only exhibition, the Maremagnum hosted the installation (including chocolate) made by Marc Xocoa with photographs by Marc Pastor, who portrayed a series of characters who showed off the gold accessories. Along with the winners of last year's edition also paraded in solitary Flora Ximenis.

6 A 11 SETEMBRE 2004
BCN FASHION WEEK

MODA
FOOD

MODAFOOD.Exposició
Dimarts 7 a dissabte 11 setembre'04
Ferran Adrià, Carles Congost, Miralda, Martí Guixé, Boris Hoppek i Bigas Luna.
Capella del Convent dels Àngels
Plaça dels Àngels, 1 – 08001 Barcelona

xu.Exposició
Dimarts 7 a dissabte 11 setembre'04
Marc Xocoa i Xavi Pastor.
Maremagnum Moll d'Espanya s/n 08001 Barcelona

PASAFAD.Desfilada
Divendres 10 setembre'04
21'30h Anne Cecile Espinach
22'00h El canto del Cuco >>> Pistolina
23'00h Flora Ximenis
24'00h Menja'm! Cómeme! Eat me!
Capella del Convent dels Àngels
Plaça dels Àngels, 1 – 08001 Barcelona

MERKAFAD.Merkat&Showrooms
Dissabte 11 setembre'04
11'00h a 23'00h
Capella del Convent dels Àngels
Plaça dels Àngels, 1 – 08001 Barcelona

maremagnum vueling'com

FRESH·READY MARTINI

www.modafad.org

Menja'm.
Cómeme.
Mange-moi.
Eat me.
わたしをたべて

Ferran Adrià
Carles Congost
Martí Guixé
Boris Hoppek
Bigas Luna
Miralda/M.Guillén
Fotografia_Sergi Pons

Exposició:
Comissariat_Chu Uroz
Instal·lació_Niall O'Flynn
Disseny Gràfic_Vasava

Col·laboren:

la sixtina casanova professional taft lights

SUMARROCA top studios oido

Generalitat de Catalunya
Departament de Comerç,
Turisme i Consum

elBulli Zig_Zag
Ferran Adrià
_Luki Huber

PUCK GASTRONOMIE
Martí Guixé
_Oriol Caba

CIGOG SACRIFICE
Boris Hoppek
_Jordi Bigas
_Íñigo Martínez

BITS I LLAVORS
Bigas Luna
_Jordi Bigas
_Arnold

PASSAREL·LA ESPECIAL
FoodCulturalMuseum
Barcelona
Miralda
Montse Guillén
_Cristina Guillén

PROTOCOL300
Carles Congost
_Santiago Garrido
_Albert Pascual

MODAFAD
_Jaume V.
_Oriol Caba
_Arturo Bastón
_Felix Pérez-Ita
_Teresa Manresa
_Laura Giménez
_Iñaki Ayabar
_Isabel Ximenis
_Oido
_Claudi Domingo
_Tatiana Donoso
_Juan A. López
_La Agencia

F7AD

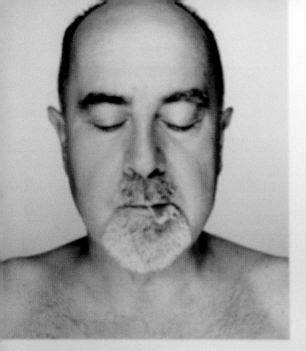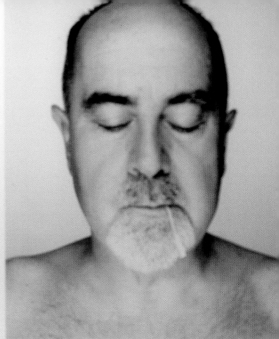

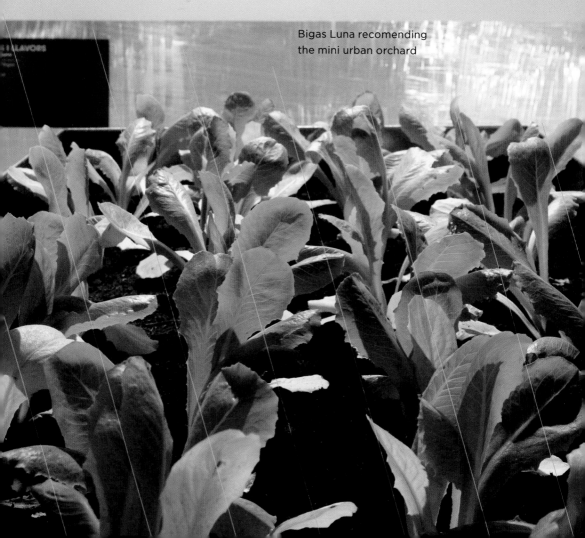

Bigas Luna recomending
the mini urban orchard

BIGAS LUNA
>

For a long time now the Catalan director has been talking about the virtues of Techno-Agricultural society, the one that bets on technological advances without forgetting the ecological agriculture. Bigas Luna, with films like "Jamón Jamón", Bilbao" or "Las Edades de Lulú", walks what he talks and between film and project looks after his own orchard. Now he is preparing the production of his next film, "Juani Hollywood," the second delivery of his last production "Yo soy la Juani".

In ModaFOOD you talked about Techno-Agricultural society, what do you mean exactly? I talk about the society that will be more interesting in the future, the one that combines new technology with ecological agriculture. People will have a computer but also its ecological orchard.

You have yours, naturally. Yes. There is a Chinese proverb that says something like this: If you want to be happy one day, kill a pig. If you want to be happy one week, make a good trip. If you want to be happy a few months, look for a good partner. And if you want to be happy for a lifetime, cultivate your orchard.

Even in the middle of Paseo de Gracia! Of course, somehow together we have to solve everything we have done wrong in the industrial era. The cars with internal combustion engine, for example, with all that pollutants and smoke. In a few years everybody will strongly disapprove of this backwardness.

What is the relationship between fashion and food? A lot. We are what we eat and fashion is a reflection of who we are. Depending on how we eat, how we are, we'll dress in one way or another. In my case, for example, I always say that the person who likes my films is because of the garlic and oil I eat. Well, and ham too.

Speaking of ham, do you prefer a good plate of ham or going to a parade of haute couture? Among a good plate of ham and a parade I will stay with the plate of ham, obviously. Fashion seems very interesting to me, but it's not the same thing. I need the food to live. Not fashion.

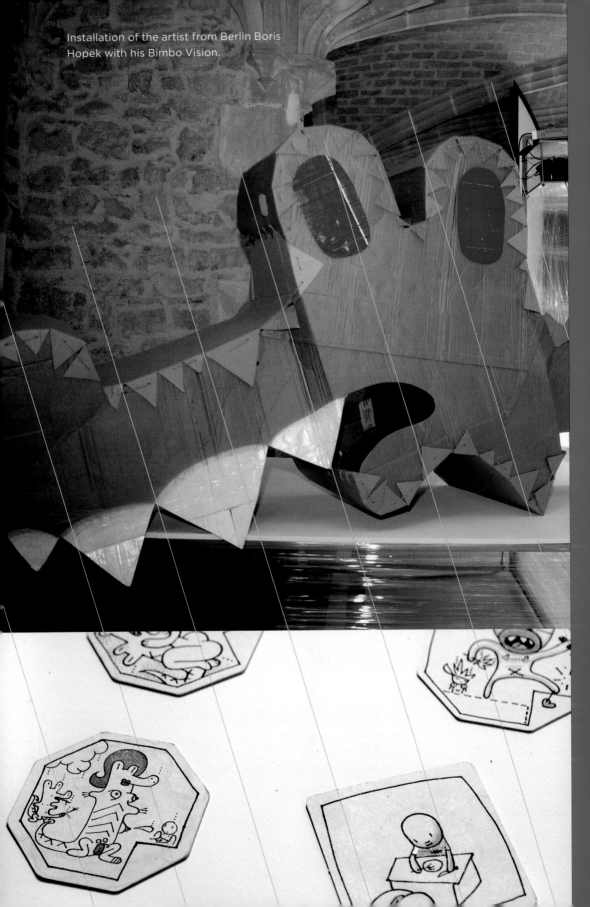

Installation of the artist from Berlin Boris Hopek with his Bimbo Vision.

< Ferran Adrià, Global gastronomical guru. Flexible plates for the menu special needs at El Bulli restaurant.
Designed by Luki Huber. Prototypes.

Ravioli crujiente de chirimoya al café y lima
MEN 3.6.1 Bandeja rejilla dos cavidades
Macarrón de arroz con queso y jamón
MEN 3.6.2 Bandeja rejilla zig-zag
Sobre chino de remolacha con pistacho amargo
MEN 3.6.3 Bandeja rejilla cuchara
Lazo de zanahoria con polvo de yogur
MEN 3.7.1 Bandeja vidrio una cavidad
Macarrón de porex y mantequilla de coco
MEN 3.7.2 Bandeja vidrio zig-zag
Kadaif con germen de rábano
MEN 3.7.3 Bandeja vidrio cuchara
Leche eléctrica "sechuan buttons"
MEN 3.8.1 Gracias por su visita
Falsa *espardenya* con sisho, sésamo y yozu
Luki Huber, diseño industrial
Ferran Adriá, el**Bulli**restaurante

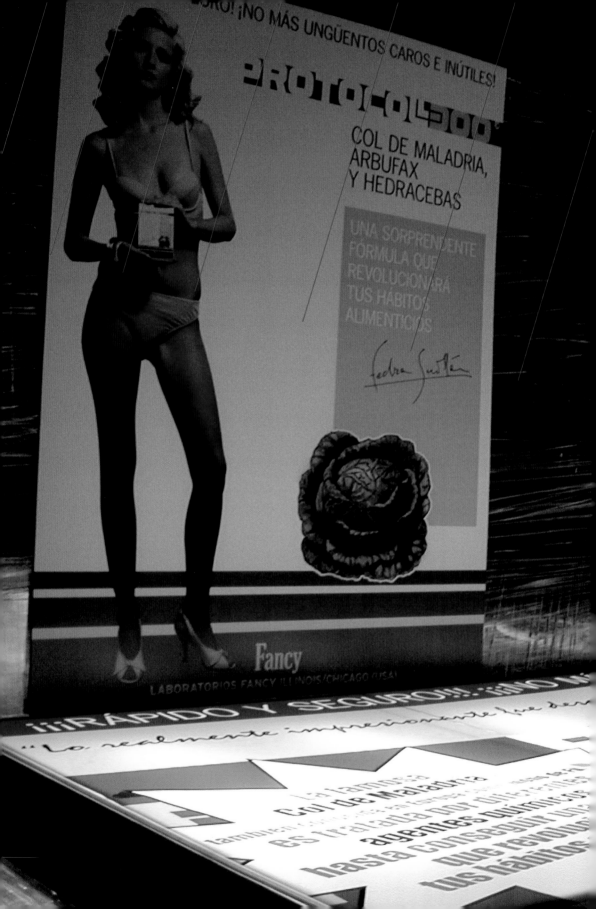

< Installation videoclip: PROTOCOL 300. Light product with magic effects of the artist Carles Congost.

What is the relationship between fashion and food? Not only designers who participated in the 20th edition had to work on this starting point, but also artists of different disciplines presented their proposals in the exhibition ModaFOOD. The exhibition hosted a total of six creatives. These were his proposals.

FERRAN ADRIÀ

The chef of El Bulli explained the process of creating a plate for the next season in twelve steps, with particular attention to his "continent", that is to say the plate. The result: a new container for the alchemical proposals of El Bulli.

MARTÍ GUIXÉ

The ex designer of Camper explained with two words his opinion on the current gastronomic culture.

BIGAS LUNA

Concerned already for some time by issues related to organic farming, the filmmaker explained his proposal for a techno-rural society, a project created with Vicente Guallart who is planting gardens in the city, even in the middle of Paseo de Gracia, the boulevard of fashion in Barcelona.

MIRALDA AND MONTSE GUILLÉN

The promoter and artistic director of the Food Culture Museum in Barcelona presented with Montse Guillén a party of anthropomorphic bottles, an iconographic chant to the culture of today and their ancestral rituals.

BORIS HOPPEK

This artist from Berlin known for his graffiti and his toys participated with what he calls "bimbosculptures" Some puppets made from recycled materials, derived in part from the world of food.

CARLES CONGOST

With a work between the teenager and the pop cultures, the artist presented this time, a video installation that broke with the traditional relationship between the figure of mannequins and the most succulent diet.

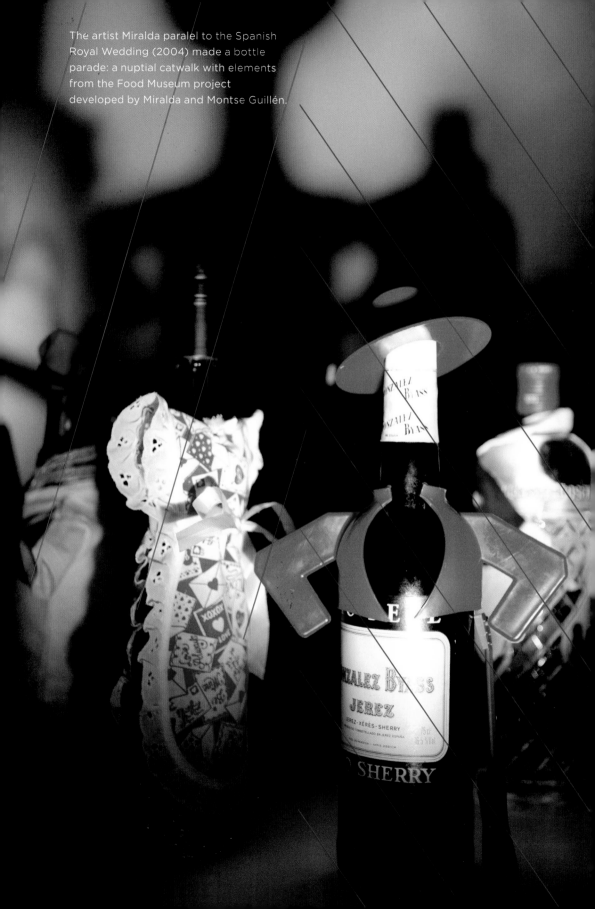

The artist Miralda paralel to the Spanish Royal Wedding (2004) made a bottle parade: a nuptial catwalk with elements from the Food Museum project developed by Miralda and Montse Guillén.

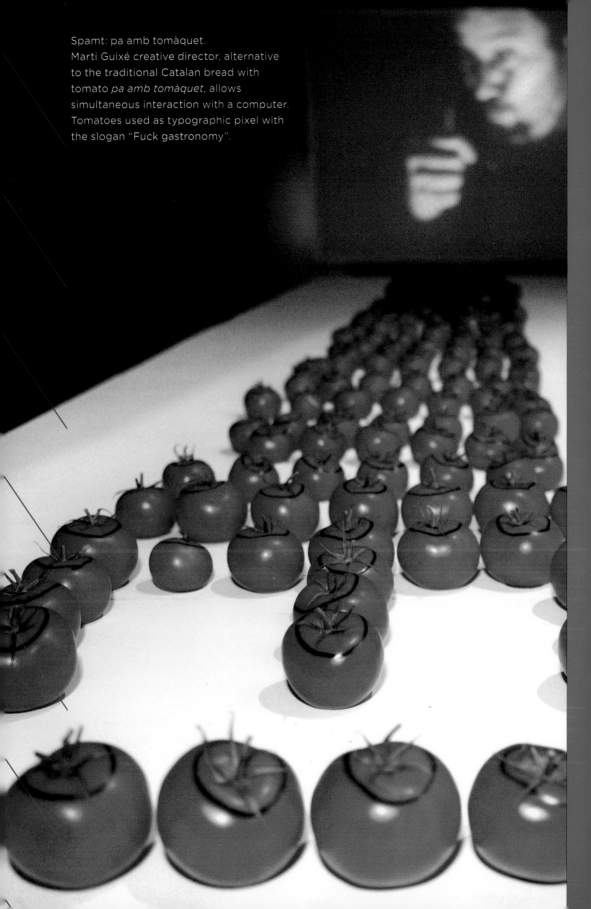

Spamt: pa amb tomàquet.
Marti Guixé creative director, alternative
to the traditional Catalan bread with
tomato *pa amb tomàquet*, allows
simultaneous interaction with a computer.
Tomatoes used as typographic pixel with
the slogan "Fuck gastronomy".

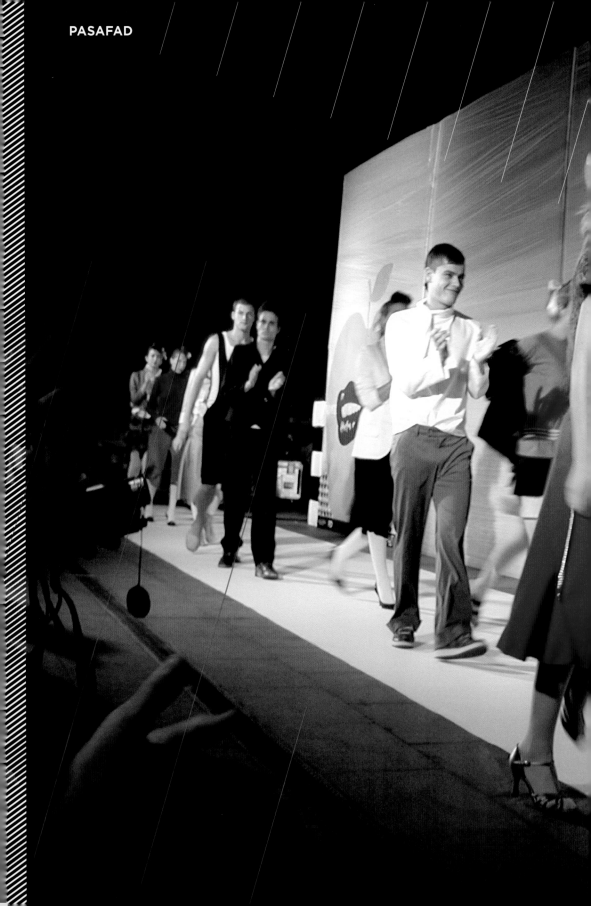

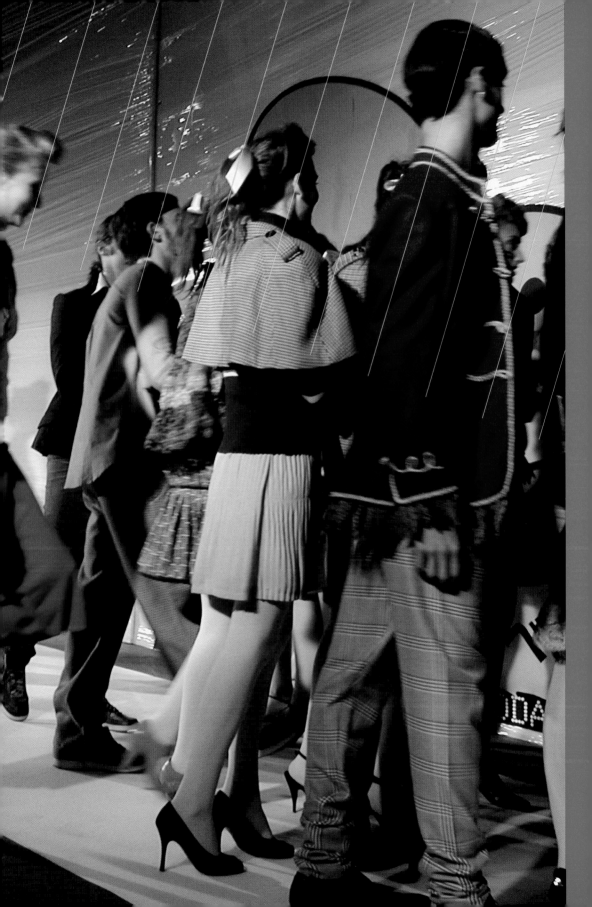

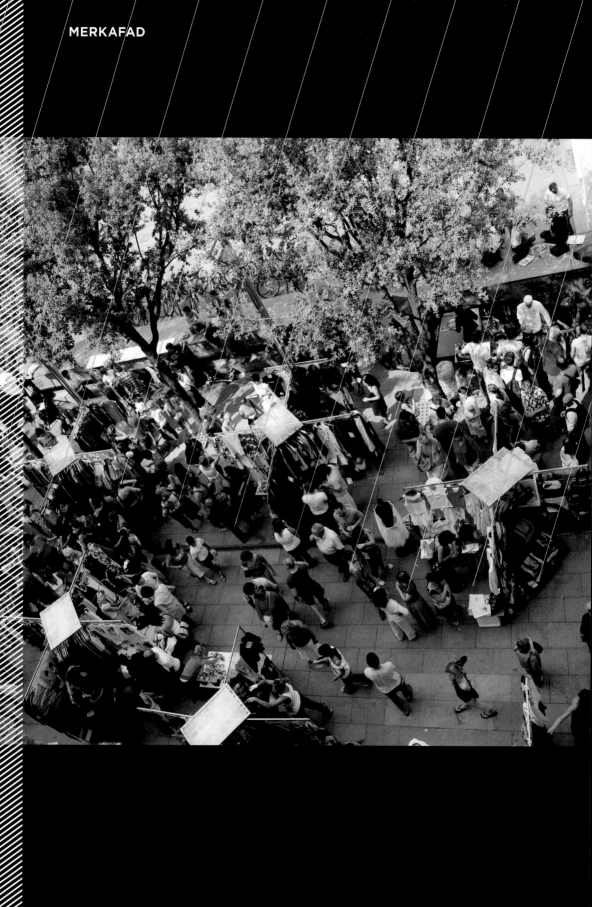

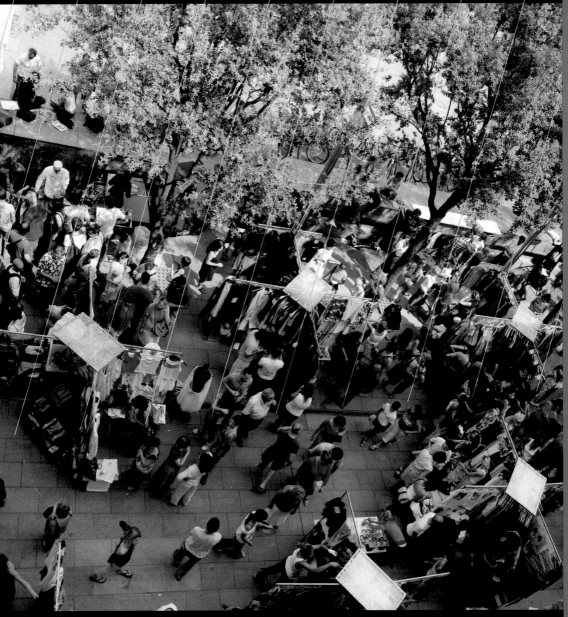

Our installations in Plaça dels Àngels,
between the MACBA and the global skate
meeting point.

Last moments of the FAD historical letters before being destroyed by urban vandalism.

MYSTIC ONION
>

Mystic Onion is the creative project that's result of the collaboration between graphic designer Eva Riu, 31 years old, and illustrator Alberto Gabari, 32 years. The firm was born 4 years ago with the aim of linking fashion to a form of artistic expression, which includes collections as well as participation in events, exhibitions, performances and festivals. Like so many other designers, they also began showing their collections in MerkaFAD. The first time was September 2004 when they presented the collection "Cómeme", in which they created a series of satin dresses with edible brooches. They define their work as "street fashion illustrative, fun and with concept" and have also participated in fairs such as Bread & Butter and catwalks as El Ego de Cibeles. They sell on 40 de Mayo (Diluvi 3, Barcelona) and in The Ugly Shop (Mercado Fuencarral, Madrid).

www.themysticonion.com

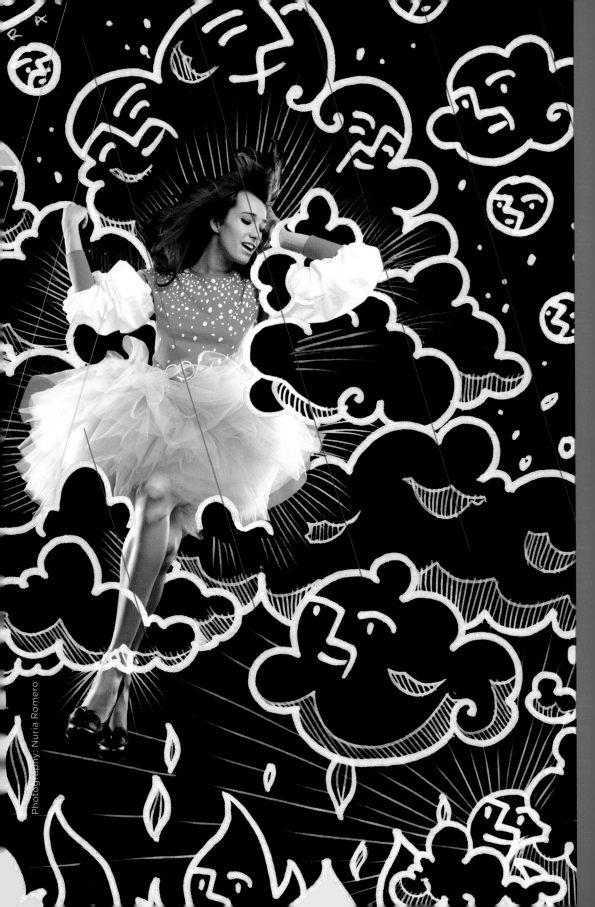

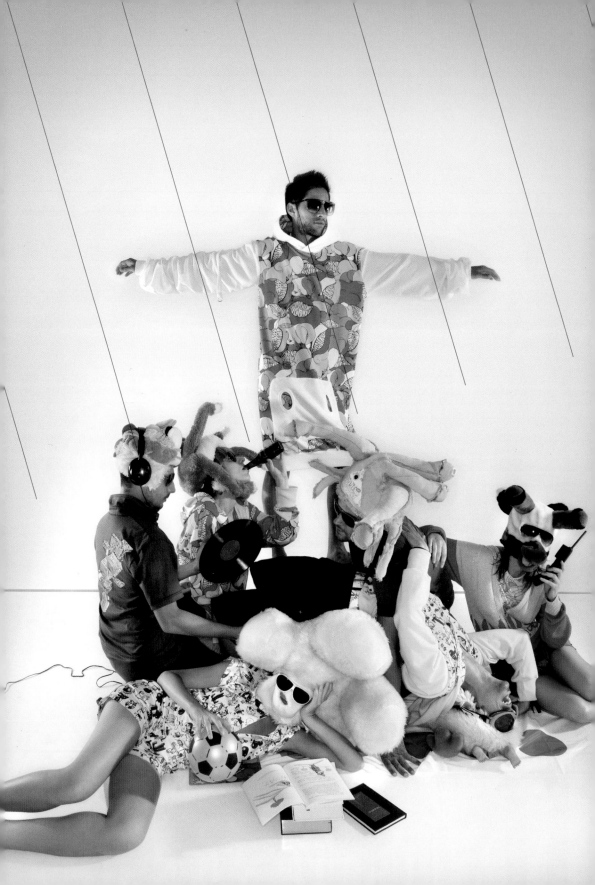

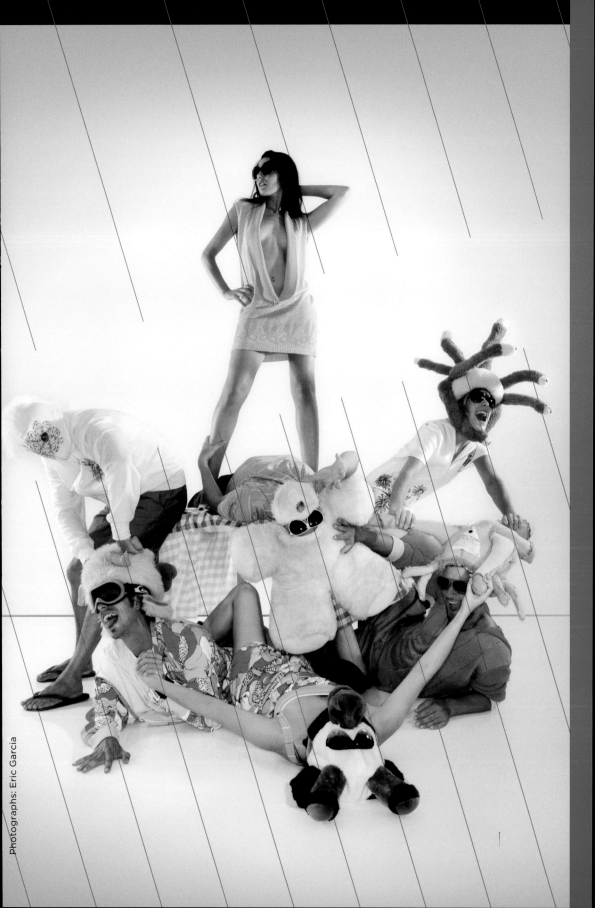

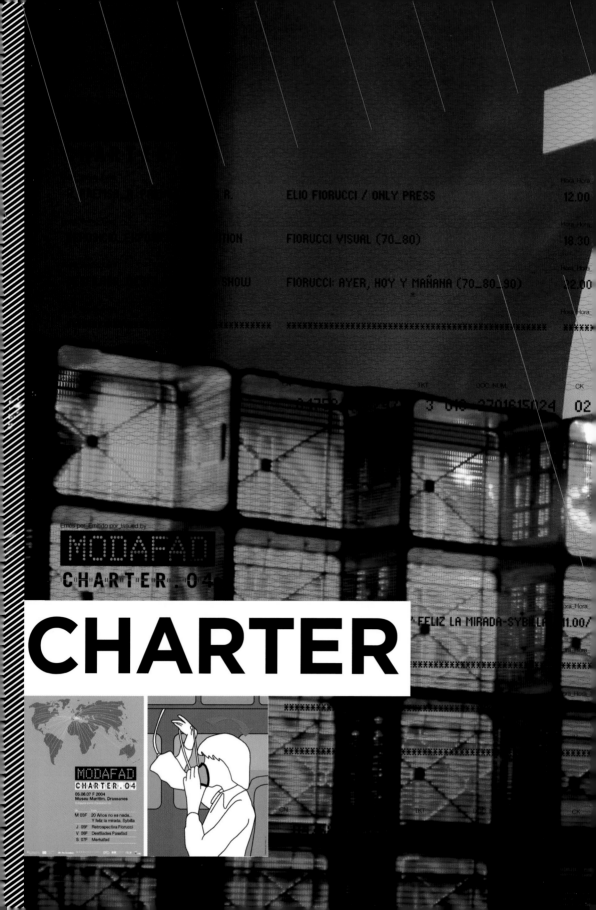

ELIO FIORUCCI / ONLY PRESS 12.00

FIORUCCI VISUAL (70_80) 18.30

FIORUCCI: AYER, HOY Y MAÑANA (70_80_90) 22.00

MODAFAD
CHARTER.04

CHARTER

MODAFAD
CHARTER.04
05.06.07 F 2004
Museu Marítim. Drassanes

M 03F 20 Años no es nada...
 Y feliz la mirada. Sybilla
J 05F Retrospectiva Fiorucci
V 05F Desfilades Pasafad
S 07F Merkafad

Fecha_Date

J 5FEB

racía_ Destino_Destination

TITUTO EUROPEO DI DESIGN

racia_ Destino_Destination

TITUTO EUROPEO DI DESIGN

racia_ Destino_Destination

ASSANES REIALS DE BARCELONA

Destino_Destination

*******X*****X************************

M 3

LA DE EXPOSICIONES

Destino_Destination

*******X*****

February 2004 in the Reials Drassanes.
Winners. Prize for Best Emerging
Designer: Anne Cècile Espinach; Second
Prize: El Canto del Cuco (Juan M. Granero
y Brinja Emilsdottir); Third Prize: Pistolina
(Jennifer Dzgun y Roman Vanini).
Graphic design: Leo Obstbaum.
Architects: Aubergine.
Hairdresser: Salva G.
Make up: Salva G.
Stylists: Txomin Plazaola, Jaume Vidiella,
Asier Tapia, Malaspina.
Magazines: AB, b-Guided, DEMOguide,
Eseté, Fake, LO, Neo2, Movin Barcelona,
Vanidad and Suite.
Subention: Generalitat de Barcelona,
Moda Barcelona.
Sponsors: Any del Disseny 2003, Istituto
Europeo di Design, Provincia di Milano,
Fresh and Ready.

The aesthetics of the summer and the
holidays were the subject of inspiration
for this Charter edition. As prominent
events: the exhibition "20 años no es
nada... y feliz la mirada," a retrospective
of Sybilla curated by Antonio Alvarado,
and the parade of Fiorucci where some of
his best vintage clothing could be seen.
The IED welcomed the exhibit "Fiorucci

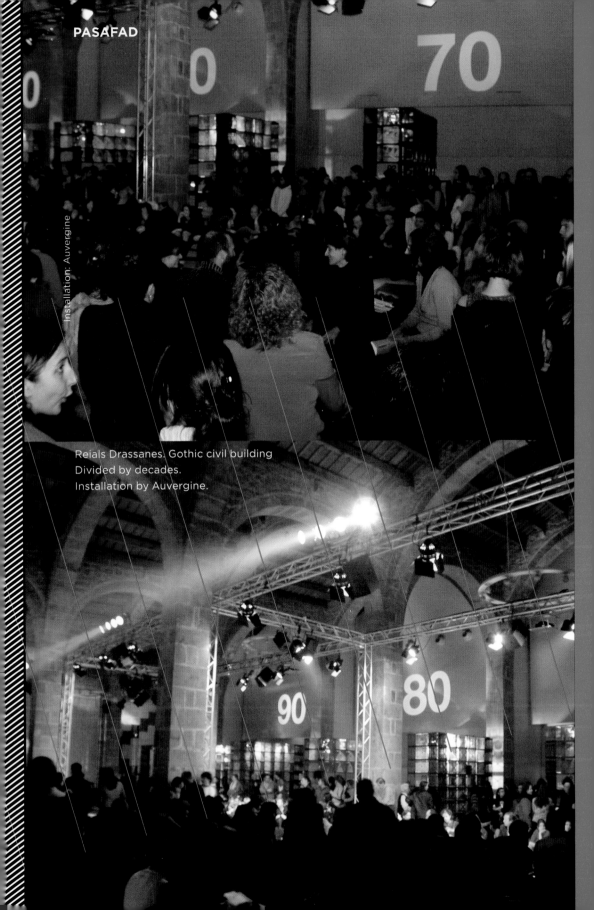

Installation: Auvergine

Reials Drassanes. Gothic civil building
Divided by decades.
Installation by Auvergine.

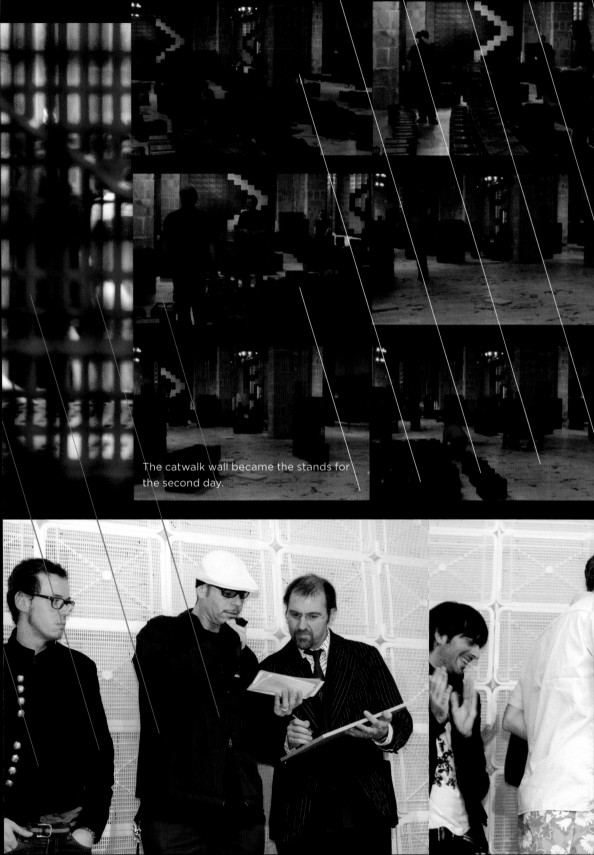

The catwalk wall became the stands for the second day.

Pixel. Minimum element for construction.

Awards presentation by Jordi Labanda, Spastor and Juli Capella, ex president of FAD and creator of the Any del Disseny.

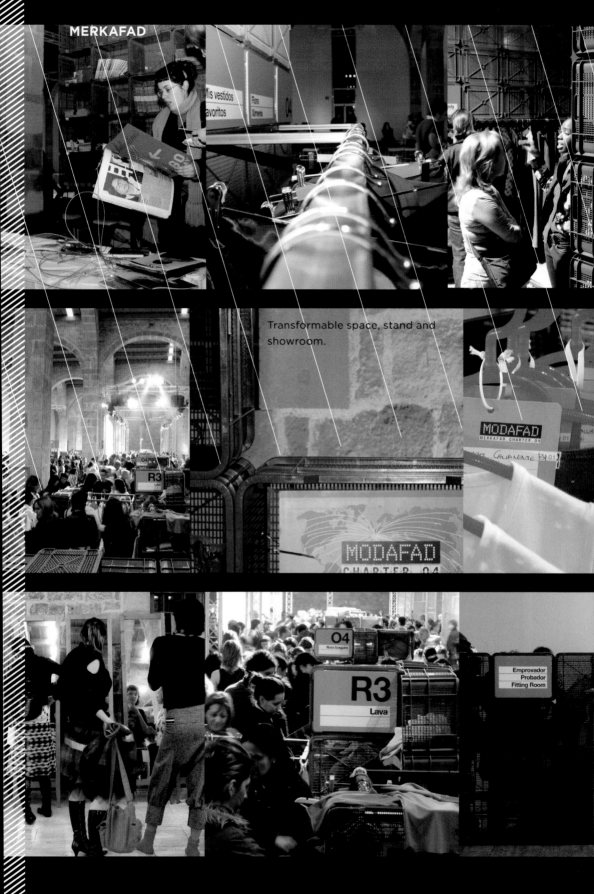

MERKAFAD

Transformable space, stand and showroom.

01

nne Cardenas
(La White)

Mis vestidos
favoritos

Flora
Ximenis

04

Verge i martir

Anne Cecile
Espinach

N1

La Reina sofrita

MODAFAD

MODAFAD CHARTER 04

01

LO AMANTE, LA ESPOSA Y LA OTRA

20€

03229

ZOE

03229

LA AMANTE, LA ESPOSA Y LA OTRA

20€

03229

Info

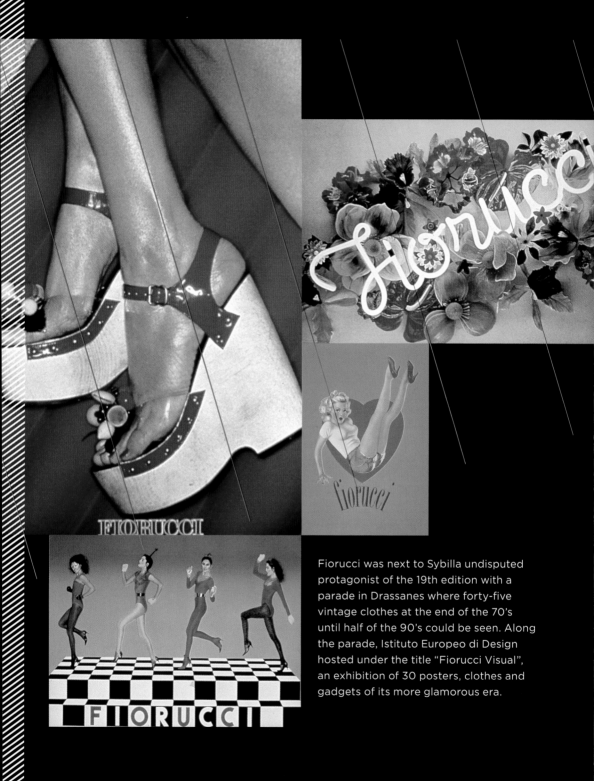

Fiorucci was next to Sybilla undisputed protagonist of the 19th edition with a parade in Drassanes where forty-five vintage clothes at the end of the 70's until half of the 90's could be seen. Along the parade, Istituto Europeo di Design hosted under the title "Fiorucci Visual", an exhibition of 30 posters, clothes and gadgets of its more glamorous era.

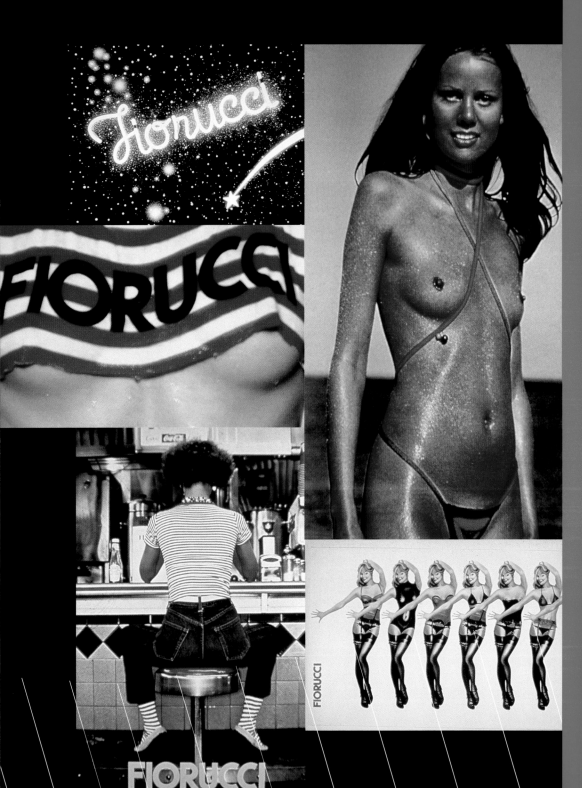

ANNE CÉCILE ESPINACH
>

Diploma in Fine Arts from the University of Toulouse, Anne Cécile won the prize ModaFAD for Best Collection in February 2004. This 33 years old French has participated in numerous artistic activities, in November 2002 she designed the costumes for the Ballet of Geneva and on that city she has presented and exposed several of her collections.

DAVINIA TEYS
>

After finishing her studies at ESDI, she made practices with Rodríguez Figueroa and Juan Pedro López, whom she continued to work with for three years. The Charter edition was her first ModaFAD and since then she has been reconciling the sale of her small collections for women and men, with the design of specially commissioned clothes and her work as stylist on television. Along with Marc Pou in 2007 she introduced her first collection of toys and from that collaboration was born Guatafak, which also has its own line of clothing and accessories for boy and girl. Davinia confesses herself as a 50's passionate, with an special attraction for Texas lifestyle and Futurism. "I think all this is merged into the design of garments sometimes eccentric but mostly very wearable" she explains. And continues: "Someday I would like to be able to fully dedicate on my collections, whether for clothing or dolls, without having to reconcile with other work. But beginnings are difficult and you're not aware until you are fully in. Clothing represents an enormous amount of work and investment that in the beginning is especially difficult to bear."

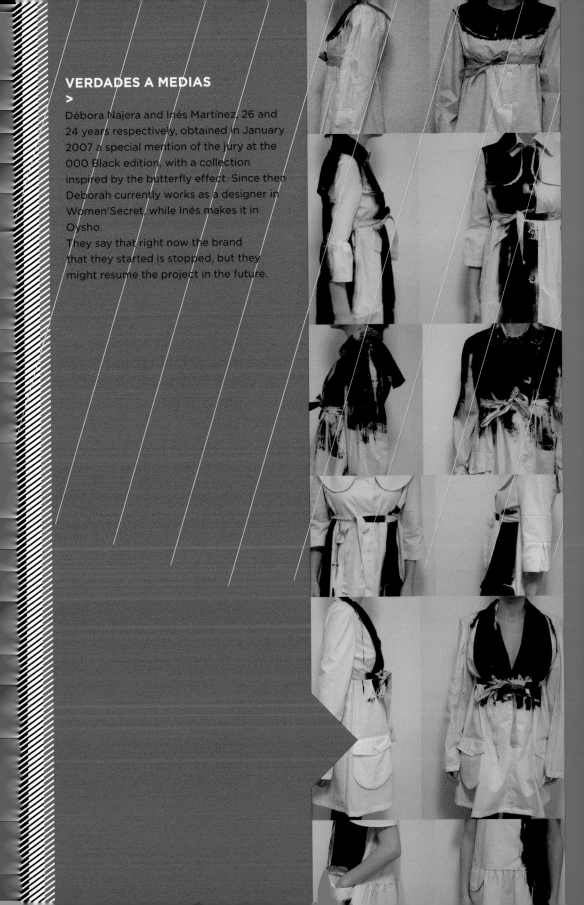

VERDADES A MEDIAS
>

Débora Najera and Inés Martínez, 26 and 24 years respectively, obtained in January 2007 a special mention of the jury at the 000 Black edition, with a collection inspired by the butterfly effect. Since then Deborah currently works as a designer in Women'Secret, while Inés makes it in Oysho.
They say that right now the brand that they started is stopped, but they might resume the project in the future.

> Antonio Alvarado, former
ModaFAD president,

"Rather than expose 'my work' I would like to tell a story: Twenty years inventing a profession on the fly, looking for a language, changing the pace, always improvising... Playing to start a business. Twenty years of adventures, frights, some heartaches and a lot of joy".

SYBILLA

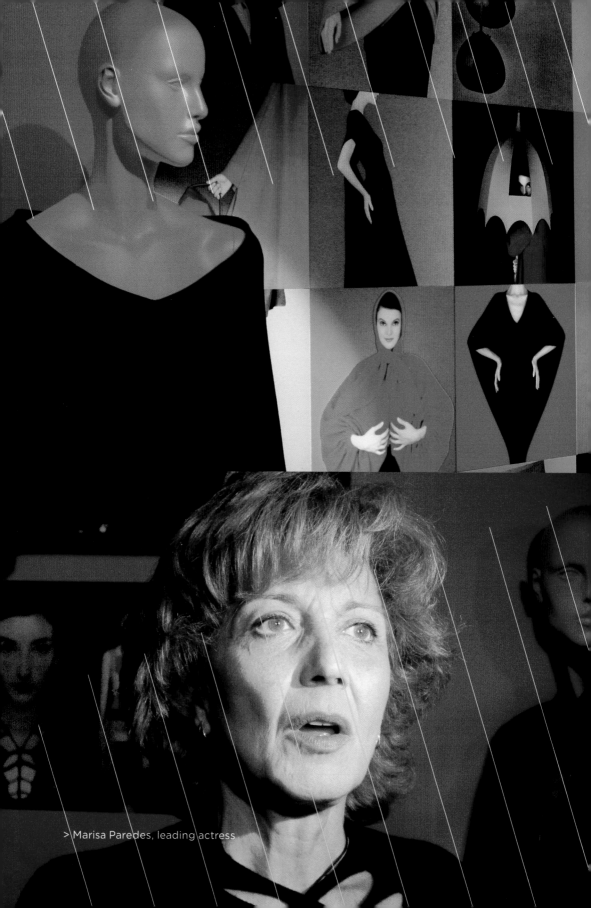

> Marisa Paredes, leading actress

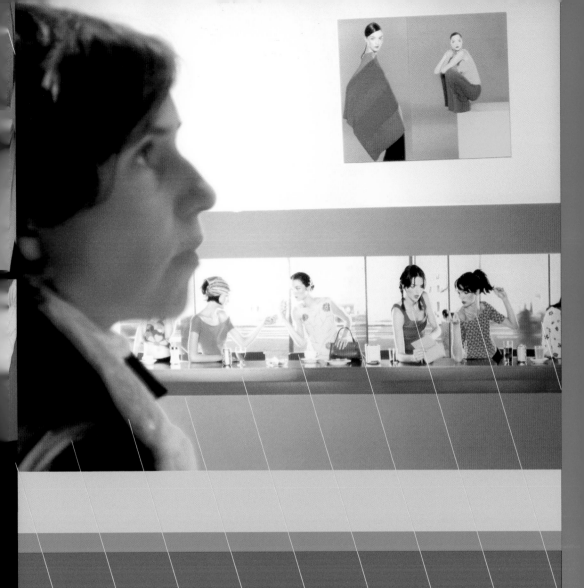

With a bolero lyrics, the 19th edition of ModaFAD hosted "20 Años no es nada... y feliz la mirada," an exhibition that reviews the 20-year career of Sybilla, one of the most personal and suggestive creators of recent times. "Faithful to herself," then said the press release, "Sybilla has been able to develop with her time but without giving in to the strict laws of marketing, looking for the beauty of the everyday gestures."

Commissioned by Antonio Alvarado the exhibition had as the main piece a large closet, perfect metaphor to receive those 20 years of sensations and ideas.

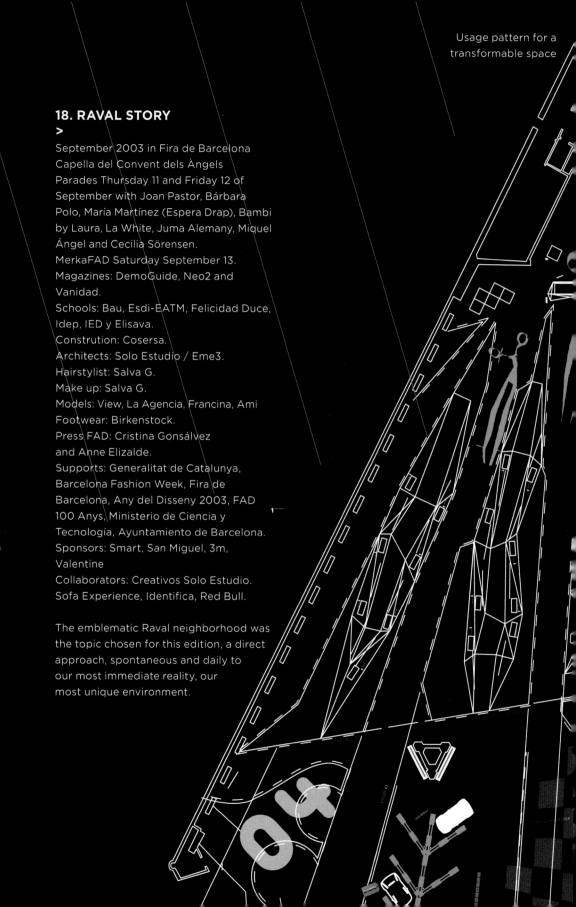

18. RAVAL STORY
>

September 2003 in Fira de Barcelona
Capella del Convent dels Àngels
Parades Thursday 11 and Friday 12 of
September with Joan Pastor, Bárbara
Polo, María Martínez (Espera Drap), Bambi
by Laura, La White, Juma Alemany, Miquel
Ángel and Cecilia Sörensen.
MerkaFAD Saturday September 13.
Magazines: DemoGuide, Neo2 and
Vanidad.
Schools: Bau, Esdi-EATM, Felicidad Duce,
Idep, IED y Elisava.
Constrution: Cosersa.
Architects: Solo Estudio / Eme3.
Hairstylist: Salva G.
Make up: Salva G.
Models: View, La Agencia, Francina, Ami
Footwear: Birkenstock.
Press FAD: Cristina Gonsálvez
and Anne Elizalde.
Supports: Generalitat de Catalunya,
Barcelona Fashion Week, Fira de
Barcelona, Any del Disseny 2003, FAD
100 Anys, Ministerio de Ciencia y
Tecnología, Ayuntamiento de Barcelona.
Sponsors: Smart, San Miguel, 3m,
Valentine
Collaborators: Creativos Solo Estudio.
Sofa Experience, Identifica, Red Bull.

The emblematic Raval neighborhood was
the topic chosen for this edition, a direct
approach, spontaneous and daily to
our most immediate reality, our
most unique environment.

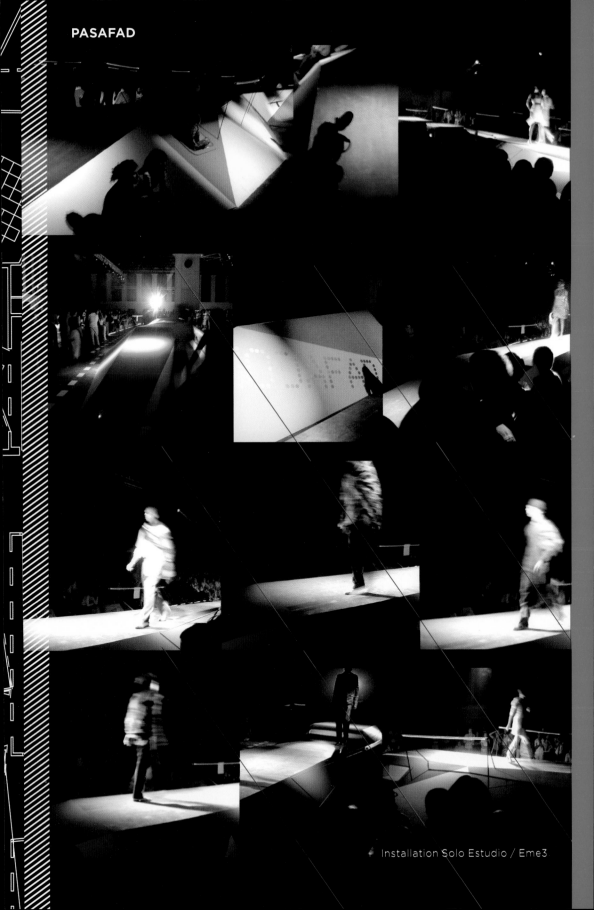

Installation Solo Estudio / Eme3

GEMMA DEGARA

>

After studying design of clothing at Llotja school in Barcelona, Gemma presents her work in the 18th edition of ModaFAD and gets the prize for Best Emerging Designer. After a time working with different companies, she decided to give absolute priority to her own firm without neglecting collaborations. She has paraded twice in El Ego de Cibeles and has participated in all editions of Changing Room. Her clothes are primarily practical, comfortable and versatile, but as she says, "there is always a small part in the collections with more special garments." Sells in Zsu Zsa, Doshaburi and Plisados (Barcelona), Isolée and Uglyshop (Madrid), Könk (Berlin) and Reward (Philadelphia).

www.gemmadegara.com

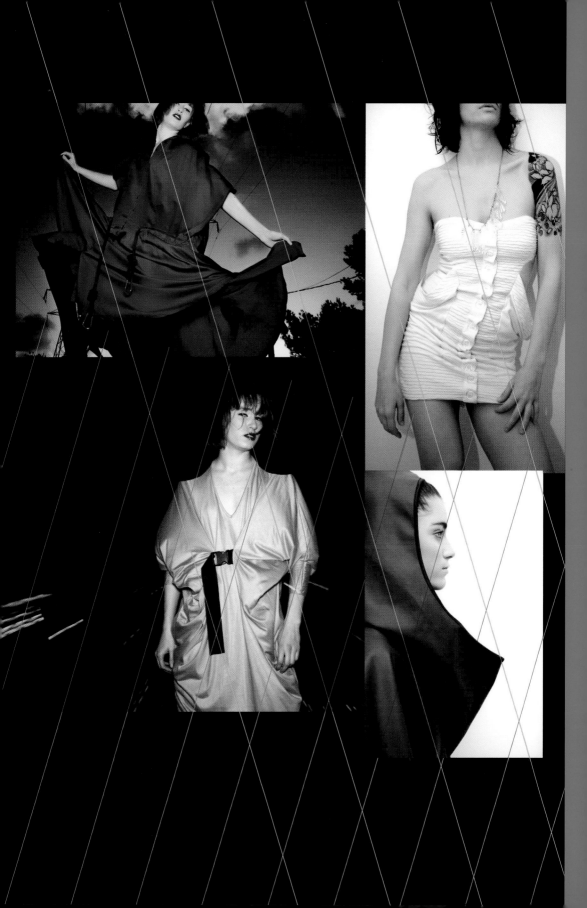

FLORA

>

First from the collective Cuatroseis and later from Tales and Tails (Provença, 290, Barcelona), Flora Ximenis has deployed her talents as a designer attached to fairy tale shapes and colours, clothing for urban princesses who like the yesterday's silhouettes (years 50 and 60 especially). Also custom design, even wedding dresses. And between design and layout she also gives classes of Trends in Fashion and Image in IED.

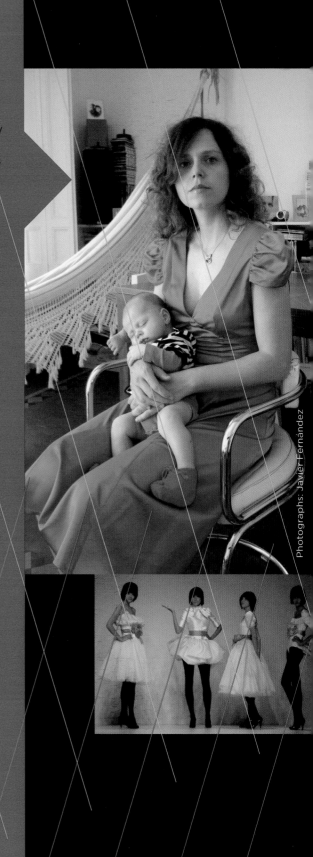

Photographs: Javier Fernández

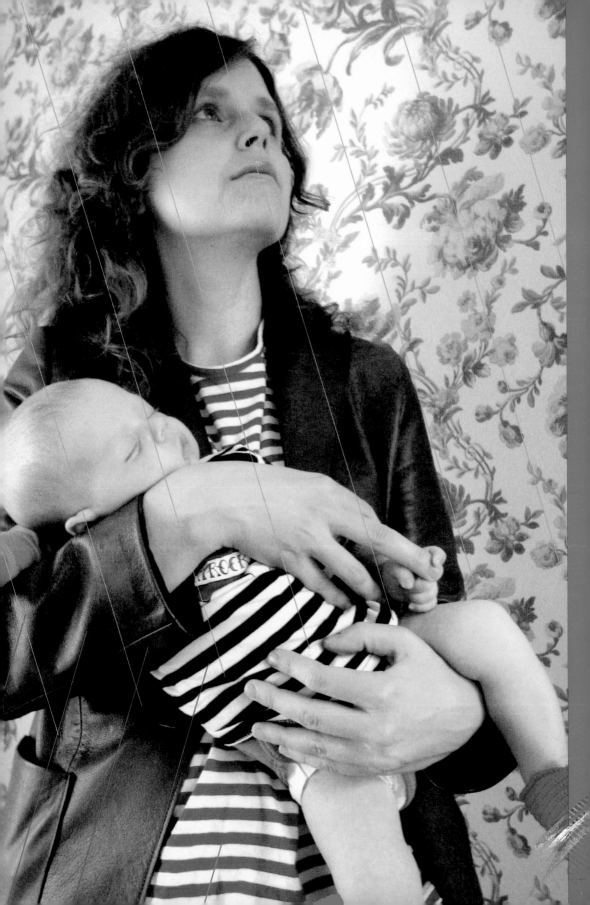

ARRELS
ROOTS
RAÍCES

Sheep?
At the 1995 annual party a herd
of sheep took over the old FAD
building. A provocative wink at
the origins of fashion.

A lot of heart is what best defines the 15-year of ModaFAD's path because supporting, nonprofit, the uncertain future of unknown emerging artists is a utopian madness that gives as many satisfactions as lashes in the soul.

On December 13, 1994, Saint Lucia, patron saint of the designers, was the opening of the first ModaFAD. A few months before had been formed the *Cercle per al Desenvolupament de la Moda i la Imatge* ModaFAD, by the initiative of Josep Maria Ballus, with the intention to promote fashion in this country. Arduous task if one takes into account the non gregarious nature of the people who specialize in this profession. After many meetings till late, in which the ideas were constant, and emerged the proposal that the best way to work for our fashion was supporting the "emerging" and decided to organize an event where the ideas of students from fashion schools and autodidacts with the sufficient quality were showed and sold. The first and mythical edition of Merka was a insurmountable success. The "emerging" became involved in the project with passion and self-confidence. The sales sum was miraculous and the participants, including Josep Abril, Isaac Reina, Giménez y Zuazo, Gabriel Torres, Susanne Hergenhahn y Celia Vela learned on the Brusi 45 street the meaning of the fashion business and it is clear that what set into practice successfully. On May 8, 1996, we through ourselves and organize the first PasaFAD in the Maremagnum parking. The idea, which has become a classic, was that the garments that will be shown the next day in Merka, were showed mixed on a parade, regardless of who did what, that is to say just the way the buyers will use it. Spastor, Miriam Ocáriz, Ailanto

and more ended up understanding and eventually enjoying the idea that in the beginning was against their ego. A year later presented the first "ModaFAD Awards." They were two: "El Sopar Merescut", as its name suggests rewarding the contribution in the fashion world and also image: Josep Font, María Vela Zanetti, Jordi Labanda, Egidio Ghezi, and "El Acerico Merescut", which honored those who, with discretion and giving all their dedication, deserved it: Maria Casanovas, Silvia Aldomá, Marcel Montlleó. The MerkaFAD has been happening between blood, sweat, tears and economic urgency, thanks to the efforts and passion of the members of this NGO with legs. With no medals, no pat on the back but with all their heart, ModaFAD has put into the gateways, industry and into the present, the best of the Spanish fashion. And this is something that should not be forgotten.

Pilar Pasamontes
ModaFAD Vicepresident

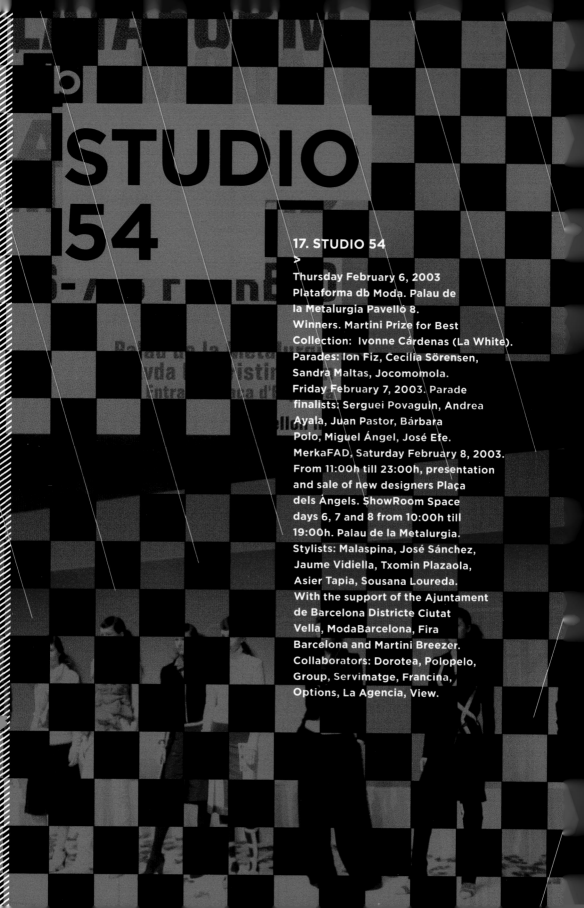

STUDIO 54

17. STUDIO 54
>
Thursday February 6, 2003.
Plataforma db Moda. Palau de
la Metalurgia Pavelló 8.
Winners. Martini Prize for Best
Collection: Ivonne Cárdenas (La White).
Parades: Ion Fiz, Cecilia Sörensen,
Sandra Maltas, Jocomomola.
Friday February 7, 2003. Parade
finalists: Serguei Povaguin, Andrea
Ayala, Juan Pastor, Bárbara
Polo, Miguel Ángel, José Efe.
MerkaFAD, Saturday February 8, 2003.
From 11:00h till 23:00h, presentation
and sale of new designers Plaça
dels Àngels. ShowRoom Space
days 6, 7 and 8 from 10:00h till
19:00h. Palau de la Metalurgia.
Stylists: Malaspina, José Sánchez,
Jaume Vidiella, Txomin Plazaola,
Asier Tapia, Sousana Loureda.
With the support of the Ajuntament
de Barcelona Districte Ciutat
Vella, ModaBarcelona, Fira
Barcelona and Martini Breezer.
Collaborators: Dorotea, Polopelo,
Group, Servimatge, Francina,
Options, La Agencia, View.

PAULA FEFERBAUM

>

This 38-year-old Brazilian, settled down in Barcelona since quite some time ago, became popular for her brand of clothing Paulinha Rio, of which she presented one of her first collections in the second edition of MerkaFAD. After the success on Circuit (which continues in Lisbon) Paula runs Clarity, a consulting agency and brandig in which among others works with clients such as Maremagnum, El Corte Inglés, Nike, Kswiss or TCN. She doesn't reject returning Circuit to Barcelona if the conditions are the right ones, neither designing again, but one thing is clear: "I remain entrepreneurial," she says, "but I do not see any possibility that I take the economic risk as I did in its day with Paulinha Rio or Circuit."

www.clarity.es

EN CIRCUIT CON ALASKA

Alaska, Spanish Pop Icon.

JE T'AIME MON AMOUR

16. JE T'AIME MON AMOUR
>
Parade Friday September 6, 2002
at 22:00h. Jardins de Rubio i Lluch
(Bibliotca de San Pau). Prize for Best
Emerging Designer: Ion Fiz / Cecilia
Sörensen. Prize for Best Emerging
Stylist: Txomin Plazaola. MerkaFAD,
presentation and sale of the emperging
designer's collections. Saturday
September 7, 2002. From 10:00h
till 22:00h. Jardins de Rubio i Lluch
(Biblioteca de Sant Pau). With the
support of Pure White. Collaborators:
Moda Barcelona, Polopelo, Servimatge,
Group, La Agencia, Options by
Francina, View, Traffic. Graphic Design:
Óscar Guitiérrez. Stylists: Malaspina,
Jaume Vidiella, José Sánchez,
Flora Ximenis, Txomin Plazaola.

I LOVE SPAIN

Miguel Adrover

MERKA MODA FAD PRIMAVERA-VERANO 2002-06-08

Porque resulta complicado hablar de lo que se tiene tan cerca , la proximidad nos hace perder la objetividad, aunque en moda nada es objetivo, pues para eso es moda... de hecho, es tendencia lo que hoy nos gusta y lo que hoy nos aparta, nos vuelca mañana para nuestros armarios... Así es todo de relativo, de fluctuante y de variable... nuestra España, Botín de España, como tema para desarrollar nuestras colecciones, va a ser puesta así, bailarina entre épocas y estilos, entre verdades y mentiras, entre genios y charlatanes, entre reyes de la caspa y musas de la modernidad, entre lo más exquisito y lo más popular... un poco de todo y para todos los gustos... cerremos lo ojos, y como si estuviéramos en el diván del psicólogo, y una vez bien abierto lo que nos ha apuntado, diremos otra las repuestas impulsivas que decimos sin orden ni concierto, cuando nos preguntan que te sugiere la palabra ..."SPAIN"... hace falta mucho para apuntarse a seguir, basta con decir... nosotros así lo hemos hecho y estas han sido nuestras respuestas...

TERMENERA
MANUEL
HORCHATA
DALI
SARA MONTIEL
MECANO
BENIDORM
LA DUQUESA DE ALBA
MORTADELO Y FILEMON
GAUDI
BERLANGA
CHICO Y CHICA
PAELLA
FANGORIA
BALENCIAGA
ALMODOVAR
ALIOLI
ALBERTO GARCIA-ALIX
SAURA
MAZAPANES DE TOLEDO
LEONOR A BOSE
IBIZA
ASTRUD
LOS CHUNGUITOS
LA FURA DELS BAUS
...
LA GIRALDA
...
EL TINTO DE VERANO...

Y vosotros podéis continuar la lista... ya sabéis cuál es la única condición precisa para formar parte de ella.

15. I LOVE SPAIN
>

Parade PasaFAD / Pure White, Prize Pure White for Best Collection: Serguei Povaguin. Friday June 14, 2002. Musical selection and special performance of Shiva Sound, in La Paloma. MerkaFAD, presentation and sale of emerging designer's collections. Saturday June 15, 2002 from 11:00h till 23:00h. Plaça de les Caramelles. With the support of Pure White. Collaborators: Polopelo, Group, Servimatge, Traffic, Options by Francina, View, La Agencia, Group, La Paloma, Agualaboca. Graphic Image: Cans / Dominich

I LOVE
SPAIN

HISTORICAL EDITIONS

14. CHINA FOREVER
>
Parade Friday December 14, 2001 22:00h.
DJ Chop Suey, La Paloma. MerkaFAD.
Saturday December 15, 2001. 11:00h till
23:00h .Presentation and sale of new
collections of designers, accessories
and jewelry, in Cibeles. With the
support of: Doritos, PureWhite Henessy.
Collaborate: Acupunture, Ami, Colors,
Francina, Group, La Agencia, Options
by Francina, Polopelo, Servimatge,
La Paloma, Sala Cibeles. Graphic Image:
Cans / Dominich. Stylists: Malaspina,
José Sánchez, Jaume Vidiella, Flora
Ximenis. Text: Jaume Vidiella.

13. NEW ROMANTICS
>
Collective Parade Circuit, Friday
June 15, 2001 at 21:30h. MerkaFAD
Saturday June 16, 2001 from 11:00h till
23:00h. Patio de los Naranjos. Casa de
la Misericordia. Presentation, sale of
collections of new designers, jewelry
illustrations and photography. DJ Yann
Mercader. Guests Antwerp Mode 2001,
Landed-Geland. Organizers Flanders
Fashion Institue (FFI) and Antwerpen
Open in cooperation with the Tourism
Office of Flanders and Tourism of
Antwerp. Collaborators: Acupunture ,
Swarovski, Options by Francina, Polopelo,
Valldonzella. Ilustrators: Bernat Lliteras.
Selected MerkaFAD: 13 Prenda, Cecilia
Sörensen/Pequeños Heroes, Juanjo Fiz,
Blonda y Olé, Sandra Maltas, El Ángel
Caído, Victor Simon, Lovers Toodleo,
Les Mains, Complementos Katia Jessek,
Sayonara Baby + iD, Claudia Danca.

12. PUNK DE LUXE
>

Parade Thusday December 14, 2000 at 22:00h. MerkaFAD, Friday December 15, 2000 from 12.00h till 24.00h. Presentation of the collection and sale of new fashion designers, accessories and jewelry. Food, and beverage by Pilé 43. DJ David Gil. Bar Pilé 43. Exhibition in Convent dels Àngels. Stylists: Miguel Malaspina, Jaume Vidiella, José Sánchez, Flora Ximenis. Magazines: AB, b-Guided, Elle, Go BCN, Línea 11, Neo-2, OFR, Scope, Woman. Collaborators: Group, Options by Francina, La Agencia, Servimatge, Aka Perruquers, Pilé 43. Graphic Design: Cans / Dominich. Ilustrators: Arbe.

11. MERKAFAD
>

Saturday June 10, 2000 from 14.00h till 2.00h sales of new collections: accessories, jewelry facilities, including unique series. Food, beverage, appetizers and performances by DJs. Bar-restaurant service by Pilé 43. Collaborate: Pure White, Pilé 43, Graphic design Mierda y Cia (Juanjo Sáez-Rafa Mateo), guest DJ Bass, La Escuadrón Sonora: Andreas I, Llowreider, Preacherman-gómez, Fran and Luis, Ventura, Xavi. Magazines: Neo-2, Punto-H, AB, Go Bcn, Linea 11, Nois, Woman, FAD Press: Laura Bayo.

10. MERKAFAD
>

Saturday December 18, 1999 from 16.00h till 2.00h Convent dels Àngels. Sell of new designers collections. To mark the turn of the millennium the pieces went on sale in 3999 and 1999 pesetas. Along with every purchase the public received a peseta of exchange commemorating the currency exchange that took effect on January 1, 2000. Thanks to Gran Teatre del Liceu. Texmundo S.L Illustrators: Domingo Ayala.

09. BIGSHOP
>

Friday December 18, 1998. From 12.00h till 24.00h.Convent dels Àngels. Sixty new designers. Red colour 1999/2000 Photography by David Dunan.

08. BIGSHOP
>

Friday May 15, 1998 from 12.00h till 24.00h. Convent dels Àngels. Fifty exhibitors of fashion, furniture, recycling, facilities. Tuesday May 12, 1998 at 19:00h audiovisual conference "El llenguatge de les mans de Roma al Guernika" Antoni Mari's text. Tuesday May 12, 1998 Exhibition "25 Barcelunas". Targetti Iluminación SA & ModaFAD. 25 fashion designers and photographers have dressed the screen of the Barceluna lamp given by Targetti Iluminación SA. Participate: Elisa Amann, Asier Tapia, Daniel Riera, Mao Ikweling, Isaac Reina, Míriam Ocáriz, Itxaso Lecumberri, Yrene Pelukes, Josep Abril, Ester Mir, Anna Vizcarro, Spastor, Gero Balado, On Land, Míriam Alzina, Paulina Ruiz, Francesc Grau, Cristina Arnau, Celia Vela, Félix Vab Ros, Ruth Castillo, Olga Mencen, Maria Àngels Sánchez, Jordi Muñoz, Gabriel Torres.

07. MERKAMODAFAD
>

Thursday December 11, 1997. From 20.30h till 24.00h. Given the difficult circumstances under which ModaFAD passed, nothing better than to simulate a duel as farewell. Fortunately ModaFAD resisted the raise bet and recovered favorably, but the duel stayed there on Thursday afternoon until close the midnight, with a small meal included as a farewell and as the good manners tell. The designers clothing also participated, scattered on hangers throughout the room.

06. MERKAMODAFAD
>

Parades Monday May 12. MerkaFAD Tuesday May 13, 1997. From 12:00h till 24:00h. On the central yard of Pedralbes Centre. Collaborators: Pedralbes Centre, Sacha, Pans &Co., Frankfurt Diagonal, Dante Gori, Cervezas Águila, Biddy Mulligans, Pub Irlandés, Cava Rovellats, Óptica del Bulevard, Teresa Gimpera, Francina, Marcel and team, Tutusaus. Cazcarra, Sebastián, Jesmyn, Dressers from the EATM and Felicidad Duce, X-FAD, Gerard Sanmartin, Prensa FAD, Aurora Segura, Ramon Ramis, Roser & Francesc, Pilar Pasamontes, Marcel Montlleó, Maite Muñoz, Montse Pauli Ruiz, Josep Abril, Susanne. Hergenhahn, Jordi Rotllan, Celia Vela, Félix Vab Ros, Francesc Grau, Gabriel Torres, Ismael Alcaine, Sergio Pastor, Daniel Riera. Presidency: Marcel Montlleó. Organization: Moda FAD board & Silvia Aldomá.

05. MERKAMODAFAD
>

Friday December 13, 1996. From 12:00h till 24:00h. Boulevard Rosa, Diagonal 474. Collaborators: Boulevard Rosa, Teresa Gimpera, Francina, Sebastian, Medias Jesmyn, Laia Moragrera, Pilar Cortés, Maria Sallent, Sandra Castañada, Hairdresser: Marcel and team. Make Up: Ester Ponce. Dressers from EATM and the Instituto Catalán de la Moda. Presidency: Marcel Montlleó. Organization: Moda FAD board & Silvia Aldomá.

04. MERKAMODAFAD
>

Thursday May 9, 1996. From 12:00h till 24:00h. Maremagnum. Moll d'Espanya First Parade: Maremagnum Parking. Collaborator: Maremagnum. Graphic Design: Anna Coll. Stylist parade: Anna Vallés &

team. Presidency: Marcel Montlleó. Organization: ModaFAD board.

03. MERKAMODAFAD
>

Wednesday December 13, 1995. Maremagnum. Moll D´Espanya. Collaborators: Maremagnum. Graphic Design: Anna Coll. Presidency: Marcel Montlleó. Organization: ModaFAD board

02. MERKAMODAFAD
>

Thursday May 11, 1995. San Ponç. From 12:00h till 24:00h, Diagonal, 609. Collaborators: Pedralbes Centre. Graphic Design: Anna Coll. Presidency: Marcel Montlleó. Organization: Moda FAD board & Silvia Aldomá.

01. MERKAMODAFAD
>

Tuesday December 13, 1994. Sta Lucia. From 12:00h till 24:00h. FAD, Brusi, 45. Collaborators: Guillermina Baeza, Polo and Co, A menos cuarto, Alambre eye wear holder. Disseny Grafic: Anna Coll. Presidency: Marcel Montlleó. Organization: Moda FAD board & Silvia Aldomá.

MARCEL MONTLLEÓ
>

Everybody knows this hairdresser by profession, which tends to work both in the field of fashion and in film and theater, as the precursor of this passionate adventure that is ModaFAD, he led the institution during the first four years. Years of uncertainty, excitement and above all a lot of hope.

In 1994, you launched MerkamodaFAD. Why? What did you had in mind? What goals did you set back then? In 1993, after the Olympics, FAD wanted to promote a fashion partnership. Major changes in the industry began and also believed that there was a need to bring together industry and the various disciplines of fashion. The primary objective was to make a bridge between schools and industry.

Until what edition did you remain as president? Why did you left off? I stayed 4 years, two legislatures. This means six editions of MerkaFAD, which initially incorporated lectures attended by Jesús del Pozo, Antonio Pernas, André Ricard, Outomuro, Mario Eskenazi, Mila and Tuch Balado, the secretariat of wool, cotton and the flax, among others. I left because I believe in renewal rather than long stays.

The parades began two years later, what took you decide to go a step beyond the flea market? How were those first parades? The parades emerge from the natural need for designers to see the outcome of their collections and moving on a human dummy, and simultaneously helped to change spaces and finding sponsors.

There were complicated moments... Yes, for example the editions 8 till 10 went through a tough semi crisis caused by the consolidation of some designers who had already started his professional career and the need to find new values among emerging students and this was not easy. If I remember rightly in those years there were no parades.

There have been also some events somewhat bizarre. I remember the 07 edition that was the first disappointment of participants and product, the discouragement grew and as a party closure decided to put on the big screen the scandal brace of Pedro J., a little bit as a complaint and a littlie bit for fun. .

And what about the sheep...? At that time, each year a different association was responsible for the annual party of FAD. And was the turn of ModaFAD. We thought about linking the wool as a staple and distinctive in the world of fashion, much more striking than cotton, the linen or any of the synthetic materials, because their animal origin allowed us to inundate FAD of a bed of straw for a truck of 30 or 40 white lambs and one black to run between the guests who surprised feed them with canapés. Plasticly it worked and had the transgressor and innocent point we were looking for.

It was also created the Camila Brusi collective. Yes, Camila Brusi was born from the interest to create in ModaFAD a nucleus of "young promises" to be submitted under the blessing of the great Camila Brusi tailor-partner of all the major designers in Barcelona (an invented character). Camila was a little tribute to Camila Hang and Brusi, because the FAD was on the Brusi street. This collective had its own space for two seasons in the Gaudi Auditorium.

What do you think of the path that leads ModaFAD since you left the presidency? Has it become what you had in mind when you began the project? Our beginnings were not so ambitious and far from what it has achieved ModaFAD in these 15 years of life is a true miracle. First survive and consolidated that it is a miracle itself. And then really interests the fashion industry, the street and the press.

Do you think the support to ModaFAD from public institutions is enough? No, I feel it's insufficient the attention given from the institutions to a partnership as ModaFAD, the only one without the slightest profit motive and with two very clear interests: fashion and Barcelona.

How do you see the future? As I said before, I see as a consolidated partnership and unfortunately at the mercy of public institutions.

And what about the future of the fashion that is being done in Catalunya? Right now, with several of our designers parading in Paris with success, others with success in Madrid, some in New York with success, and a few others struggling in Barcelona, we can say that the future is encouraging.

> Video scandal before YouTube. Media baron Pedro J. surprised in a private moment, projected at the MerkaFAD.

JOSEP MARIA GARCIA-PLANAS I MARCET
>

Degree in Business Administration by ESADE and knowledge on Political Science at the Hans Seidel Stiffung of Germany is president of Artextil, a company dedicated to the manufacture of high-end fabrics and creativity for women and men. We talked about how his relationship began with ModaFAD.

You're in ModaFAD since the beginning... Yes, I was a founder of ModaFAD and collaborated for about three years. I stopped taking part of its board by presenting my resignation for my total disagreement on how ModaFAD was projected.

With which designers you worked with? Do you have any story during all this time? I hired Irene Peukes. She was working with me for three or four years until she joined as a designer in Camper. . As an anecdote, I recall a fact that prompted my decision to leave: in the first edition of Merka, I proposed that a percent of the turnover of "consecrated" designers during the market days, were devoted to a fund to help the novice. The consecrateds refused. I was so disappointed that I did not have the willpower to continue supporting and dedicating hours of work and my family time to a senseless cause.

And despite of that, do you follow the ModaFAD path? I've been away from it, but I try to attend all events that are organized.

What's your opinion about the fashion in our country? How do you see the future? There is "talent" but poorly managed by both the designers themselves and the administration of their companies. Doris Lessing, British writer and Nobel Prize in Literature, said that "talent is something quite common, not lacking intelligence but constancy." The future depends on the assumption by the designer to understand that there is no project with future without a business project. And therefore or assumes alongside its creative capacity the role of managers, or exercise his profession integrating as professionals in large groups of fashion distribution in our country, which have a lot of future.

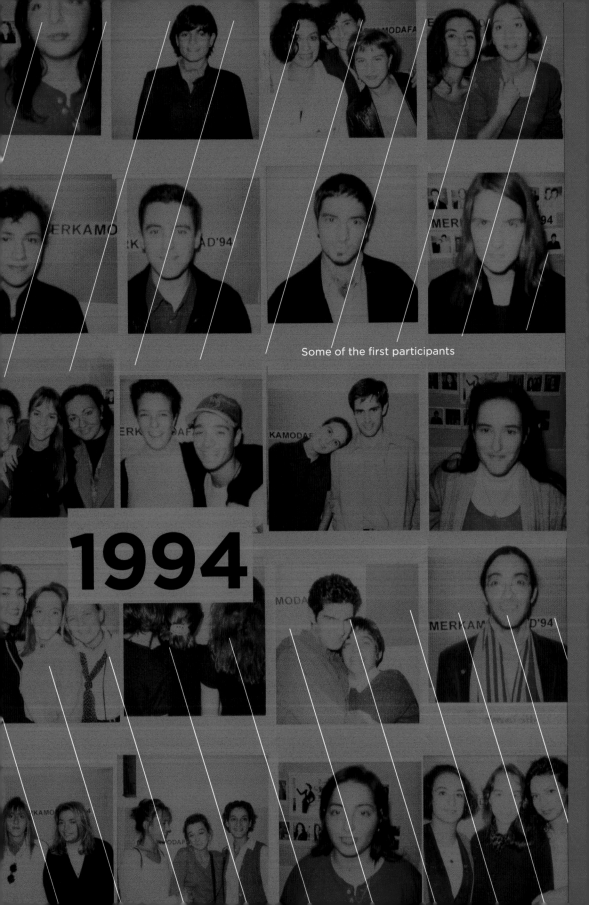

Some of the first participants

1994

Isaac Reina accessories display

Josep Abril first show

ANDREA AYALA
>

She is one of the most talented designers of the latest promotions, as shown on his career at Antwerp Royal Academy of Fine Arts. Part of the work that she developed in Antwerp was seen in PasaFAD of the 22nd edition. Since March, this 28 years old designer from Barcelona, also graduated in Fashion Design in ESDI, lives in Dublin and works as a designer for John Rocha. "I do not look much in fashion," Andrea said, "for me the important is the clothes. The pieces themselves. A coat, a skirt. How they are built. I believe that in my graduation collection this was very well shown. The important things for me are the ideas and develop these ideas into garments. Nothing more. I believe that a young designer must be very observer, propose new concepts, be critical with himself and try to give a different view or at least very personal, of what already exists."

www.andreaayala.com

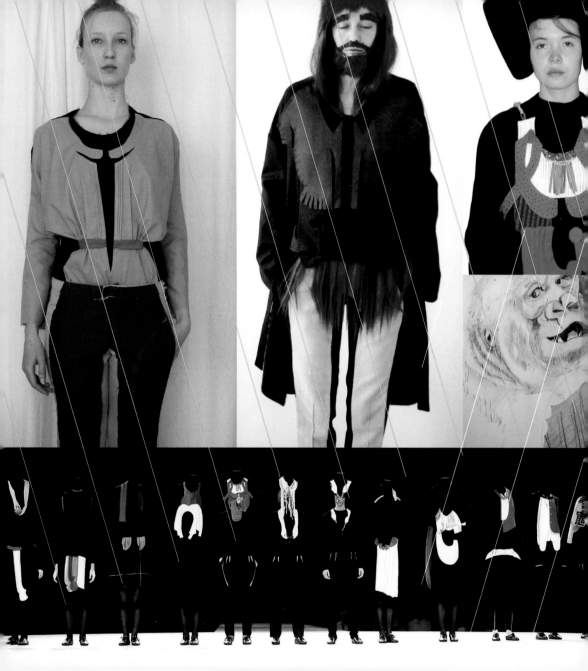

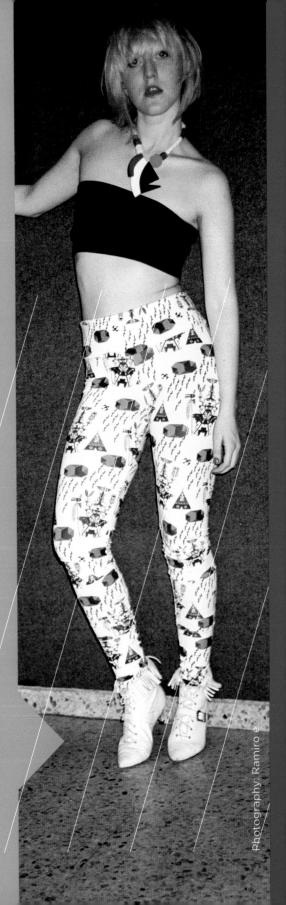

AURORA VILABOA

>

Her personal project is the collection that performs with Gonzalo Cutrina, in which he is responsible for the prints and Aurora for the design and pattern, but this 31 year old designer from Vigo is an expert on accessories, as well demonstrated through brands as Burberry, Bimba & Lola or Zara. Now she develops her work in Mango, the house in which she has just landed to design collections of handbags and jewellery for both men and women. "Working in a large company brings me a lot of experience, but I think I have a lot to learn yet", she answered when asked, when was she going to design her own collection. For now she prefers to focus on her work in Mango and Gonzalo Cutrina, "a challenge in which we still have a long way to go."

www.gonzalocutrina.com

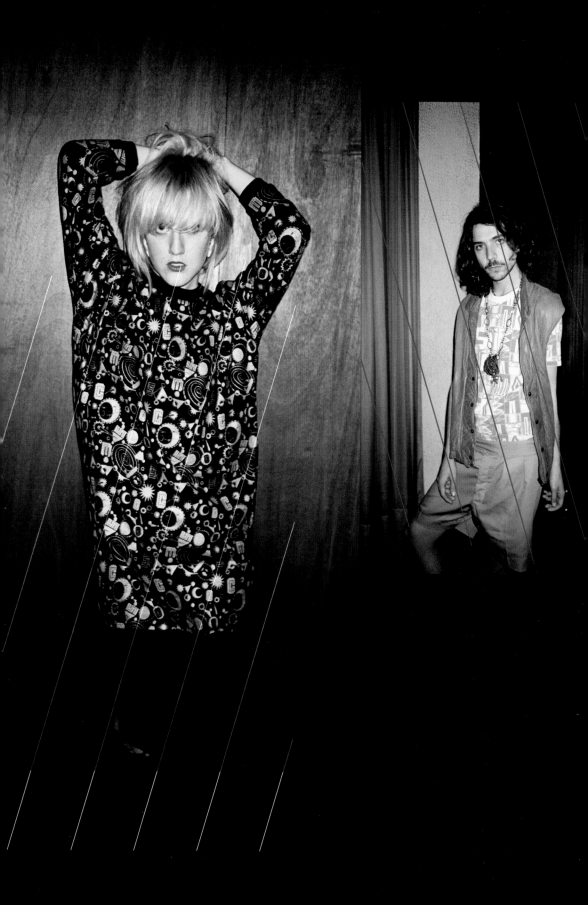

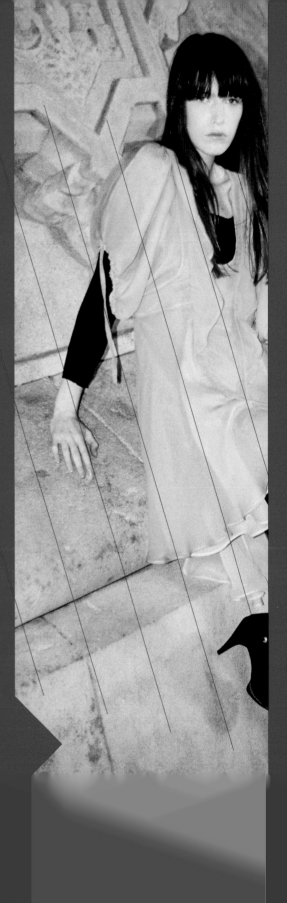

BAMBI BY LAURA
>

The first time we knew about her was in the 9th edition of Circuit, in 2004, and her parade was one of the most commented. Only a year earlier, Laura Figueras, 28 years old, former student of ESDI and Winchester School of Art, launched her own brand, Bambi by Laura. She didn't need experience because she had already worked in London for Preen in the Spring-Summer 2003 collection and as a designer for Women'Secret. Preen left her the love for high quality fabrics and a very elaborate pattern. "The cut of my clothes," she says, "makes you feel very special." Four adjectives that define her clothes: sophisticated, romantic-futuristic, independent and chic. She sells, among other places, in Dernier Cri (New York), Falline (Tokyo), Le66 (Paris), Konka (Berlin) and Paco Rueda (Barcelona).

www.bambibylaura.com

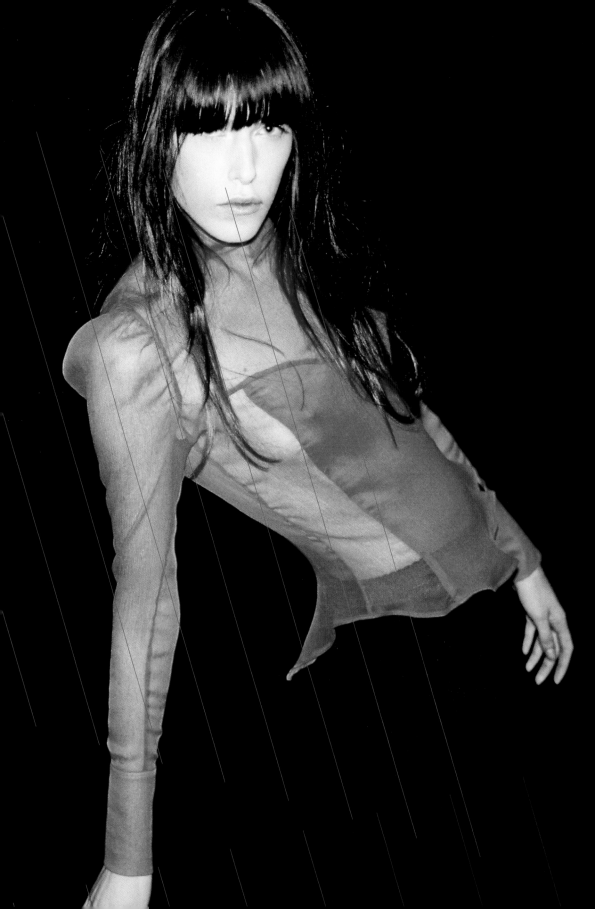

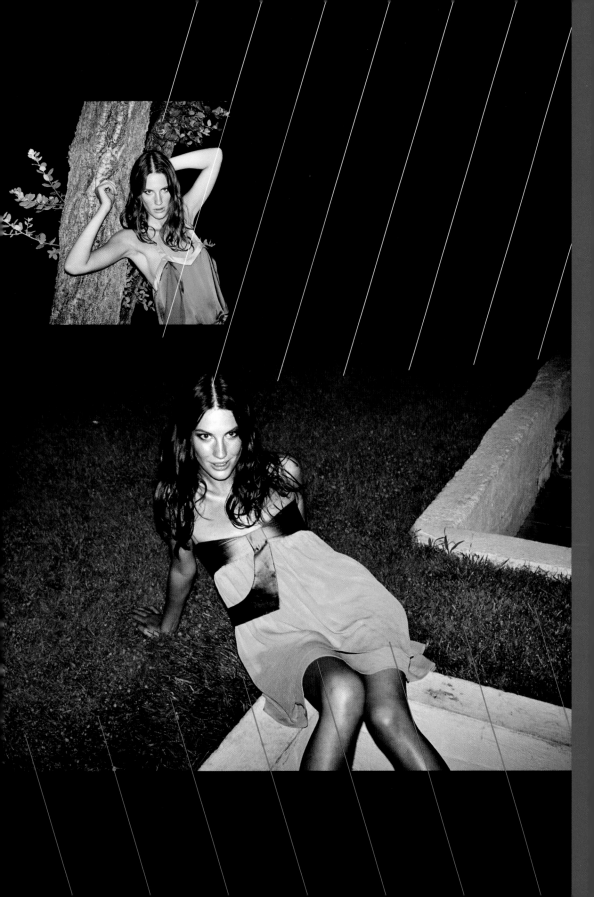

CARLOTA SANTAMARÍA

>

Along with Susana del Sol they start up just4fun, a collection of limited editions of leggings, overalls and shirts with a production socially committed that you can buy on the Internet. She explains the reason for this option: "We wanted our project to have an international scope since the beginning and we had a limited budget. So the Internet has been our best ally. The result is excellent and indirectly the traditional sell point has come to us thanks to the website. We already have offers from boutiques in New York, Los Angeles, Taiwan, Argentina and Barcelona". In addition to her personal project, Carlota, who has studied in ESDI and at Antwerp Royal Academy of Fine Arts, also develops collections for different companies and works as an illustrator and photographer, although photography is "a more sporadic activity in which I intend to improve gradually and with humility because it is a long way to go." At the moment she has already published her photographs in magazines like Suite or Dresslab on-line.

www.just4funweb.com

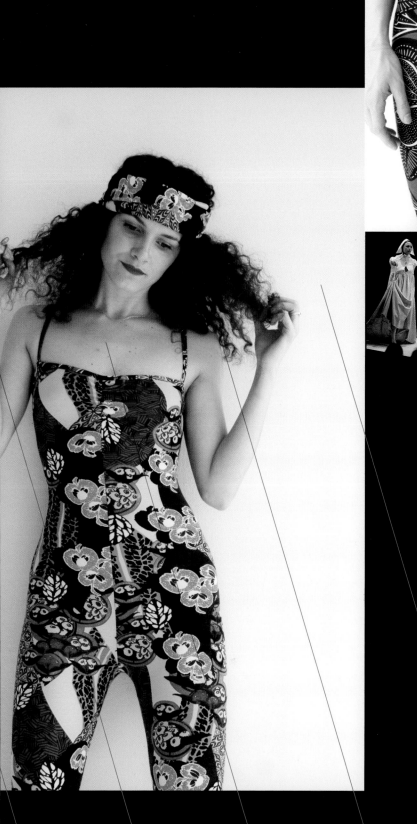

CECILIA SÖRENSEN
>

Cecilia Sörensen (Helsinki 1976) has
exhibited his work on all platforms,
parades and fairs possible in Barcelona.
He began with six editions of ModaFAD,
since 99, and then came Gaudí and
Circuit. Also participates in the Bread &
Butter fair of Barcelona and Berlin, and
since 2006 she participates in Rendez-
Vous in Paris and Showroom de
Barcelona. Cecilia does not design for
one mark for itself but two, the one which
bears his name and Pequeños Héroes, a
line of clothing for women which comes
from recycled material such as bed
sheets, shirts or male jackets. Both can
be found at Comité, her store in
Barcelona (Notariat, 8) which she shares
with other designers such as Pia Kahila.
She defines her clothes as sensitive,
feminine, clean, strong and fragile. And
for this winter her clothes in wool, flannel
and denim viscose, they come packed
with pleated and draped. Among his
future plans, make an artisan perfume.

www.ceciliasorensen.com

CELIA VELA
>

She is 37 years old and a curriculum to take off your hat. Celia Vela was one of the designers who participated in the first edition of MerkamodaFAD, and since then her meteoric career as a designer has done nothing but grow at an enviable rhythm. Excellent student at Felicidad Duce, Celia was presenting his thesis in 1993 and the following year she has already made his first collection for the first MerkaFAD of history. In 1995 creates along her husband Jordi Rotllan the brand that bears his name and that same year opened its first store in Figueras, her hometown. From there, it follows: collections for the home, kids and brides, parades in Gaudi, new stores (one in Tokyo), the marketing firm in the United States, parades in Paris... Her's is undoubtedly one of the strongest paths.

You participated on the first edition of ModaFAD, what do you remember? Yes, I participated in the first edition and if I remember correctly, I participated during the first five editions. In the first edition I appeared along with Charlotte Rodés, and after I appeared individually. The first MerkamodaFAD in December 1994 was the first thing I did after leaving school, and it's because of the very positive results we got in the following editions that I decided to create my firm.

They have been some years since then, what is the greatest satisfaction that your job has given you? The biggest satisfaction is to continue here, dedicated to what I have always wanted, do what I like, as I like and make a living from it.

Are you where you wanted to get when you were that young designer who sold their clothes in MerkaFAD? In the first Merka I was very surprised when people bought clothes from me. When I saw someone with something I made in Barcelona I used to desire to stop them and say: "I have done it." At that time my only ambition was to have my firm and live from it; that ambition is fulfilled, it has been some years now and more goals to conquer have appeared, if we succeed, fortunately, new goals to achieve will appear on the path. Life is moving forward and forward and I think that the world is one of those who hold.

What's your opinion about the work of ModaFAD? I've been very disconnected for many years, but at that time it was an essential institution for the promotion of the sector and, above all, young designers. There was a lot of enthusiasm and desire to do things.

www.celiavela.com

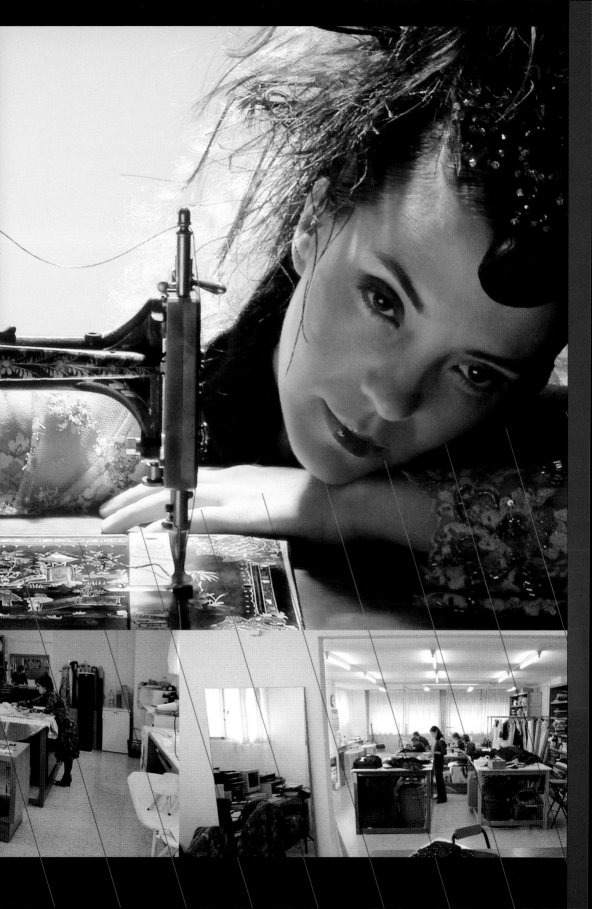

ELENA CARDONA

\>

She has worked for Givenchy and Maison Martin Margiela, from who is responsible for the line 11, the collection of leather goods and accessories for men and women, a task that she has been developing since 2004. Besides Elena, 29 years old from Barcelona, whose first involvement in ModaFAD was on the 19th edition, has since last year her own brand of shirts that responds to the name of Groundwork. "The idea," she explains, "is to create garments needed to develop and demonstrate a single concept. It is intended that people of different artistic fields of fashion or other fields, become involved in every collection. The first one gives people the possibility to become transparent with the shirts, which are stamped with a series of landscapes more or less implausible as a total eclipse of the sun, a road or a starry night. The person who puts these shirts on has to follow the instructions that are attached to reach a state of total fusion with the landscape. In this project have participated: Guillermo Pfaff, Assaf Shoshan, Linus Sundbal and Caterina Barjau." Groundwork can be purchased in Doshaburi (Barcelona), Isolée (Madrid), Eleven (Valencia), Quatriforum (Palma de Mallorca) and Isetan and Tokishirazu (Tokyo).

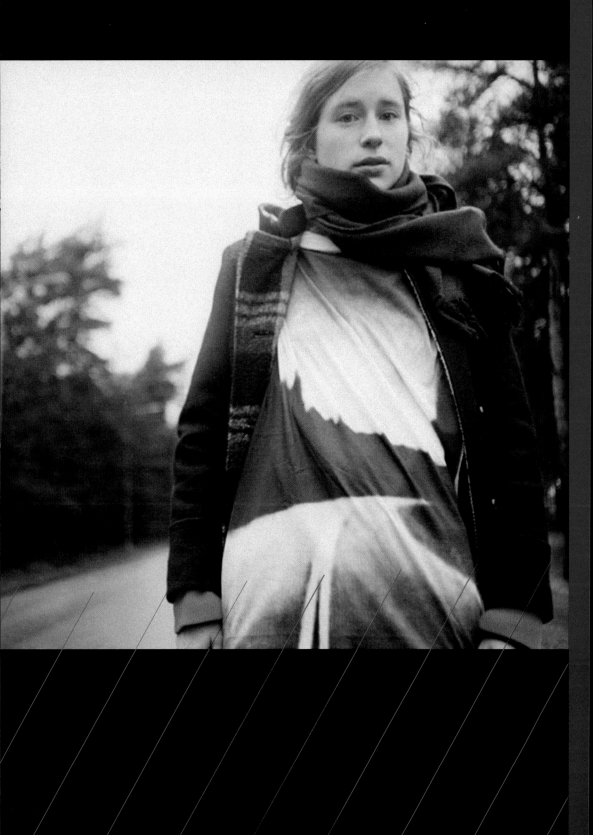

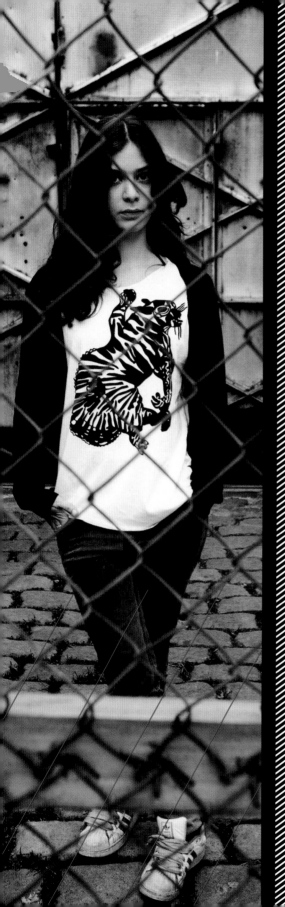

GORI DE PALMA
>

The real name of this 32-year-old Mallorcan is Gregorio F. Romero, but everybody calls him Gori de Palma, one of the most personal designers that we have here. "The aesthetic of Gori de Palma is linked to rock & roll, punk, subcultures and movements such as bondage or sadism and masochism" this can be read on his website. He is known for his work recycling with Levi's 501 ("Confusion", which was presented in the Gaudi gateway in September 2004) and his trilogy in black ("Die Rote Rechie Hand", "Fade to Black" and "Fallen Woman "). Besides of Gaudí he has also paraded at Bread & Butter and the missing Pasarela de Barcelona. Among his collaborations with brands are Vans, American Apparel and Swarovski.

Do you remember your first ModaFAD? I participated in the China Forever edition. I still was at school and from the perspective time gives you, I recall a collection made with great enthusiasm and a lot of colour, forgive me God. It was a great opportunity to begin to visualize the intricacies of the designers, the selection of fabrics, production and sales...

How are your clothes? Sensual and avant-garde. Although we have no predefined style, we conceive each collection as a reflection on our experiences and our mood, everything comes from our own personal imagination. We like to skip the formalities and conceive an utopic woman with a strong sexual burden. We always face ourselves to new challenges, it's about asking yourself continuously questions, to overcome your own habits and prejudices.

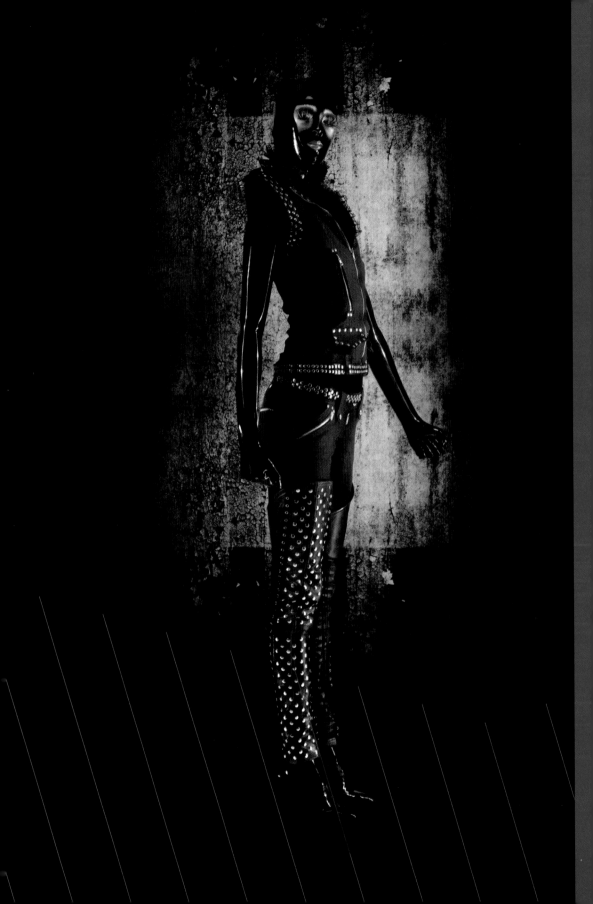

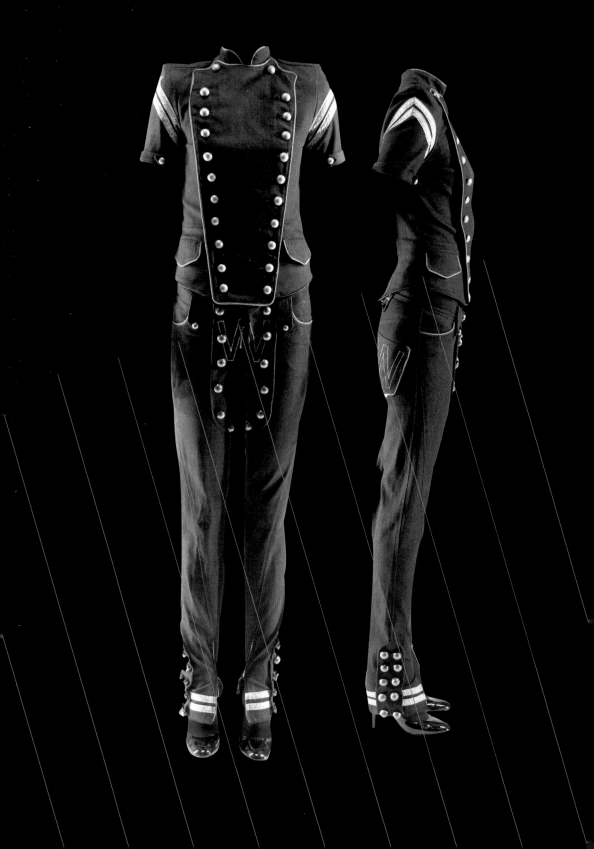

Tell us about your collection for this winter. "Le temps détruit tout" has as regards the research and development of masculine tailoring, to design new women's clothing. As a source of inspiration, John Cassavetes film "Opening night". The most unique detail is the new generational approach, a tribute to the mature woman of 40 to 59 years old, the collection is focused the decadence and vulnerability as a result of the pass of the years. A woman incapable to admit she is getting older. The collection is a reference of loyalty to the classical style over the years, although in a renewed way. Playing constantly with the duality between the masculine and feminine style.

How do you see the future? I love to see the future as a reflection of things in the past, Our four years of experience has led us to often rethink many things. To have a more realistic vision of fashion, to grow as individuals and creatives. To obtain a complete picture increasingly critical about our work. To seek and find a middle ground between the creative consciousness and the real market. Looking ahead it would be interesting to find private financing, a business group that is willing to believe in our product and of course continue our line of collaborations.

www.goridepalma.com

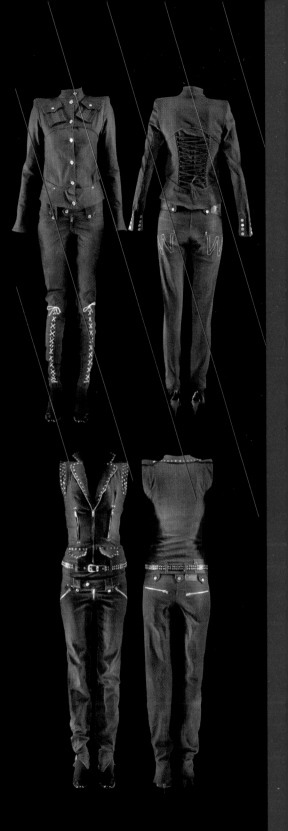

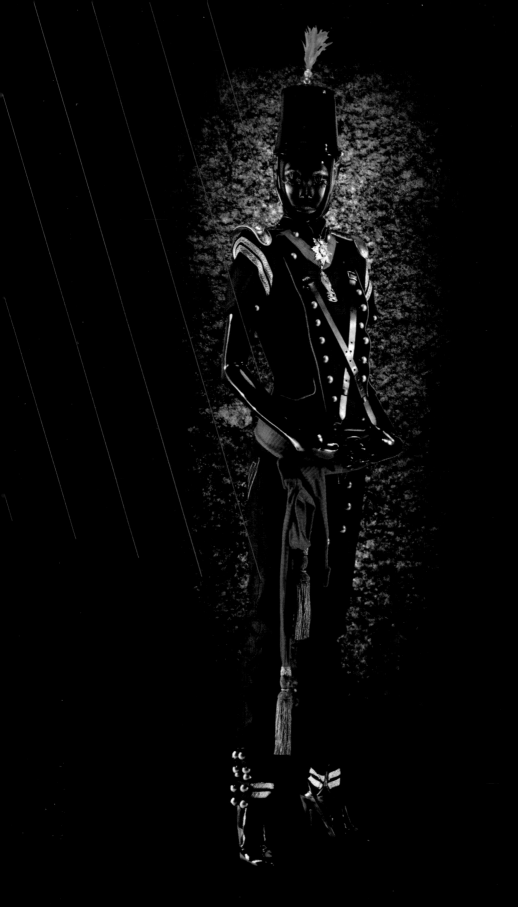

ION FIZ
>

In 2002 he won the prize for Best
Emerging Designer, but the year before
was the first time that Ion Fiz approached
ModaFAD with some garments made
from old quilts in brocade cotton. "On the
pink and baby blue quilts I drew some big
flowers in thick stroke and exotic colours,
fuchsia pink, strong red and green grass
which provide an oriental resemblance to
the garments." Juanjo Fiz (Eibar, 1976)
has his own shop in Bilbao and Madrid,
city where he presents his collections
now outside the calendar of Cibeles,
although he did so within the gateway for
seven editions, also he paraded before in
Circuit and Pasarela Abierta de Murcia.
Apart from his first line, Juanjo has a
second line more casual and young which
is called Serie by Ion Fiz, and also makes
a collection of female fashion lingerie in
collaboration with the brand Marie Claire.

www.ionfiz.com

winner! M

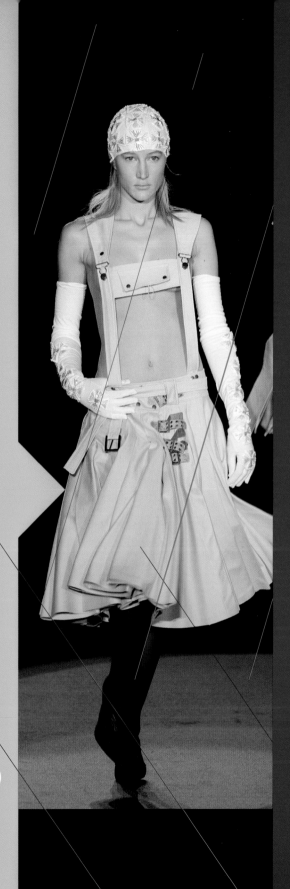

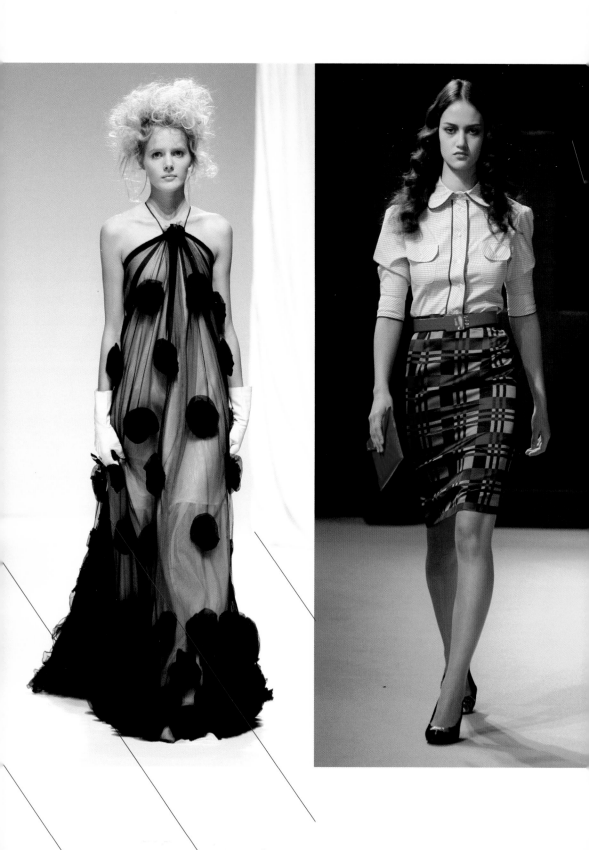

ITXASO

>

Since 2001 this 38 years old from Lleida and self-training designer, works in the design department of Camper, but years earlier, between 1994 and 2002, Itxaso was devoted mainly to her own line of handbags (although she also designed collections for Florentino and Josep Font) which she presented on the first Merkamoda. "I remember the first edition in the former headquarters of FAD," explains the designer, "it was very exciting, a real platform where the must cooler and crazy ideas emerged. Marcel, Pilar, Silvia... All those who came to see us and shared the project, made possible to continue the editions of that laboratory market. Here I presented my first collection of leather handbags, "Instantáneas". Each bag was a picture and had his name. Here were born "La gallinita María", "La luciérnaga de las siete", "La nariz meretriz" and those who came later. It was called platform and it really was for many people, for me it was a big turning point in my career and the start of one of the most exciting projects in my life." Itxaso coordinated in Camper until last year's project Locus, a collaborative project with artists from different disciplines on a trip to different cities around the world.

Designed as team member of Camper

Locus BCN: with Gabriel Torres, Toormix, Martín Ruiz de Azúa.

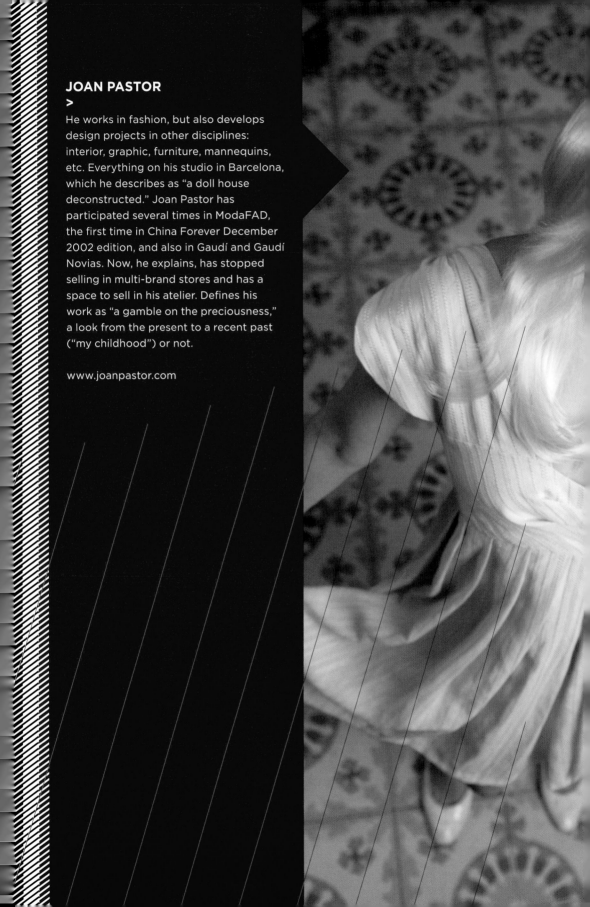

JOAN PASTOR
>

He works in fashion, but also develops
design projects in other disciplines:
interior, graphic, furniture, mannequins,
etc. Everything on his studio in Barcelona,
which he describes as "a doll house
deconstructed." Joan Pastor has
participated several times in ModaFAD,
the first time in China Forever December
2002 edition, and also in Gaudí and Gaudí
Novias. Now, he explains, has stopped
selling in multi-brand stores and has a
space to sell in his atelier. Defines his
work as "a gamble on the preciousness,"
a look from the present to a recent past
("my childhood") or not.

www.joanpastor.com

JORDI LABANDA

>

He is certainly one of the illustrators of our country most recognized internationally, but Jordi Labanda is much more than that. Not only is one of those responsible for the boom of the illustration in the mid-nineties, but his name has become a brand that is synonymous of success and glamour. And that is because Labanda knows how to diversify his work without losing a bit of style and attitude. Besides for three years he also has his own brand of clothing called, obviously, Jordi Labanda. The first shirts that young girls like so much have given way to more mature collections and worked addressed to a woman who wants to look elegant and feminine. He has its own shop in Barcelona, and like many others went to ModaFAD, even before doing illustration.

You also went to ModaFAD, what did you present? Do you remember when and how was the experience? Well, my passage through ModaFAD was just 12 or 13 years ago, even before I began to work as an illustrator. My memories of that time are very vague, I remember Marcel, Pilar Pasamontes and Silvia of FAD trying to rise up things, like someone who tries to light a fire by rubbing a stick with the hands and blowing at the same time. My participation was small pieces of jewellery made of papier-mache. All very naïf, but remember that they were the happy nineties. I think I sold everything.

Did you repeat the experience or do you went only once? How did participate in ModaFAD helped you? I didn't repeat but I participated in other amusing experiences in the FAD, such as the successful "Todo a 100" in which I became a little crazy doing everything. It

helped me to contact with people of my generation who are now doing really good things, as Spastor or Ailanto and to know what is right and wrong of the reality of fashion in this country (especially the bad).

What do you think about the work that this institution has been making all these years? I find commendable everything they are doing. It is an ant-work, we could almost say underground, but like everything that is done well and with enthusiasm, helps to build foundations and to educate people.

Do you still visit new editions? Have you ever bought clothes? I went to the editions that have been done every time I can, and yes, I bought something, for me and for a gift.

How are you finding the experience with your own collections, are you happy with the achievements? I started three years ago and the experience is turning out to be interesting, but also has taught me that fashion is something slow and difficult, is a tough and competitive industry, nothing frivolous. This also has taught me that what works on paper sometimes does not work on 3D.

You said once that you were more interested on ending up working in haute couture than in prêt-à-porter, is still something that you have as an objective to make? Uf, now I see it even more distant... And now, knowing what it costs to raise a serious production of prêt-à-porter this yearning for haute couture is a little bit unconscious and not very humble. Although life is very long ...

With what project or collaboration have you been more excited to perform? I just

work with the team of colourists of the hair dye of Swarkoff to design new trends of colour for the brand worldwide. It has been a very interesting work, along with British and Austrian professionals in which I have been requested more to assimilate trends than as an illustrator. I think it is a very exciting way to collaborate with another facet of fashion.

You travel a lot and attend to international shows, so what do you think about the fashion in our country? Can you tell us some of your favourite designers? Um... Whenever someone asks me that question I have to count up to ten to try to not offend any sensibilities. I really think that nothing remarkable is being done in general. My favorites are Spastor, Delgado Buil, Davidelfín and Pertegaz.

All the designers that are beginning agree on one thing: how hard it is to start up your own brand and gain a hole. We do not know if you're a man of advice, but could you give them one? Uf, to put aside the ego and try to spend some formative years in any foreign firm in Milan, London or Paris, there is the reality of fashion. I sincerely believe that people who start have an excess of confidence in a talent sometimes immature. It is as if the whole world would like to see his name in bright letters just after leaving school before passing through an era of old-style learning. How many names do we read in trend magazines that are flower of a day and of which we'll never speak again. Fashion is a career with a long way to go.

www.jordilabanda.com

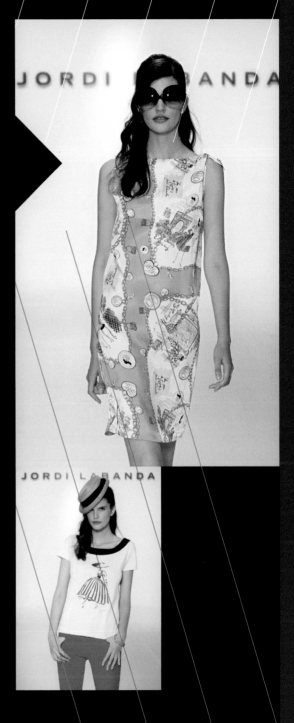

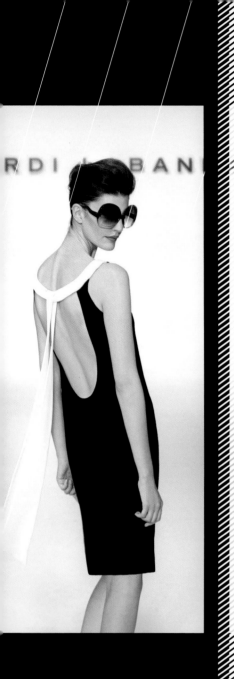

LA MARTHE

\>

Graduated in 1995 in Fashion Design on the University of Middlesex in London, Marthe Esteban (Geneva, Switzerland, 33 years old) stands out for her ability with modelling. She commercialized her own brand that same year and in 2001 opened a shop in the Gothic neighbourhood, now closed. Cofounder of the Circuit, she participated in the first three editions. She has also parade on the Pasarela Abierta in Murcia, where in 2004 she won the prize for Best Creative Collection. Her garments are halfway between the must refined haute couture and the young prêt-à-porter. With clean and feminine cut, her clothes are close to military uniforms with seductive silhouettes but rigorous, always very romantic lines that are accentuated with the use of tissues with great fall. La Marthe is currently working to order or custom design and teaches at various centres in Barcelona.

www.lamarthe.es

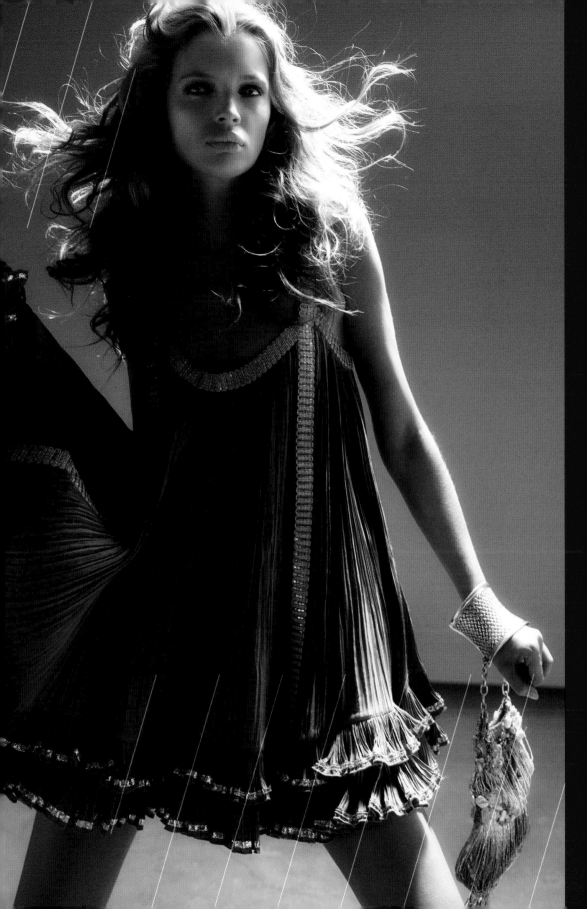

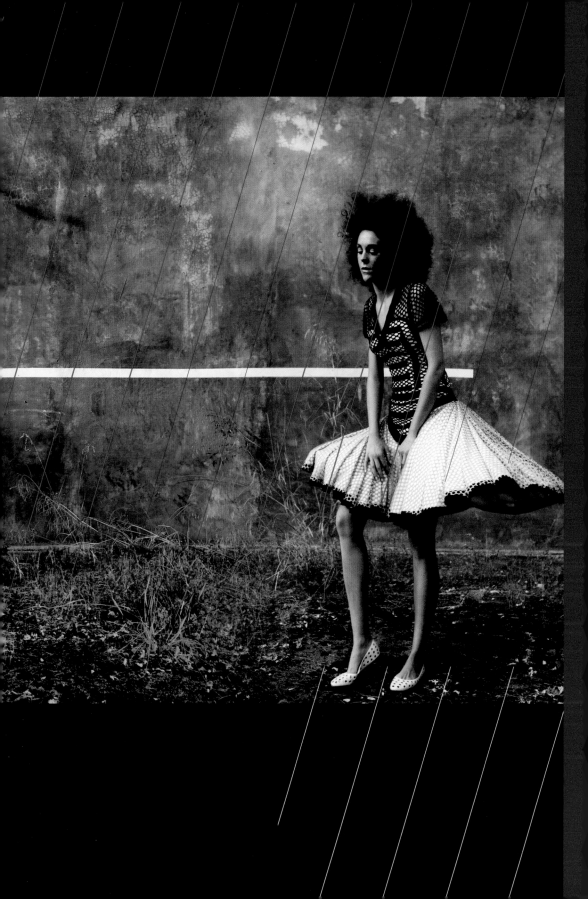

LA WHITE
>

Not being able to be more multifaceted,
Ivonne Cardenas is the designer and
founder of La White, as well this Cuban
born in Havana 28 years ago is a
contemporary dancer and has been on
scenarios such as his hometown and New
York, Hanover or Barcelona. After going
through several schools (ESDI, Escola de
la Dona and Felicidad Duce), Ivonne won
in December 2003 the Martini Award for
Best Emerging Designer with a collection
inspired on Studio 54 in black and silver,
sober but at the same time very feminine
and sensual. She has shown on Gaudi,
and currently sells in stores such as
Comité (Notariat, 8) or *L'Armari de Sant
Pere* (Sant Pere Més Baix, 77 store 3) and
is part of the project Changing Room, a
young designers showroom that twice a
year is hosted at the Chic & Basic hotel in
Barcelona. The 50's and her spectacular
volumes are her inspiration. In her own
words: "La White is the woman that I
would like to be everyday: extreme and
simple, feminine and légère, but always
perfect."

www.lawhite.com

 winner!

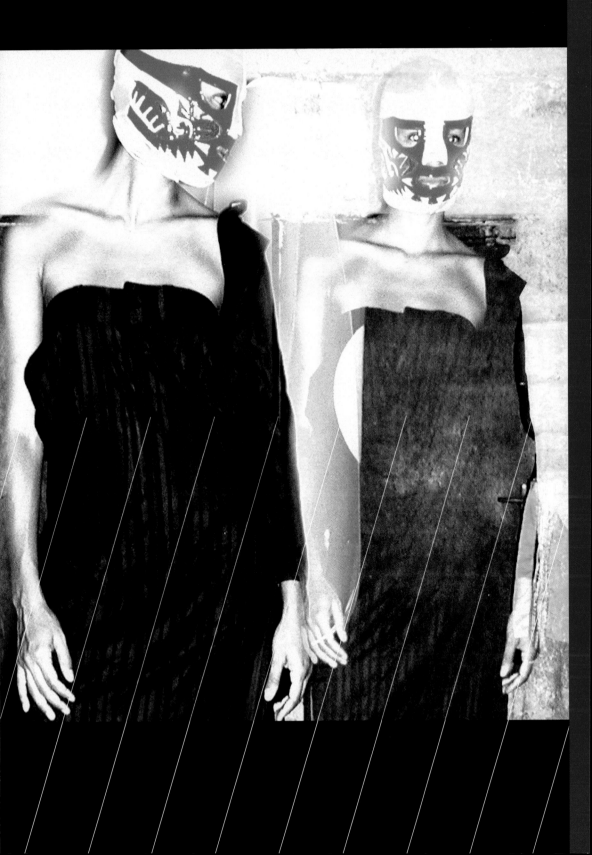

LLUIS CORUJO

>

This Majorcan 26 year old has studied in the BAU and Llotja, and in June 2008 he graduated in Fashion Design by the Royal Academy of Fine Arts in Antwerp. Currently works as an assistant in the studio that Miguel Adrover has in Mallorca, and among its future plans is to open his own studio. Lluís asserts that his work is "a search result and a creative process that is constantly changing. It's very influenced by the techniques, fabrics and construction of each garment, every moment and every emotion that I receive daily, which is a routine like that of any Spanish born in the early eighties in a wonderful middle class family, and that has always been surrounded by fabulous people, friends and family who have given me freedom to live my life without any social, cultural or religious boundaries."

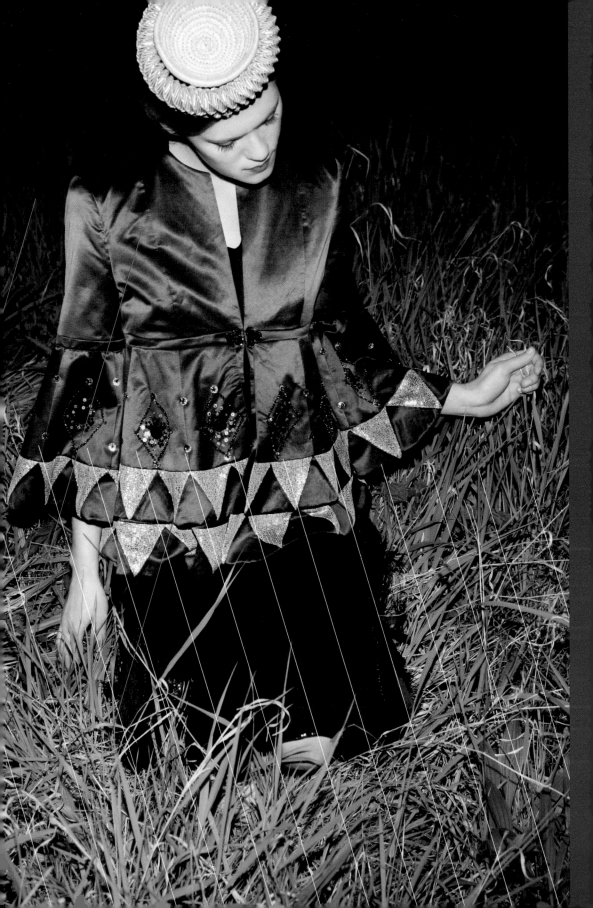

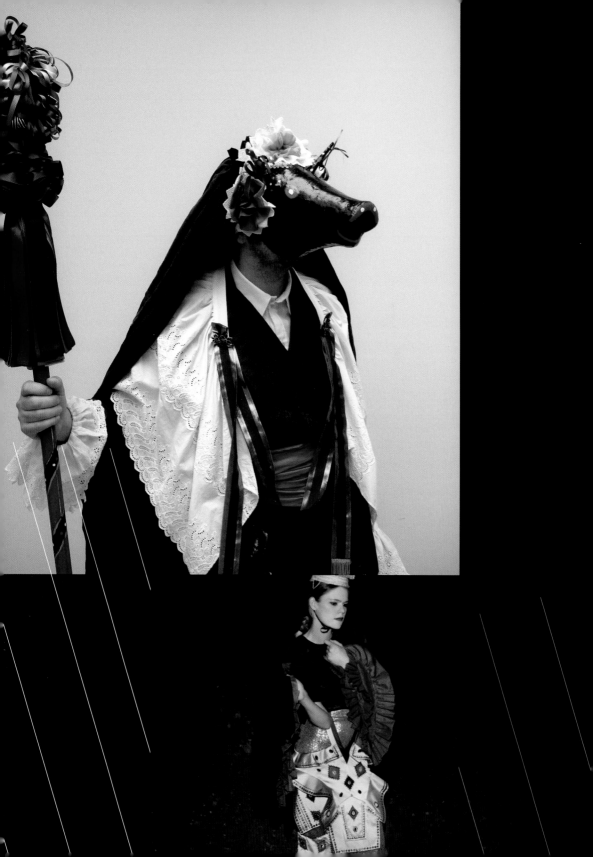

SERGUEI POVAGUIN

>

In 2002 he won with "I love Spain" the
Pure White Award for Best Collection.
Since then, his designs have been seen in
the former Gaudí and Pasarela de
Barcelona, Barcelona Bridal Week and
the first edition of 080. This 28-year-old
Russian who studied at ESDI, said he
searches the balance in his job between
the aesthetic and the practical trying to
escape from the obvious to recreate in
the subtlety of things. His woman is a
woman with personality: "A woman who
does not hide her femininity and takes
fashion as a game." For this winter
volumes are the absolute protagonists of
a collection that is a reflection of the
contradictions that surround us. Serguei
sells in Yedra, a shop in Bilbao where he
makes custom made designs.

www.sergueipovaguin.com

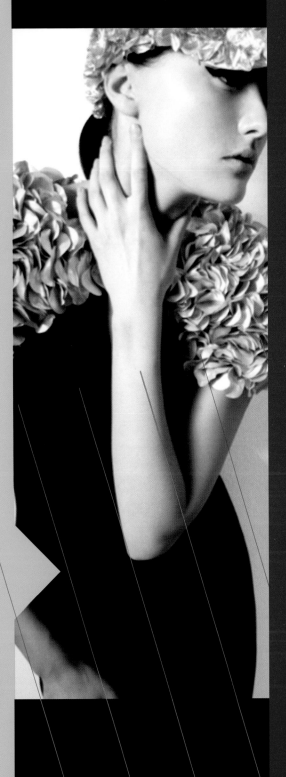

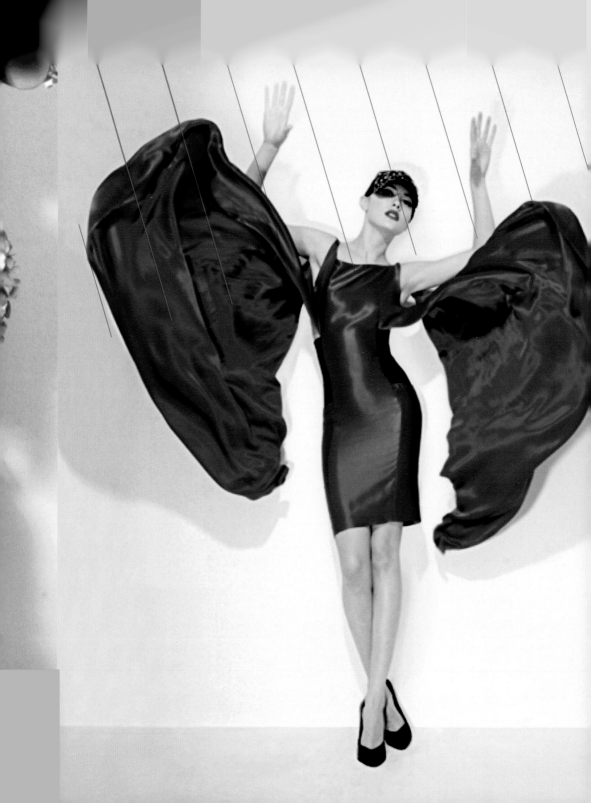

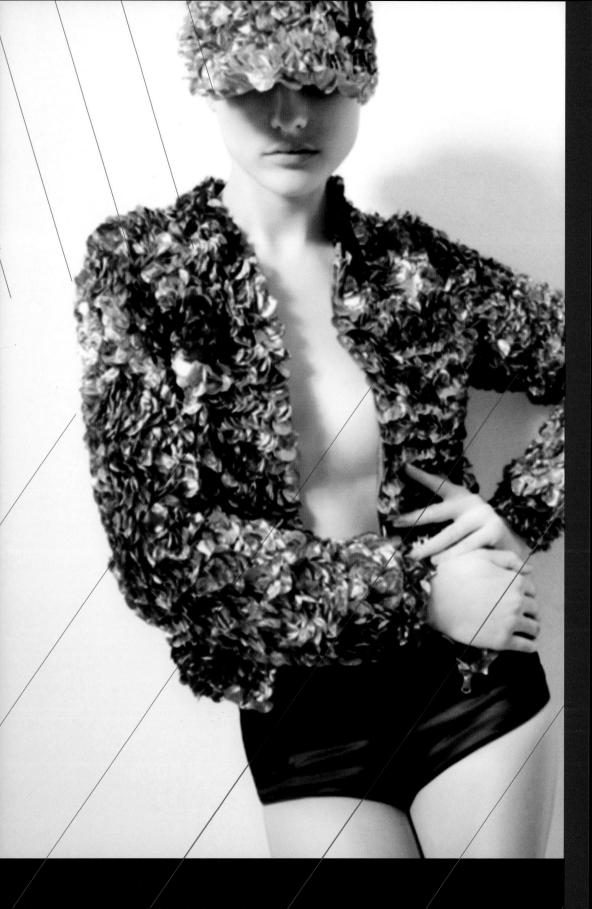

SPASTOR

>

Sergio Pastor (Girona, 1975) and Ismael Alcaina (Barcelona, 1975) make one of the most interesting creative tandems that has given Catalunya in recent times. The creation of its brand dates back to 1995 but would not be until 2004 when Spastor Homme *prêt-à-porter* was born. Four years that have given a lot. So far, Spastor has shown in the Parisian catwalk within the official calendar, including Gaudi and Cibeles, has worked with Marcelo Krasilcic in presenting his collection "Kind of Man" Spring-Summer 2005, at the Espace Hexamo Paris, as well as the realization of the video series "Get Inside" Fall-Winter 2005/06 that could be seen on the opened catwalk of Murcia, and has also done collaborations with Marilyn Manson, The Kills and Rammstein, among others, for their videos, tours or events. More? Costume Design for choreographers as Rafael Bonachela; collaborations with Design Against Aids, Luan Maró or Swarovski, and several exhibitions such as "MMODANY" fashion in the Spanish Institute Reina Sofia in New York or "12 costumes for Tokyo", which was attended by twelve Spanish designers who showed their work at the Cervantes Institute in Tokyo. Their latest collaboration: design a gown for the singer and actress Juliette Lewis, for the video directed by the Swiss Björn Tagemose. And between collaboration and collaboration they have decided to make a pause on the way to catch air, rethink things and come back even harder.

Do you remember the first time that you participated in ModaFAD? In December 1995. We presented just a collection of dresses, some quilted and other nylon and lining's swimsuits skin colour. The experience was good, we just sold a dress but we learned a lot. Above all to know how our colleagues were positioned.

What is it resulting the experience of 080? For this second edition we have only participated in the first phase of the project and we have decided to get off. Now we are only in charge of an act which, although it is included in the gateway Barcelona Fashion 080, it's parallel and independent.

Will we see soon a new collection of Spastor? We don't have a date, it will be when we find what we need and we believe we can work as it should be.

www.spastor.org

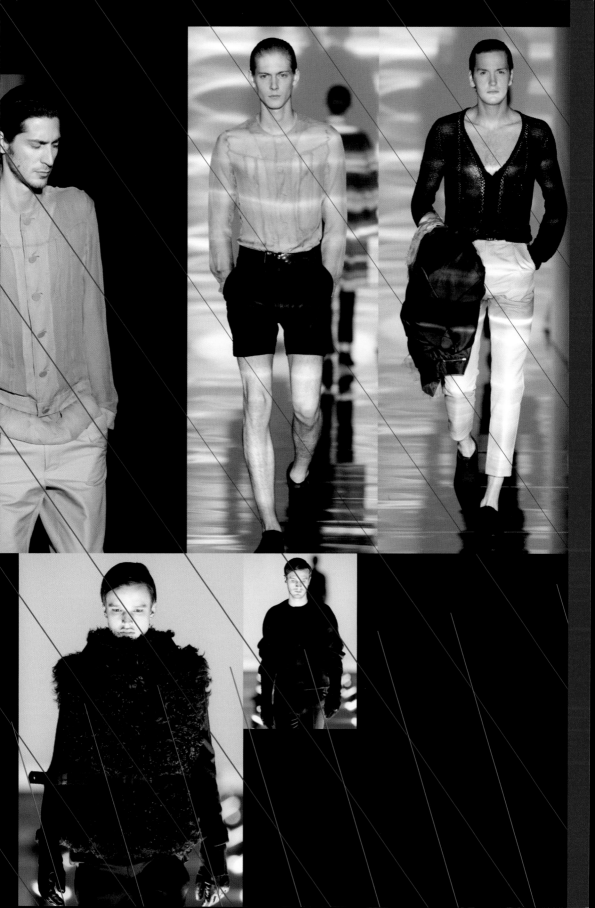

POTIPOTI
>

Silvia Salvador and Nando Cornejo are the designers of Potipoti, a brand that has on its prints his hallmark: leggings, shirts, pants, sweatshirts and dresses always with these so characteristic prints that made them popular. Earlier this year they opened a shop in Berlin, a city that has fascinated them and where they live since long ago. Their collections have been seen in El Ego of Cibeles or in the Pasarela Abierta de Murcia and between their future plans is going to a Pacific island that is called Potipoti. "We have to go there," they say, "it's the destiny."

www.potipoti.com

SYNGMAN CUCALA
>

To this designer of Barcelona the profession comes from the family because her mother is the designer Lurdes Bergada. Syngman Cucala (Barcelona, 1974) already worked in the collections of his mother two years before graduating in Fashion Design by EATM which he did with honors. Once licensed, and after two years working for Josep April, designs his own first collection in 2002 that begins to sell very well in different Spanish stores. A year later jumped into the international market, selling today to stores in Tokyo (Membre, Isetan, Ships), New York (Bus Stop), Moscow (Le Form, Traffik), Antwerp (Walter), London (Concrete) and Paris (Spirito Divino) among others. Syngman said about his clothes that are clothes without age, "for nonconformist men (this a little bit on quotation marks) who are looking to wear something simple but different, that distinguishes them but without falling into the costume. Clothes, not noise."

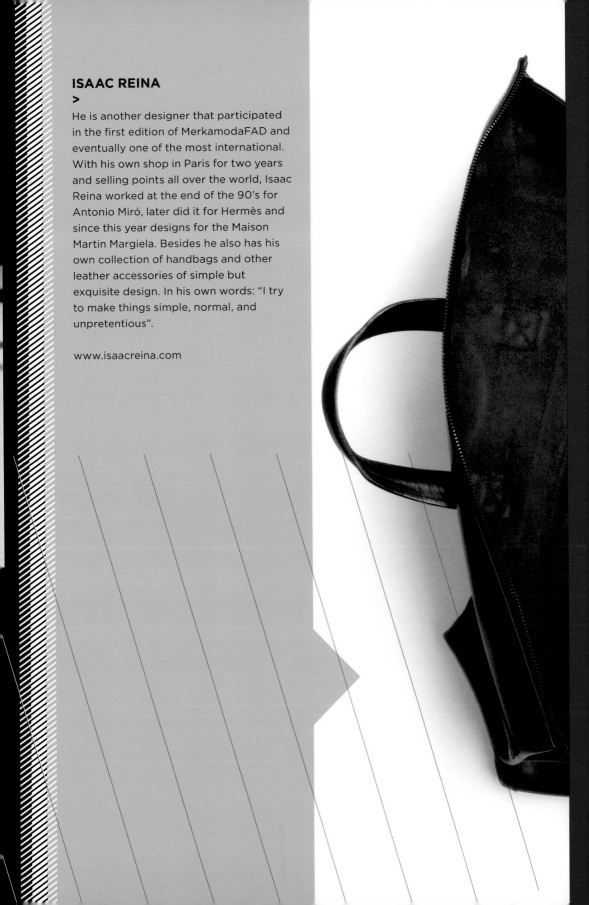

ISAAC REINA
>

He is another designer that participated in the first edition of MerkamodaFAD and eventually one of the most international. With his own shop in Paris for two years and selling points all over the world, Isaac Reina worked at the end of the 90's for Antonio Miró, later did it for Hermès and since this year designs for the Maison Martin Margiela. Besides he also has his own collection of handbags and other leather accessories of simple but exquisite design. In his own words: "I try to make things simple, normal, and unpretentious".

www.isaacreina.com

JOSEP ABRIL
>

He is one of the most veteran designers in ModaFAD also is part of the association since it was born. With 45 years, Josep Abril is obligatory reference if we talk about men's fashion in our country, because he not only designs his own collection but he is also the designer of Armand Basi Homme. Although both collections are directed to a similar type of man, he makes clear the difference: "The same difference that exists between a company of 400 people, with many stores and customers, and a company of 5 people with a more creative and risky goal". He recalls that he was unable to sleep because he was so nervous when he participated in the first edition of MerkamodaFAD, "I presented a man collection and I bought a store for which I am still working." He assured that he will continue showing in Cibeles (started doing it in February 2008) because it "has been very positive and want to empower man", and among his future projects are the line of shoes and accessories that launches next January with Fosco, and the opening (yet undated) of an area of purchase which will also be tailoring made to measure.

www.josepabril.com

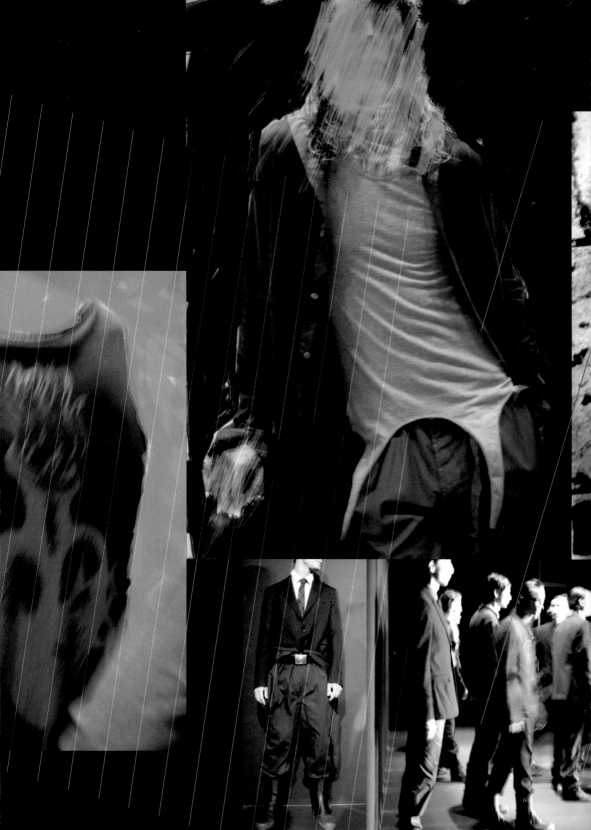

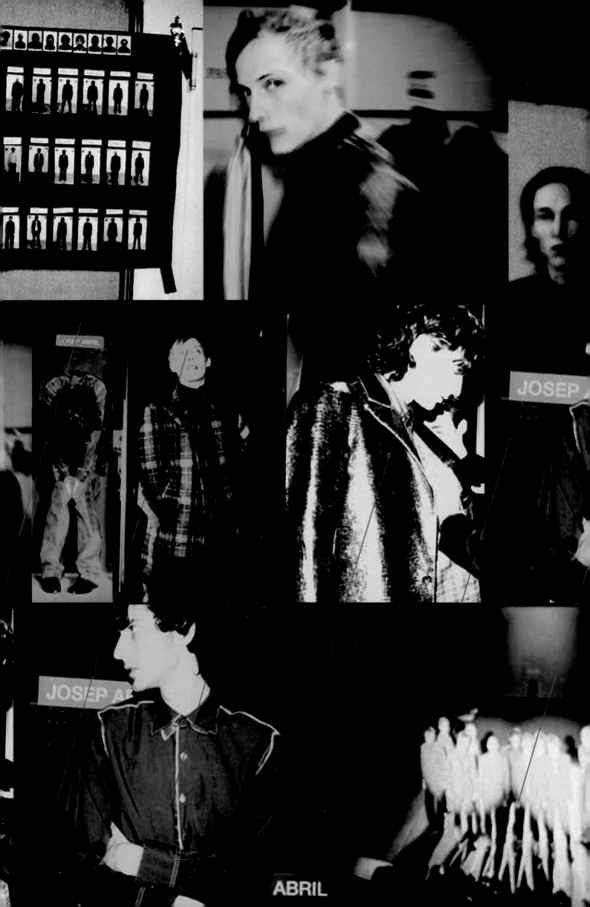
ABRIL

A PLATFORM TO BE TAKEN INTO CONSIDERATION
>

In March 2007 the nine leading fashion schools in Barcelona (BAU, Escola de la Dona, Escuela Guerrero, ESDI, FD Moda, ICM, IDEP, IED and Llotja), representing more than 2,000 students, decided to meet in a Platform with the goal of being able to ensure that the point of view of the training centres would be taken into account before a changing or even agitated situation. Fashion in our city after the disappearance of the Gaudi and Barcelona gateways, the confirmation of Bread & Butter as a new benchmark for urban fashion or for the develop of new proposals by the government.

At that time, most of the organizational flow seemed to focus on young designers, as ModaFAD had done for many years. They felt that if we had to work for the so-called "emerging scene" it was imperative that schools, as main responsables for the quarry and the formation of these new and young professionals, took an active part in decisions that could be developed towards them.

With this idea we signed a joint manifest that has marked the footsteps of the Platform since and has allowed, even being competition in a professional level, the nine schools to act, when circumstances required so and with a united voice in front of different speakers. The key points of this manifest are:

• To ensure the professional continuity of our students after their graduation.
• Have presence as an adviser after the institutions regarding any strategy destined to promote policies that want to support emerging designers.
• Promote Barcelona as a brand and benchmark in the field of training in fashion design.

These three principles of work have enabled the platform to develop new proposals for work or improve others that already existed with our collaboration, towards "emerging" designers with the leading institutions in our city (ModaFAD, Generalitat de Catalunya, Bread & Butter, City of Barcelona, etc.) who, like us, face and should help define the future of fashion in Barcelona.

ESCOLA DE LA DONA

www.diba.es/francescabonnemaison

Àrea d'igulatat i ciutadania
Diputació de Barcelona

The Diputación de Barcelona established 125 years ago the Escola de la Dona to improve the vocational training for women of that time. Among other specialties, the fashion lessons have a great tradition within the School who have successfully adapted to the different needs of the moment.
Nowadays several lessons are taught within the fashion industry, which enable students to obtain a qualification based on their specific interests (general fashion specialty, fashion design specialty, pattern specialty, cutting and sewing techniques specialty, specialty on ironing techniques). Besides we also have other lessons as: painting on clothes, accessories, flowers, lingerie and patchwork.

All this lessons combined craft techniques with other more current (computer and industrial support) focused on the incorporation of our students to the labour market.

The Department of Fashion and their students participate in competitions and national and international fairs: Bread and Butter, Murciajoven, Fashion Contest Art&Fashion, Puerta Nupcial, Gillette Venus, Premi Catalunya, Modafad ect

Also works with leading companies within the industry as the fashion house Gratacós.
Nowadays the Escola de la Dona i el Department the Moda, participates along with other European members, in the Leonardo Project: "Fashionnet", which aims to update the trainers of the fashion industry, through different territorial studies.

Escola de la Dona
Sant Pere Més Baix, 7
08003 Barcelona
Phone: +34 934 022 762

ESCOLA SUPERIOR DE DISSENY (ESDi)

www.esdi.es

The Escola Superior de Disseny (ESDi) was founded in 1989 and is assigned to the Universitat Ramon Llull, Spain's first private university. It is a pioneering force in promoting degree-level education in diverse areas of design including: fashion, product, graphic, audiovisual, interior and multidisciplinary design.

The school's mission is to nurture a strong and vibrant design culture through training future professionals to confront successfully the challenges and different opportunities present in today's fast-paced society.

Nowadays ESDi is the first university in Catalonia to offer the Official Degree on Design adapted to the EHEA (European Higher Education Area) and the first in Spain to offer the complete range of modalities in design.

Escola Superior de Disseny (ESDi)
Marqués de Comillas, 79-83
08202, Sabadell – Barcelona
Phone: +34 937 274 819
Fax: +34 937 274 249

ES Di Escola Superior de Disseny
centre associat
Universitat Ramon Llull

www.idep.es

IDEP Superior Institute of Design
(Associate center of the Universitat Abat
Oliba CEU)

Coinciding with the new century, an
evident change has taken place on the
scene of professions, which like fashion,
are linked to the world of communication.
Transforming tools, work processes,
professional habits ... and most
importantly, ways of thinking, dressing
and communicating. A hermetic vision of
the *pret-a-porter* or a product without a
label. These are already concepts of the
20th century that, to the new generation,
seems distant at best and, for the
majority and with good reason, obsolete.

The traditional role of the designer, the
photographer, the stylist or the
communicator is insufficient to be
competitive in the global world of the
present and the immediate future: the
specialties intermingle; the borders
between different professions are
ambiguous. And then appears a
professional who, being a specialist with
a solid foundation in the world of fashion,
is capable of creating daring and
competent proposals, which go beyond
the mere formal presentation.

It is in this project that all of the
professionals of IDEP Superior Institute of
Design have put all of our vision,
ambition, and passion.

IDEP
Gran Via de les Corts Catalanes, 461.
08015 Barcelona
Phone: +34 934 161 012

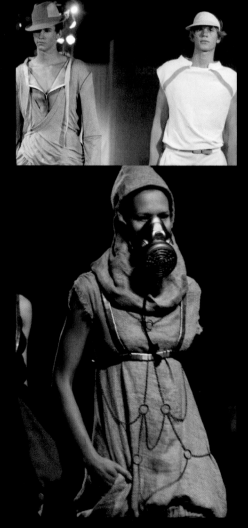

IDEP
INSTITUT
SUPERIOR
DE DISSENY

Universitat
Abat Oliba CEU
centre associat

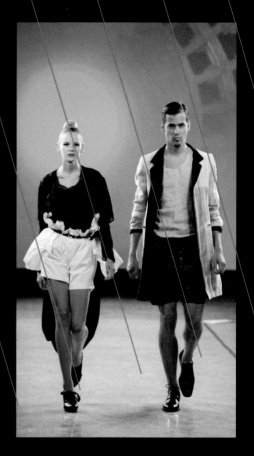

INSTITUT CATALÀ DE LA MODA

www.incatmoda.com

With more than 25 years of experience ICM is one of the leading fashion schools in Europe. Research and development have been our motto and our main concern and that is why we have been able to develop an up to date curriculum so our students can keep up with the ever-changing fashion world.
ICM educational methodology is based not just on theory but also on practical knowledge, to ensure that our graduating students can have a wide and real view of the fashion field.
We have been pioneers since our foundation in 1981 in preparing good and knowledgeable professionals, and we are proud of their achievements in national and international fashion events.

Institut Català de la moda
Gran Vía de les Corts Catalanes, 696
08010 Barcelona
Phone: +34 932 651 115
Fax: +34 932 653 068
Mail: incatmoda@retemail.es
www.myspace.com/institutcataladelamoda

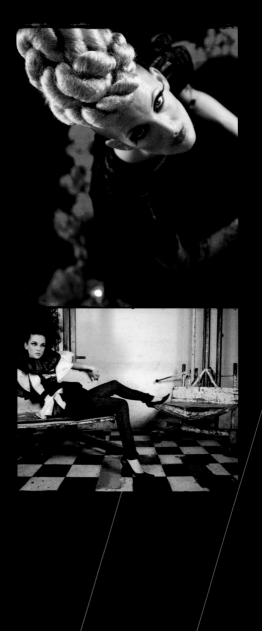

MODAFAD THANKS:

Generalitat de Catalunya, Ajuntament de Barcelona, Fira Barcelona, Barcelona Fashion Week, 080, FAD, Any del Disseny

Cervezas Moritz: Albert Castellón, Iolanda Granel, Oriol Padró, Jordi Noguera, Aida Marcet, Montse Comabella

Actar: Ramon Prat, Anna Tetas, Dolors Soriano.

Bread and Butter: Karl-Heinz Müller, Wolfgang Ahlers, Kristyan Geyr, Bernadette Wittmann, Katharina Kemmler
Moda Barcelona
Circuit

FAD Presidents: Beth Galí, Juli Capella, Ramon Bigas

ModaFAD Presidents: Marcel Montlleó, Jordi Roset, Paulino Ruiz, Antonio Alvarado

Medallas FAD: Manuel Pertegaz, Antonio Miró, Roser Melendres

Sopar Merescut Award: Maria Vella Zanetti, Egidio Ghezzi, Jordi Labanda, Josep Font, Maria Casanovas

Albert Castellón, Montse Comabella, CosmoCaixa, Anna Sanahuja, Katty Carreras-Moysi, CCCB, Museu Marítim, Josep Maria Garcia-Planas, Josep M. Ballús, Sybilla, Jordi Labanda, Silvia Prada, Juan Salvadó, Xavi Sánchez, Bigas Luna, Ferran Adrià, Martí Guixé, Carles Congost, Boris Hoppek, Moritz Waldemeyer, Emilio Saliquet, Uovo, Fiorucci, Diane Pernet, Unit F, FFI, La Fura dels Baus, Alaska, Txell Miras, El

Delgado Buil, Miriam Ponsa, Bassols, Lupo, Wgsn, Schoeller Textile, Réplica, Línea De General Óptica, Nobel, HP, IMG, Orbyce, Abr, Atrezzo, Fiorucci

Plataforma d´ Escoles de Barcelona: BAU, Escola de la Dona, Escuela Guerrero, ESDI, Felicidad Duce, IDEP, ICM, IED, Llotja

Architects / Instalations: Aubergine, Bopbaa, Josep Bohigas, La Granja, Solo Estudio, Eing, Niall O'Flynn, Xnf Arquitectes

Graphics: Vasava, Sofa Experience, Leo Obstbaum, Cans/Dominich, Javier Navarro, Domingo Ayala, Juanjo Saéz, Mierda y Cia, Anna Coll, Guillem Pericay

Photography and Video: Josep M. Civit, Daniel Riera, Sergi Pons, Xavi Pastor, Carles Roig, Xavi Padrós, David Dunan, La Fotográfica, Abutardarts, Susana Ferran, Marcel Montlleó, Juanjo Onofre, Ojo Móvil, Víctor Torres, Jordi, Olivia Aracil

Lomography: Cristina Hinrichsen, Anna Gura Llobet, Araceli Trullenque, Benjamín Julve, Berta Fernández, Camila Dnati, Celeste Arroquy, Daniel Aguilar, Elisa Rodríguez, Elva Rodríguez, Esther Martínez, Eva Palacios, Fabricio Lasorsa, Federico Scorzoni, Fernando Alcalá, Fran Somo, Gartzen Martínez, Gloria Blázquez, Helena Batlle, Irene Belmonte, Jordi Cortés, Juan B. Mallol, Juan Cristóbal Rubio, Julia Gaspar, Laia Buil, Laia Murcia, Luci Cambo, Lucía García, Mª Luisa Vives, Marta Benzo, Marta Vlez, Mateo Rebuffa, Miles Dufrasne, Mireia Costa, Pepe Alorda, Pere Gallifa, Raquel Cantero, Raquel Reina, Raúl Cervera, Roger Santos, Sandra Cano, Sandra Valecillo, Sebastian Vidal, Xesco López Iturbe, Xevi Serrano, Zaida Pernas, Zita Vehil

Stylists: Anna Vallés, Asier Tapia, Flora Ximenis, Jaume Vidiella, José Sánchez, Juan Vidal, Miquel Malaspina, Rachel Shaw, Sousana Loureda y Txomin Plazaola

Hairdressers & Make up: Marcel, Neus Tutusaus, Salva G., Aka, Polopelo, Iñaki Ayabar

MODAFAD COUNCILS
>

01.1993 – 08.1995
President Marcel Montlleó, Treasurer Ramon Faus Santaulària, Coordinator Josep M. Ballús Ribas, Secretary Pilar Pasamontes, Pilar Díaz de Quijano, Javier Escobar, Josep M. García-Planas, Àngela Guardiola, Nacho Malet

08.1995 – 10.1996
President Jordi Roset, Curator empresa Josep Subirats, Vicepresident, Marcel Montlleó, Treasurer Vicens Gilabert, Maite Muñoz, Javier Escobar, Josep M. Ballús, Pilar Pasamontes, Xavi Sánchez, Andrea Morros, Jordi Coca

10.1996 – 07.1997
President Marcel Montlleó, Xavier Sánchez, Maite Muñoz, Treasurer Jordi Rotllan, Pilar Pasamontes, Francesc Molinos, Miquel Gili, Josep Abril, Cristina Arnau, Paulí Ruiz, M. Àngels Sánchez, Gabriel Torres, Jorge Zuazo

07.1997 – 10.1999
President Paulino Ruiz, Vicepresident Montse Ferrer, Treasurer Jordi Rotllan, Josep Abril, Gabriel Torres, Itxaso Lecumberri, Cristina Arnau, M. Ángeles Sánchez, Ruth Castillo, Sergio Pastor, Isaac Reina, Susanne Hergenhahn

10.1999 – 06.2003
President Antonio Alvarado, Vicepresident Pilar Pasamontes, Treasurer Jordi Rotllan, Jaume Vidiella, Secretary Josep Abril, Miguel Malaspina, Gabriel Torres, Itxaso Lecumberri

Cristina Arnau, M. Ángeles Sánchez, Ruth Castillo, Sergio Pastor, Isaac Reina, Susanne Hergenhahn, Montse Ferrer, Josep Abril, Anna Vallés, Maite Muñoz, Alessia Zoppis, Flora Ximenis, José Sánchez, Sousana Loureda

06.2003
President Chu Uroz, Vicepresident Pilar Pasamontes, Treasurer Alessanro Manetti, Sylvia Nevado, Miquel Malaspina, Josep Abril, Jaume Vidiella, José Sánchez, Txomin Plazaola, Mahala Alzamora, Maite Muñoz, Asier Tapia, Leo Obstbaum, Javier Navarro, Tatiana de la Fuente, Silvia Aldomá

MODAFAD FOUNDERS
>

Josep Mª Ballús, Anna Vallés, Gilbert Solsona, Matilde M. Oriola, Margarita Nuez, Lluís Llongueras, Ángela Guardiola, Anna M. Álvarez, Pilar Pasamontes, Esther Casaldaliga, Ramon Faus, Marcel Montlleó, Conxa Blanch, Nacho Malet, Joseph Mª Garcia Planas, Eduard Bosc, Rolande Gounkevitch, Kima Guitart, Carlota Durán, Antoni Ruiz Aragó, Antoni Casala, Pedro Martínez, Mamen Domingo, Joaquim Verdú, Dolors Cots, Javier Escobar, Encarna Delgado, Pau Pascual, Yann Mercader, Conchita Vilella, Carlos M. Galindo, Montserrat Figueras, Mª Teresa Garcés, Mercedes Faus, Marta Faus, Guillermo Ballares, Pedro Farré, Anna Páramo, Mercè Roca, Roser Melendres, Dídac Martínez, A. Jorge Larruy, Pepe Reblet, Silvia Aldomà, Ramon Salado, Miquel Planas

THIS BOOK HAS BEEN PUBLISHED CELEBRATING MODAFAD TWENTY FIFTH EDITIONS

BRANDNEW GUIDE: ONE WEEK IN BARCELONA

>

DESIGNER'S FAVORITE PLACES. SHOP, DRINK AND PLAY.

MORITZ

DAY ONE
VISIT US AT EL RAVAL

\>

RESTAURANTS
01. CASA ALMIRALL. Joaquim Costa, 33
02. PLA DELS ÀNGELS. Ferlandina, 23
03. LAS FERNÁNDEZ. Carretas, 11

VINTAGE SHOPS
04. LE SWING. Riera Baixa 13
05. LAILO. Riera Baixa, 13 / Notariat, 3

BARS & COCKTAIL BARS
06. LE SWING CAFÉ. Notariat 7
07. LA PENÚLTIMA. Riera Alta 40
08. SIFÓ. Espalter 4
09. NEGRONI. Joaquin Costa 46
10. CERVECERÍA MORITZ. Ronda Sant Pau 5
11. EL CANGREJO. Montserrat 9
12. FELLINI. La Rambla 27
13. MOOG. Arc del Teatre 3
14. LA CONCHA. Guàrdia 14
15. LA CASETA DEL MIGDÍA

COMICS & ART BOOKS
16. Ras. Doctor Dou 10

OTHERS
17. MACBA. Plaça dels Àngels 1
18. CAIXAFORUM.
Avda Marquès de Comillas, 6-8 (Montjuïc)
19. FUNDACIÓ MIRÓ. Parc de Montjuïc s/n

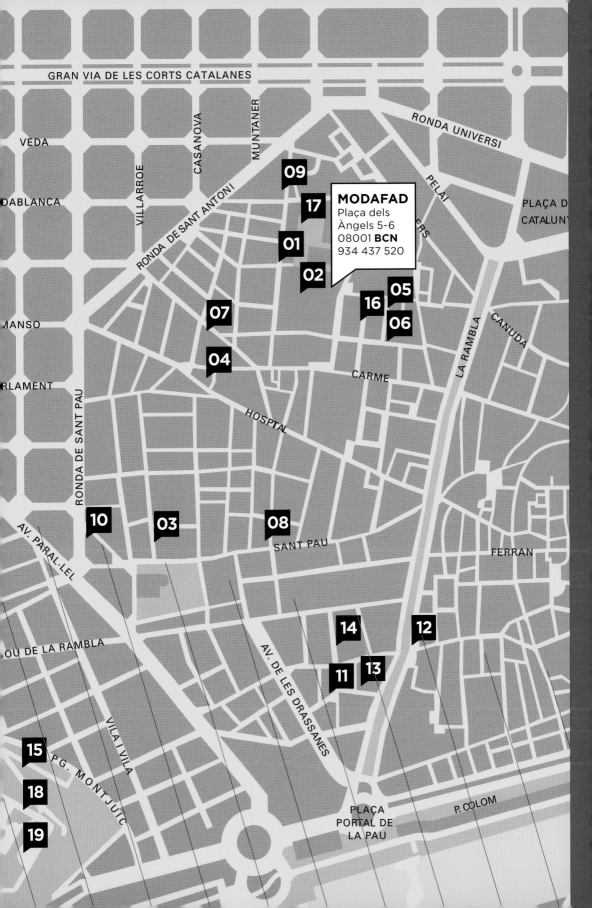

GRAN VIA DE LES CORTS CATALANES

VEDA

DABLANCA

VILLARROE

CASANOVA

MUNTANER

RONDA DE SANT ANTONI

RONDA UNIVERSI

RONDA DE SANT PAU

PELA I

ERS

LA RAMBLA

CANUDA

PLAÇA D
CATALUNY

09

17

01

02

MODAFAD
Plaça dels
Àngels 5-6
08001 **BCN**
934 437 520

16 **05**

06

CARME

07

04

HOSPTAL

MANSO

RLAMENT

AV. PARAL·LEL

10

03

08

SANT PAU

FERRAN

OU DE LA RAMBLA

AV. DE LES DRASSANES

14

12

11 **13**

VILA I VILA

15

P.G. MONTJUIC

18

19

PLAÇA
PORTAL DE
LA PAU

P. COLOM

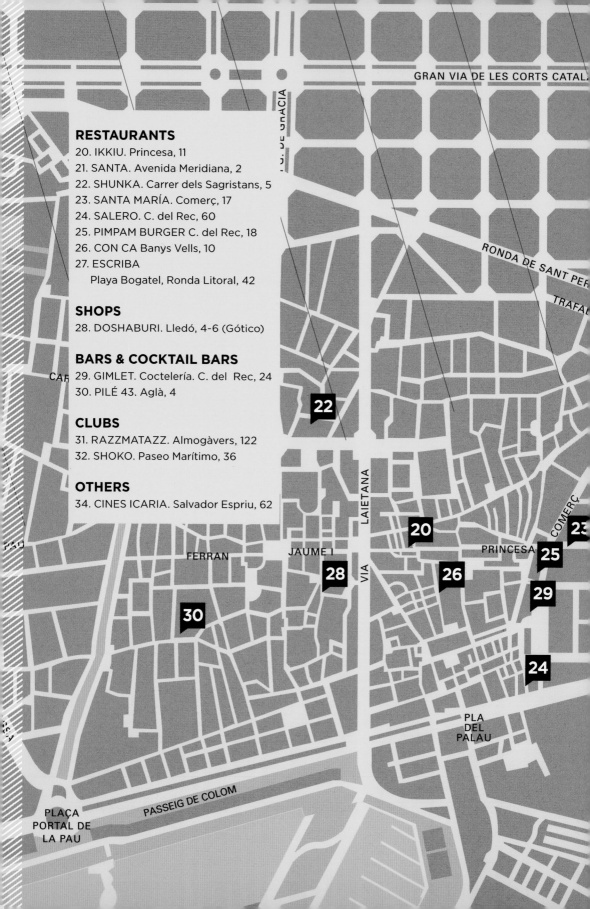

RESTAURANTS

20. IKKIU. Princesa, 11
21. SANTA. Avenida Meridiana, 2
22. SHUNKA. Carrer dels Sagristans, 5
23. SANTA MARÍA. Comerç, 17
24. SALERO. C. del Rec, 60
25. PIMPAM BURGER C. del Rec, 18
26. CON CA Banys Vells, 10
27. ESCRIBA
 Playa Bogatel, Ronda Litoral, 42

SHOPS

28. DOSHABURI. Lledó, 4-6 (Gótico)

BARS & COCKTAIL BARS

29. GIMLET. Coctelería. C. del Rec, 24
30. PILÉ 43. Aglà, 4

CLUBS

31. RAZZMATAZZ. Almogàvers, 122
32. SHOKO. Paseo Marítimo, 36

OTHERS

34. CINES ICARIA. Salvador Espriu, 62

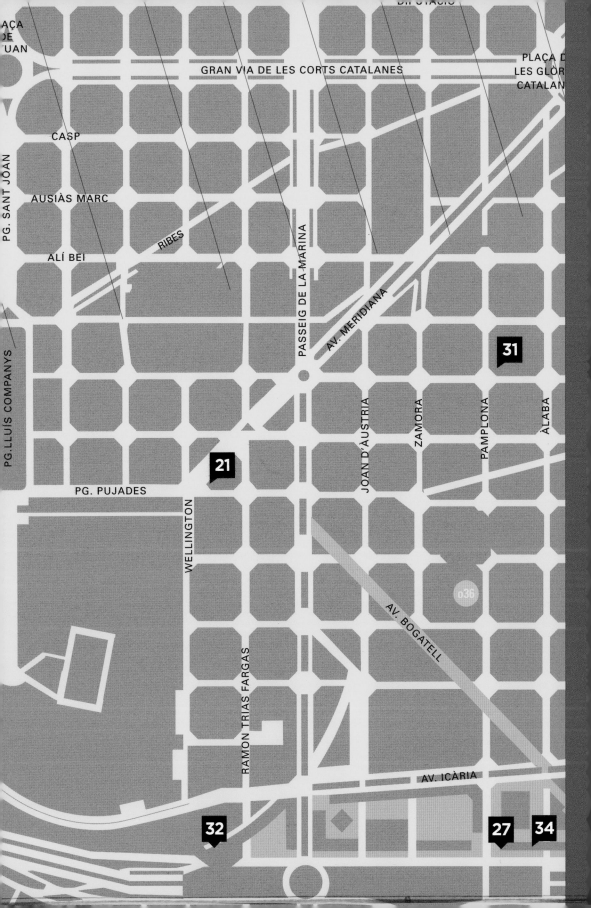

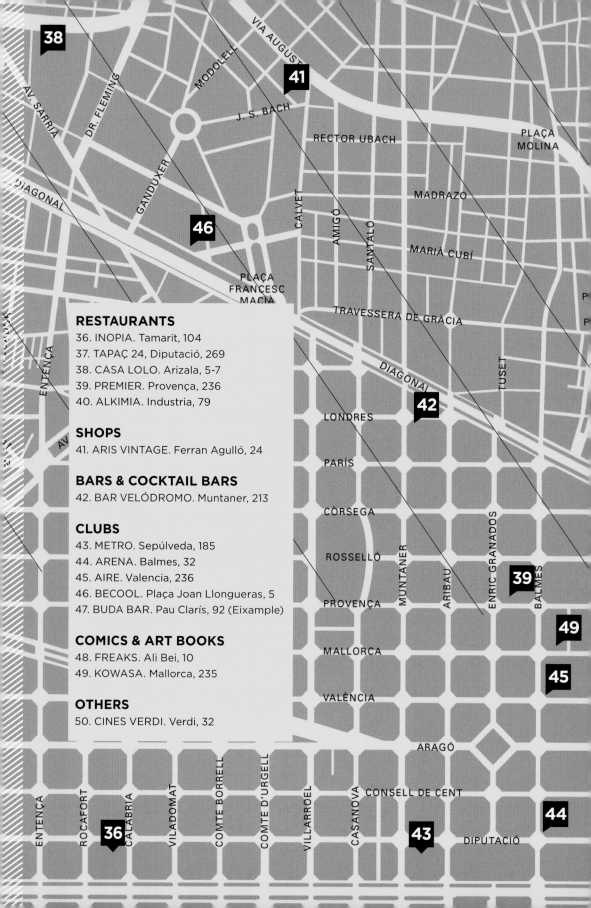

RESTAURANTS
36. INOPIA. Tamarit, 104
37. TAPAÇ 24, Diputació, 269
38. CASA LOLO. Arizala, 5-7
39. PREMIER. Provença, 236
40. ALKIMIA. Industria, 79

SHOPS
41. ARIS VINTAGE. Ferran Agulló, 24

BARS & COCKTAIL BARS
42. BAR VELÓDROMO. Muntaner, 213

CLUBS
43. METRO. Sepúlveda, 185
44. ARENA. Balmes, 32
45. AIRE. Valencia, 236
46. BECOOL. Plaça Joan Llongueras, 5
47. BUDA BAR. Pau Clarís, 92 (Eixample)

COMICS & ART BOOKS
48. FREAKS. Ali Bei, 10
49. KOWASA. Mallorca, 235

OTHERS
50. CINES VERDI. Verdi, 32

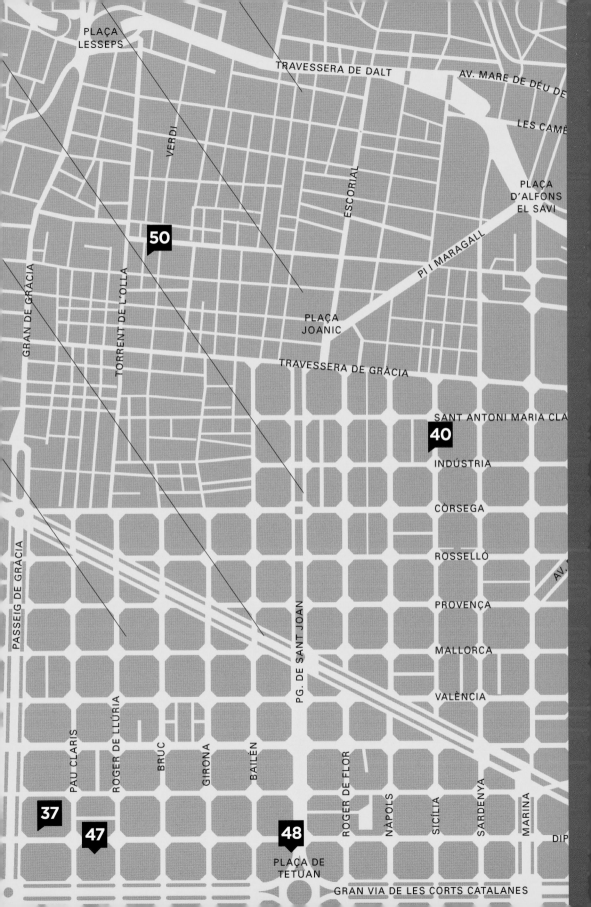

DAY TWO

>

DAY THREE

>

DAY FOUR

>

DAY FIVE

>

DAY SIX

>

DAY SEVEN

>

ES CORTS CATALANES

VILLARROEL

CASANOVA

MUNTANER

RONDA DE SANT ANTONI

RONDA UNIVERSITAT

PELAI

TALLERS

PG. DE GRÀCIA

PLAÇA DE CATALUNYA

28

29

04 **11**

07

18

15

LA RAMBLA

CANUDA

27

09

CARME

30

HOSPITAL

31

24

35

SANT PAU

FERRAN

23

JAUME I

06

AV. DE LES DRASSA

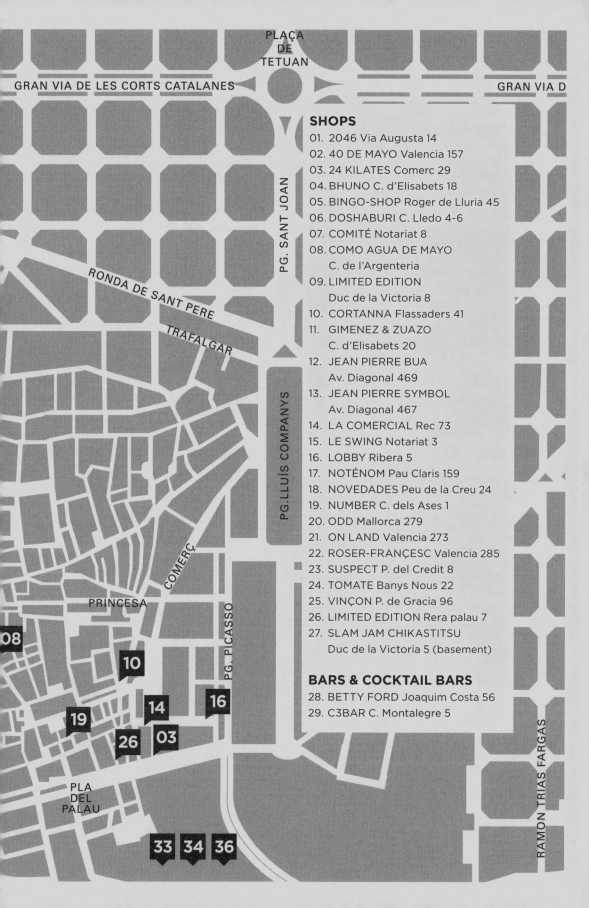

SHOPS

01. 2046 Via Augusta 14
02. 40 DE MAYO Valencia 157
03. 24 KILATES Comerc 29
04. BHUNO C. d'Elisabets 18
05. BINGO-SHOP Roger de Lluria 45
06. DOSHABURI C. Lledo 4-6
07. COMITÉ Notariat 8
08. COMO AGUA DE MAYO
 C. de l'Argenteria
09. LIMITED EDITION
 Duc de la Victoria 8
10. CORTANNA Flassaders 41
11. GIMENEZ & ZUAZO
 C. d'Elisabets 20
12. JEAN PIERRE BUA
 Av. Diagonal 469
13. JEAN PIERRE SYMBOL
 Av. Diagonal 467
14. LA COMERCIAL Rec 73
15. LE SWING Notariat 3
16. LOBBY Ribera 5
17. NOTÉNOM Pau Claris 159
18. NOVEDADES Peu de la Creu 24
19. NUMBER C. dels Ases 1
20. ODD Mallorca 279
21. ON LAND Valencia 273
22. ROSER-FRANÇESC Valencia 285
23. SUSPECT P. del Credit 8
24. TOMATE Banys Nous 22
25. VINÇON P. de Gracia 96
26. LIMITED EDITION Rera palau 7
27. SLAM JAM CHIKASTITSU
 Duc de la Victoria 5 (basement)

BARS & COCKTAIL BARS

28. BETTY FORD Joaquim Costa 56
29. C3BAR C. Montalegre 5

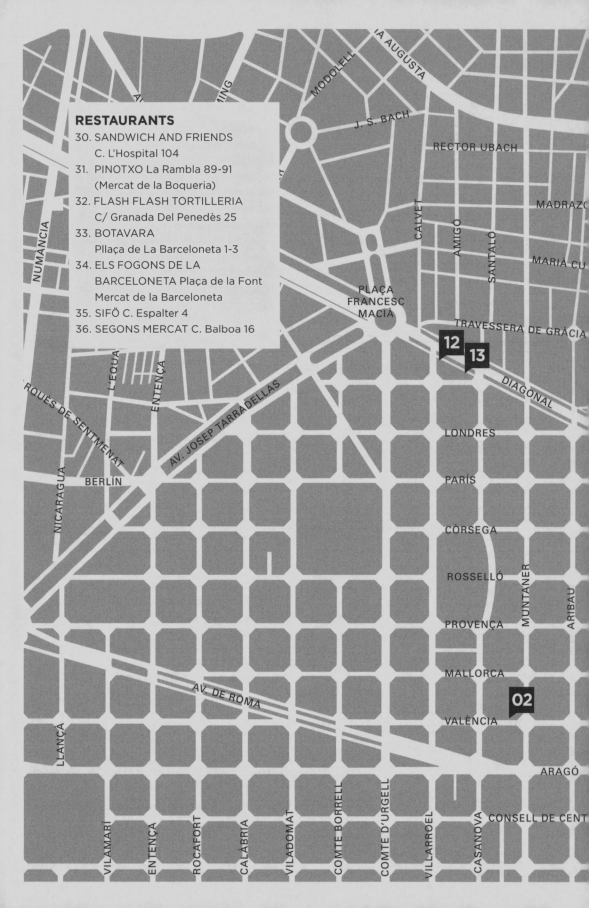

RESTAURANTS

30. SANDWICH AND FRIENDS
 C. L'Hospital 104
31. PINOTXO La Rambla 89-91
 (Mercat de la Boqueria)
32. FLASH FLASH TORTILLERIA
 C/ Granada Del Penedès 25
33. BOTAVARA
 Pllaça de La Barceloneta 1-3
34. ELS FOGONS DE LA
 BARCELONETA Plaça de la Font
 Mercat de la Barceloneta
35. SIFÖ C. Espalter 4
36. SEGONS MERCAT C. Balboa 16

WAIT!
ARE YOU
REALLY
SURE YOU
WANT TO
LEAVE?

>

2FOR1

MORITZ moda ▶ fad

WHILE IN BARCELONA, VISIT OUR BARS. PAY ONE MORITZ BEER, GET TWO.

2FOR1

MORITZ moda ▶ fad

WHILE IN BARCELONA, VISIT OUR BARS. PAY ONE MORITZ BEER, GET TWO.

2FOR1

MORITZ moda ▶ fad

WHILE IN BARCELONA, VISIT OUR BARS. PAY ONE MORITZ BEER, GET TWO.

2FOR1

MORITZ moda ▶ fad

WHILE IN BARCELONA, VISIT OUR BARS. PAY ONE MORITZ BEER, GET TWO.

VALID IN:

INOPIA: C/Tamarit 104

TAPAÇ24: C/Diputació 269

PLA DELS ÀNGELS: C/ Ferlandina 23

LA SANTA: Avinguda Meridiana 2

CASA LOLO: Arizala 5-7

ELS FOGONS DE LA BARCELONETA:
Plaça de la Font s/n. Mercat de la
Barceloneta

SIFÓ: C/ Espalter 4

SEGONS MERCAT: C/ Balboa 16

VALID IN:

INOPIA: C/Tamarit 104

TAPAÇ24: C/Diputació 269

PLA DELS ÀNGELS: C/ Ferlandina 23

LA SANTA: Avinguda Meridiana 2

CASA LOLO: Arizala 5-7

ELS FOGONS DE LA BARCELONETA:
Plaça de la Font s/n. Mercat de la
Barceloneta

SIFÓ: C/ Espalter 4

SEGONS MERCAT: C/ Balboa 16

VALID IN:

INOPIA: C/Tamarit 104

TAPAÇ24: C/Diputació 269

PLA DELS ÀNGELS: C/ Ferlandina 23

LA SANTA: Avinguda Meridiana 2

CASA LOLO: Arizala 5-7

ELS FOGONS DE LA BARCELONETA:
Plaça de la Font s/n. Mercat de la
Barceloneta

SIFÓ: C/ Espalter 4

SEGONS MERCAT: C/ Balboa 16

VALID IN:

INOPIA: C/Tamarit 104

TAPAÇ24: C/Diputació 269

PLA DELS ÀNGELS: C/ Ferlandina 23

LA SANTA: Avinguda Meridiana 2

CASA LOLO: Arizala 5-7

ELS FOGONS DE LA BARCELONETA:
Plaça de la Font s/n. Mercat de la
Barceloneta

SIFÓ: C/ Espalter 4

SEGONS MERCAT: C/ Balboa 16